Perfect Color Choices for the Artist

by Michael Wilcox

The Michael Wilcox School of Colour Publishing

Artist Quality products created by Artists

SCHOOL OF COLOR PUBLICATIONS

www.schoolofcolor.com

Acknowledgements

This book would not have been possible without the dedication, hard work and professionalism of the people listed below. Without their determination it would not have seen the light of day. This was a particularly difficult project as we worked to the very edge of print technology in order to reproduce the colors as accurately as possible. To all involved, thank you for allowing me to get the contents of this book out of my system, it was a long held ambition. Michael Wilcox

Publisher:
Anne Gardner

Planning, picture research
and illustrations:
Matthew Brown

Consultant:
Joy Turner Luke

Scanning and color balance:
Wesley Thorne

Technical assistance:
Jo Holness and
Lucy Robinson

Page design and layout:
Brian Gillespie

Print coordination:
Desmond Heng

Illustration on pages
73,74,106,110,114,120:
Craig Letourneau

Finishing:
Maureen Bonas

Research and text:
Michael Wilcox

ISBN 1-931780-19-6

Text, Illustrations and
Arrangement Copyright:
The Michael Wilcox School of
Color Publishing Ltd.
Gibbet Lane, Whitchurch
Bristol BS14 OBX England
Tel: UK 01275 835500
Facsimile: UK 01275 892659
www.schoolofcolor.com

Printing:
Imago Productions
F.E. Singapore

Did nothing:
Jasper the company cat

Distributed to the trade
and art markets in North
America by:
North Light Books
F & W Publications Inc.
4700 East Galbraith Road
Cincinnati,
OH 45236
USA
Tel: (800) 289 0963

Distributed in the UK, EEC &
associated territories by:
Search Press Ltd.
Wellwood, North Farm Road
Tunbridge Wells, Kent
TN2 3DR England
Tel: (01892) 510850
Facsimilie (01892) 515903
Email sales@searchpress.com
Website www.searchpress.com

Distributed to the trade and art
markets in Australia by:
Keith Ainsworth Pty. Ltd.
Unit 6/88 Batt Street
Penrith NSW 2750
PO Box 6061
Australia
Tel: 02 47 323411
Facsimilie: 02 47 218259
Email: ainsbrook@ozemail.com.au

Until I started to research this book I felt that I knew what the term 'color harmony' meant. As I reached further into the subject I realised that I had only the vaguest of ideas.

All who I have spoken to, from artists to craft-workers to designers, have also 'known' what the term 'color harmony' meant until asked to define it.

The following is my attempt to unravel this complex mystery. Given the nature of the subject I will only be able to go so far, as much has yet to be discovered.

Michael Wilcox

Contents

Contents

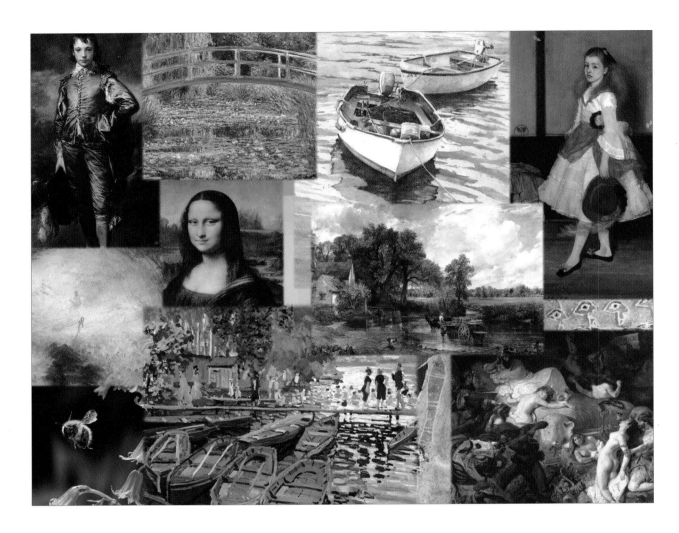

As individuals we may find that certain color combinations harmonise while others clash. An arrangement is perceived as being harmonious, contrasting or discordant within the brain of the viewer and therefore should be regarded as a subjective perception.

If one person finds pleasure in a particular combination while another experiences the opposite reaction, both must be correct.

With color use there can be no rights and wrongs. As an analogy we could say that the diner who enjoys tomatoes has the same right and entitlement to his or her tastes as another who dislikes tomatoes.

If I enjoy seeing red and green together and you find that they clash, who is to say whether they harmonise or are discordant?

The final answer lies in our brain. But, as with so many other areas, the brain keeps itself to itself. As we cannot know how another person sees color, let alone reacts to it, how can we decide on harmonious combinations? And why would we want to?

The second question is probably easier to answer. It seems that, in the main, we either wish to produce color arrangements which please others or we wish to define the subject; to find out just why certain combinations might give pleasure to the majority.

The first question, 'how can we decide on harmonious combinations' is going to be a lot harder to tackle.

Perfect harmony follows hidden rules

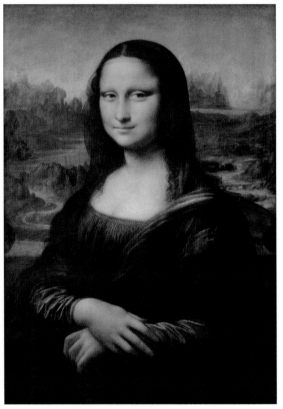

Mona Lisa, 1503-6 by Leonardo da Vinci (1452-1519)
Louvre, Paris, France/Bridgeman Art Library

Does perfect harmony exist?

In an attempt to find the answer, several main themes have developed slowly and interacted with one another over the ages.

One of the earliest recorded approaches was based on Plato's belief that perfect concepts, perfect form, perfect harmony exists but that what we see on earth are imperfect glimpses of these underlying truths.

The world that most of us are aware of was somewhere below the surface of reality and incomplete. Nearer the surface lies true beauty, hidden from most.

Occasionally, perfect beauty and harmony might be glimpsed, but only by the select few able to reveal or recognise the various aspects of this perfection.

The dedicated artist, *trained in the sciences,* is able to create forms which reveal the otherwise hidden beauty and the true connoisseur is able to enjoy the aesthetic pleasures which can result.

Although this approach is, in my opinion, heavily flawed, its main finding seems to be with us still. Many an 'artist', particularly the professional with an eye to promotion, is happy to build on the 'I am a special person with insight denied to the rest of you' myth.

'I am painting a moving ostrich with rancid bear fat because I have been gifted with artistic insight'. The art critic, gallery owner and art connoisseur go along with this as they too have a 'special insight' and can recognise the 'true artist' in society. Or maybe they are all just making money, who knows.

7

Perfect harmony follows hidden rules

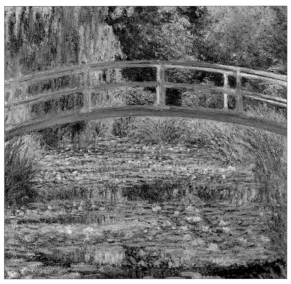

The Waterlily Pond, 1899, Claude-Oscar Monet
© National Gallery, London

Everyone has an equal say in what color arrangements are harmonious.

Although the 'I have insight and am special' approach is widespread, the belief that there might exist certain in-built rules of beauty and harmony is still genuinely held by many.

In another area, this way of thinking can be applied to many of the world's religions.

Enlightenment being available to a certain few devotees prepared to seek it.

Having now looked at many other approaches to our subject, I have come to feel that harmony and beauty are too fleeting, variable and individual to have any quantifiable basis.

Close to the bottom of my list would be the notion that true harmony of color follows certain inherent objective rules that could *potentially* reveal true beauty to everyone.

It might seem that whenever a new form of beauty is revealed, what is being exposed is the truth that had been there all along.

However, that 'truth' is only meaningful to particular and identifiable viewers. Many peoples in the world might look at a Monet painting, for example, and agree amongst themselves that it gives a glimpse of true beauty.

But what of the so called 'primitive' tribe, living in a remote area, who find true and genuine beauty in a mix of chicken intestines and peanuts.

Can we be so arrogant as to deny that they have also tapped into true beauty? Or do they need our sophisticated education and background to see that they should be able to also appreciate the work of Monet?

There have been few truer sayings than, 'beauty is in the eye of the beholder'.

Perfect harmony follows hidden rules

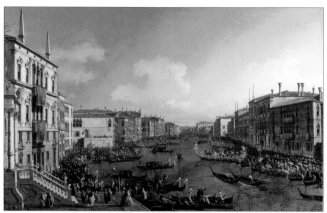

A Regatta on the Grand Canal, 1735, Canaletto
© National Gallery, London

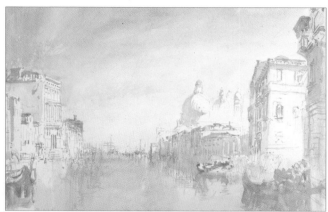

Venice, The Grand Canal, J.M.W. Turner
© Tate, London 2002

"Canaletto and Turner both painted the Grand Canal, and their pictures are completely different. Both are sincere expressions of the artist's realisation, both are true to the facts, and to a sense of real feeling".

The following is typical of the view taken by many observers.

Obviously, in fact, the propriety of such judgments turns on the validity of Keats' statement, that 'beauty is truth, truth beauty'.

"Has this statement any basis?"

I suggest, with all diffidence, that it does mean something of importance; that when we recognize beauty in any ordered form of art, we are actually discovering new formal relations in a reality which is permanent and objective to ourselves, which is part of that reality that includes both human nature and its reactions to color, line, mass and sound, and the material consistencies which maintain them.

That is, we are recognizing aesthetic meaning in the character of the universe, and this aesthetic order of meaning gives us the same sense of belonging to a rational and spiritual whole of character as does the moral truth of a Dante or Tolstoy.

"When the Impressionists devised their new technique to express and reveal their new intuition, they gave us a revelation of a beauty no one had seen before.

But it had always been potential in the actual nature of the world of color, light, paint and human sensibilities.

They revealed a truth as a scientist reveals a new element. Such an element is true in the deepest sense. It is part of the universal order of things.

"But the school of David and Ingres rejected by the Impressionists was equally valid. How can we have two different truths within the same order, the same context?

"Canaletto and Turner both painted the Grand Canal, and their pictures are completely different. Both are sincere expressions of the artist's realisation, both are true to the facts, and to a sense of real feeling. When I say they are true to the facts, I mean they represent material fact in such a way that it can be identified. But this is not important except insofar as an aesthetic value belongs to the recognition of the fact."

From: **'Art and Reality: ways of the creative process',** by Joyce Cary.

Color and music

Another approach is the idea that the perception of harmony is a universal human attribute, and therefore, is manifested in both art and music. There is a long history, continuing to the present, of attempts to equate color harmony with musical harmony.

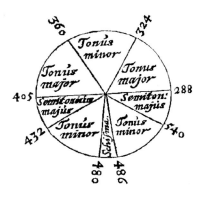

The circle of major and minor tones drawn up by Rene' Descartes shows similarities to Newton's Color Wheel. (Compendium Musicae Utrecht 1650)

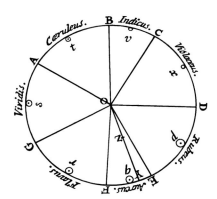

Newton's Color Wheel.

The following is reproduced from **'Color and Culture: Practice and Meaning from Antiquity to Abstraction'**, by John Gage

'The extended and more coherent color-scales of the Baroque made it possible to devise more complete correspondence with musical scales: Cureau de la Chambre in 1650 was able not only to plot the consonances in a double octave from white to black but also to number the hues along the scale, so the combinations of colors were seen to have harmonic relationship with each other.

Thus red at 16 was dissonant with blue at 9 and yellow at 18 but formed an octave with purple at 8 and a fourth with green at 12...

'It was left to Newton at the end of the century to free the color-scale from the Aristotelian tonal scheme and to develop Kepler's and Descartes's quantification of colors in the spectral sequence, so that this sequence could be related more plausibly to the quantified musical scale...already in his Cambridge lectures of 1669 Newton had argued for a 'musical' division of the spectrum of white light... In a draft for an unpublished section of Opticks, written probably in the 1690s, he stated, 'green agrees with neither blew nor yellow for it is distant from them but a note or tone above & below.

Nor doth orange for the same reason agree with yellow or red: but orange agrees better with an Indigo blew than with any other color for they are fifths... Newton's proposals gave a more comprehensive and a more detailed account of the analogy between aural and visual sensations.

The great authority of the Opticks has made this appear to be a legitimate and potentially fruitful area of inquiry until our own day'.

Color and music

Newton changed the details of his proposals at different times, as others have who tried to place hues in scales related to musical scales.

In fact, once hooked on the idea that there might be a correlation between music and color, the goal posts keep moving as the artist/musician changes his/her mind about the relationship.

'Is a bright orange-yellow related to the higher notes of the trumpet or is it more of a C, F or G on the guitar'?

One minute Ultramarine Blue might suggest the middle ranges of a harpsichord, the next, the sound of a drunk tap dancing in a puddle.

At the end of the day, many who have investigated this area find that almost any color can suggest almost any sound.

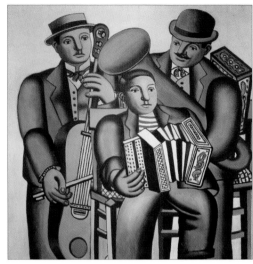

The Three Musicians, 1930 by Fernand Leger
Heydt Museum, Wuppertal, Germany/
Index/Bridgeman Art Library
© ADAGP, Paris and DACS, London 2002

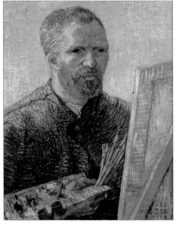

Self Portrait before his Easel, 1888 by Vincent Van Gogh (1853-90) Rijksmuseum Vincent Van Gogh, Amsterdam, The Netherlands/ Bridgeman Art Library

Beginning about 1769, various machines were designed that would play color as one would play music. In the above, 'a design for a Musique Oculaire', the inventor G. G. Guyot describes a machine which rotated, exposing transparent colored paper slips illuminated by a lantern.

From 'Nouvelles Recreations physiques et metaphysics', Vol 111 Paris 1769.

Many an artist has been drawn to the idea that color could be related to music. Amongst others was Van Gogh, one of the great colorists. He started piano lessons in 1885 in order to identify colors with notes and chords.

His teacher soon became tired of his continual comparisons and dismissed him: 'for seeing that during the lessons Van Gogh was continually comparing the notes of the piano with Prussian Blue and dark green, and dark ochre, and so on, all the way to bright Cadmium Yellow, the good man thought he had to do with a madman.'

From: **'Collected Letters'**, 3 Vols. Van Gogh, 1958

11

Color and music

'The Art of Mobile Color' by A. Wallace Rimington, 1912

Visual vibrations (wavelength)	395	433	466	500	533	566	600	633	666	700	733	757UV
Color	Deep Red	Crimson	Orange Red	Orange	Yellow	Yellow Green	Green	Bluish Green	Blue Green	Indigo	Deep Blue	Violet
Musical Note	C	C#	D	D#	E	F	F#	G	G#	A	A	#BC
Sound vibrations	256	277	298	319	341	362	383	405	426	447	469	490 512

Rimington was among the individuals who were attempting to find a direct relationship between musical harmony and color harmony.

This was during the period that 'color organs' were in vogue. In some cases the composer just fitted moving colors to a musical composition to increase its expressiveness. Some, like Rimington, believed that a direct relationship existed. He devised the table shown above.

Exactly why anyone would expect that dividing the spectrum evenly this way would result in uniform perceptual changes I can't imagine!

It requires a very small change in wavelength to result in a perceived difference in hue in some regions of the visual spectrum, and quite large changes in wavelength before a difference can be seen in other places.

Furthermore, anything above 700nm cannot be seen by anyone, and so could not be heard. Fine for playing 'Silent Night' I suppose.

As we are comparing the various approaches that have been taken to identifying harmonious color arrangements, I would offer the following;

The idea that the 'notes and scales' of color and those of music are in some way related has attracted many, including myself. The main drawback to this approach would seem to be the high degree of suggestibility involved.

A certain note can strongly suggest, say Cadmium Red Light. But if asked to compare the same note with Cerulean Blue, that color might then become the favourite choice, later to be replaced by Yellow Ochre perhaps?

It would seem to be for this reason that those seeking the relationship often make one alteration after another in their quest.

This is not to say that color/music compositions cannot be very beautiful, awe inspiring or moving. But they are surely one-off arrangements. 'Blue Suede Shoes', for example, certainly had its moments.

Color harmony and nature

A further belief is that harmony and beauty are revealed to us in nature and that harmonious color arrangements are those that follow faithfully what is seen in nature.

This approach, with certain reservations, is, I feel, closest to the answer that we are seeking. For this reason I will return to it for a closer inspection later in the book.

The idea that the colors of nature reveal true harmony has been around since antiquity, and it's easy to see why.

An unspoilt land or seascape, sunrise or sunset all offer combinations of color which give and have given, pleasure to people from all backgrounds, all cultures, and from all countries.

The aesthetic appeal of nature's color schemes does not seem to have differed over the centuries, unlike almost all other approaches.

I would like to offer the following observations, made by others. Although we are not yet looking at practical applications, such findings help to build up the full picture.

From: **'Coloritto'** *By J.C.Le Blon. First Edition 1723-1726 Second Edition 1756, dedicated to Robert Walpole. Facsimile Edition with Introduction by Faber Birren, 1980*

About the author:

Le Blon applied the red-yellow-blue theory to printing, producing fine, full-color prints in the early part of the eighteenth century. He "was among the first to produce multi-colored mezzotint prints from basic inks and registered plates."

The first edition of his book was illustrated with a series of mezzotint portraits in color of a young girl. The text of the second edition, like the first, was in both French and English and is of interest because it describes using pigments to achieve full color paintings and because his use if the word "harmony" gives some insight to the meaning of the word in the 1700's.

I have updated the English as follows.

In his dedicating Epistle to Walpole, Le Blon says: "Your Honour knows the Ancient Grecians did certainly understand the Harmony of Colors, or Coloring, and some great modern Colorists were not ignorant of it; only the Moderns in hiding their knowledge as a mighty secret, have deprived the Public of a great treasure......And as one Invention oftentimes improves another, so, that of the Imprinterie (Printing) afterwards led me into a further Pursuit of this Art until I arriv'd at the Skill of reducing the HARMONY of Coloring in PAINTING to Mechanical Practice, and under infallible Rules: And now I humbly submit my System to the Judgement of the Learned."

L'Harmonie du Colors dans la Peinture

"COLORITTO or the Harmony of Coloring, is the Art of Mixing COLORS, in order to represent naturally, in all Degrees of painted Light and Shade, the same FLESH, or the Color of any other Object, that is represented in the true or pure Light....."

Further along he writes of, "the Joy and Sweetness of that Harmony we usually perceive in natural Objects...."

I take this to mean that Le Blon believed that a picture is harmonious when the colors accurately represent nature; in other words, fit together in a natural and attractive way.

For his part he claimed to be able to produce the same results mechanically, following set rules.

Color harmony and nature

Most of the detail was printed first on the blue plate, followed by the yellow, red and black.

Le Blon was 'among the first to produce multicolored mezzotint prints from basic inks and registered plates'. He applied his red-yellow-blue theory to printing, producing fine, full-color prints in the early part of the eighteenth century. Most of the detail was printed first on the blue plate, followed by the yellow, red and black.

His claim that, in essence, he could mechanically reproduce "the Joy and Sweetness of that Harmony we usually perceive in natural Objects" is at odds with the severe limitations of color printing.

Color harmony and nature

28 TRACT OF COLOURING.

PAINTING can reprefent all visible *Objects, with three Colours, Yellow, Red, and Blue; fort all other Colours can be compos'd of thefe* Three, *which I call* Primitive; *for Example.*

Yellow
and } *make an* Orange Colour.
Red

Red
and } *make a* Purple *and* Violet
Blue } Colour.

Blue
and } *make a* Green Colour.
Yellow

And a Mixture *of thofe* Three Original Colours *makes a* Black, *and all other Colours whatfoever; as I have demonftrated by my Invention of* Printing Pictures *and* Figures *with their* natural Colours.

Le Blon invented the 'Three Primary System', outlined here. This breakthrough, together with his advances in color printing made it possible to reproduce colors which he felt were similar to the colors of nature.

Or rather, I should say, this is my interpretation of his belief. As with many of the approaches to color harmony that we will be examining, it is not always easy to be sure of the intended meaning of what was written.

Le Blon's approach to mixing colors and representing nature might be of interest:

True PAINTING represents:
1. Lights by White.
2. Shades by Black.
3. Reflections by Yellow.
4. Turnings off* by Blue.

"In Nature, the general Reflection Color is Yellow; but all the accidental Reflections, caused by an opposite Body or Object, partake of the Color of the opposite Body that caused them.

"The White will serve to represent the Lights and Black the shadows; but White And Black are not alone sufficient to represent like Nature itself....To represent such a white object, we must add to the Shades, or join them with the Reflection, or Color of the reflection, viz. the Yellow; and with the Turnings off* , or roundings, we must join the Color of the Turnings, viz. the Blue".

"When a Painter says, that such Artists make a good Coloritto, he means, that they represent truly and naturally the Nude, or the naked human Flesh; supposing they can paint all other visible Objects well, and without Difficulty."

** To depict a 'turning off' in a painting is to show a curved surface, the side of a head or edge of a hand.*

Color harmony and nature

'When we behold how the sea and sky do meet in one thinne and misty Horizontal Stroke'.

The following is reproduced from **'Color and Culture: Practice and Meaning from Antiquity to Abstraction'**, *by John Gage*
This is a valuable book when looking for information on original sources related to color.

Gage reports that Dutch scholar Franciscus Junius discussed the Greek concept of harmogen—(harmony), reported by Pliny.

"An unperceivable way of art, by which an artificer stealingly passeth over from one color into another, with an insensible distinction...when we behold how the sea and sky do meet in one thinne and misty Horizontal Stroke, both are most strangely soft and confounded in our eyes, neither are wee able to discerne where the one or the other doth begin or end: water and aire, severall and sundry colored elements, seeme to be all one at their meeting...Yet doth the Rain-bow minister to us a clearer proof of this same Harmoge, when she beguileth our sight into the scarce distinguished shadowes of melting, languishing & leisurely vanishing colors.

For although there doe shine a thousand severall colors in the Rain-bow, sayth Ovid...their transition for all one where they touch, though farther off they are much different."

"Another seventeenth-century Dutch theorist, Karel van Mander, who gave rather detailed instructions about how the six rainbow colors might be matched by pigments, also argued that the bow demonstrated an intrinsically harmonious juxtaposition of these colors: blue looked especially well next to purple, purple to red, purple to red, red with orange-yellow and so on.

"In 1817 Benjamin West said, "...the order of Colors in a rainbow is the true arrangement of colors in an Historical picture—viz: exhibiting the warm and brilliant colors in a picture where the principal light falls & the cool colors in the shade; also that as an accompanying reflection, a weaker rainbow often accompanies the more powerful rainbow, so it may be advisable to repeat the same colors in another part of the picture...

...And yet, however improbably in practice, the assumptions that lie behind this theory—that nature has revealed the secret of color harmony in the structure of the prismatic spectrum - were far from peculiar to West and continued to occupy the attention of painters from the Romantics to Cézanne".

Color harmony and nature

In the early 1800's the most contentious subject regarding color was the debate pro and con Newton's findings.

Many artists, including Ruskin and William Blake, felt that Newton's discoveries, using a prism concerning the nature of color, took all the poetry out of looking at the rainbow.

Others looked at the discoveries as a foundation for an understanding of color harmony. "One man's meat' as they say.

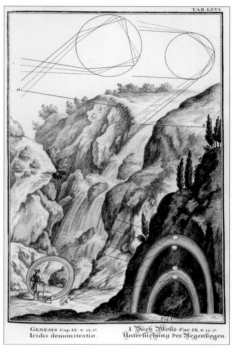

The Foundation of the Rainbow, J.J. Scheucher Physica Sacra 1731

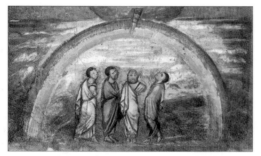

God's Covenant with Noah : the 'Vienna Genesis' 6th Century

Gage continues:

"In the rainbow and the prism artists found, so they thought, a scheme of color-harmony sanctioned by masters such as Leonardo, Raphael and Rubens and recommended by nature herself. 'If you wou'd have the neighbourhood of one Color, give a Grace to another' said an eighteen century English version of Leonardo's "Trattato," 'imitate Nature, and do that with your pencil, which the Rays of the sun do upon a cloud, in forming a Rainbow, where the colors fall sweetly into one another, without any stiffness appearing in their extremes.

"...What was surely the most exciting possibility for Leonardo was that link between the chromatic *sfumato* of the rainbow and musical pitch might also be a link with the principles of color harmony...."

As this stage you might well be wondering why the story seems to be rather incoherent and why I have not simply traced the development of ideas step by step from the earliest times.

If it were as simple as that I would have done so. As with so many areas of color use, much of the original meaning has become jumbled through changes in language and understanding.

As it is, the best I can do is offer an outline and an interpretation of what seems to be the case, however vague it might be at times.

Visual requirements

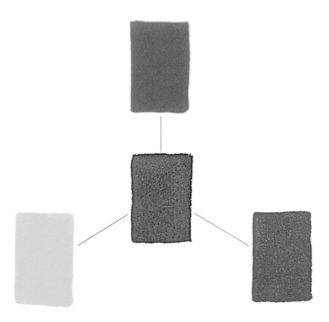

Maybe the brain does seek a mid-grey from a colour arrangement. <u>Maybe</u> is the word.

Still another theme is that harmony in a work of art is based on satisfying certain visual requirements, and this necessitates a balance among the colours.

As an example of our attraction toward set laws, it has been stated by a well known authority on colour (Itten) that, *"If two or more colours will form a neutral grey when physically mixed, then the brain will find those same colours harmonious when they are placed side by side"*.

Complicated, rigid laws of colour theory have been built around this assumption and stated as fact. These laws that I refer to have become almost the backbone of contemporary teaching of colour.

They are very neat, tidy and plausible. Many students of colour, and I include myself here at one time, have accepted the rule that colours that will mix to a mid grey, harmonise, and that the complementary colours take on added vibrancy because the eye attempts to combine them into a grey, to satisfy the brain.

But why should the brain wish to achieve equilibrium by attempting to mould all colour presented to it into a neutral grey?

The fact that an all embracing set of laws can be set down to conform to this way of thinking, is no proof of their validity.

Results of experiments which point in this direction should be viewed warily, for many of the very plausible 'proven' findings on how the eye and brain work have been shown to be very suspect, if not nonsense.

Although our brains have long been trying to unravel the mysteries of their own workings, very little about them is really understood. What we accept as established fact today, may well be disputed tomorrow.

But having said all that, it may well be that the established approach *is* correct.

Maybe the brain *does* wish for a mid-grey. *Maybe* is the word.

But the reasons that have been put forward to back this assumption can be disputed with little difficulty.

Visual requirements

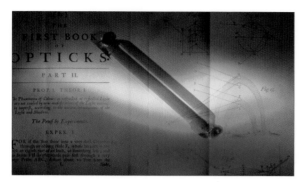

Frances Evelegh : Newtonian optics
Science Photo Library

A large glass prism is seen resting on a page from Newton's book "Opticks" of 1704, the whole lit by a spectrum.

If you look intently at the patch of orange-red for 20-30 seconds and then look at the black dot, you might become aware of a bright blue-green area. This is known as the after-image and the two colours; the orange-red and the blue-green, are complementaries.*
** Not everybody can see an after-image straight away. This subject will be further covered, later in the book.*

The following is reproduced from **'Colour and Culture: Practice and Meaning from Antiquity to Abstraction'**, *by John Gage*

...Newton's view of opposite colours ...in a paper of 1672 he had already regarded red and blue, yellow and violet, and green and 'a purple close to scarlet' as opposite,"

"The first use of the term 'complementary' seems to be in a paper by the American scientist Benjamin Thompson, Count Rumford, in the context of the colours of shadows and of colour-harmony: two colours are harmonious when one of them is balanced by the product of the two remaining primaries.

Rumford had been stimulated by the work of Robert Waring Darwin on 'ocular spectra', that is the coloured after-images perceived when a patch of a particular colour is looked at closely for a considerable time.

The after-image of a patch seemed to be its complement, which gave many writers on harmony, notably Goethe, an added confirmation that the eye 'demanded' certain pairings.

It is notable that although all these early observations of after-images pointed out quite correctly that the complement of red, for example, is not green but blue-green, the by now canonical circular arrangement and the doctrine of secondary mixtures made green the almost universally accepted 'complementary' of red."

From: Philosophical Papers, by Count Rumford, B. Thompson, 1802 and 'Complementäre Farben: zur Geschichte und Kritik eines Begriffes', Neue Hefte zur Morphologie, by R. Matthaei, 1962.

Visual requirements

The German poet and color theorist Goethe wrote at length about the involvement of the eye in color perception, after-images, colored shadows and other concerns of the practising artist.

As was mentioned on the previous page he, like others, felt that the eye 'demanded' certain color pairings.

'Goethe's Color Theory', Arranged and edited by Rupprecht Matthaei, translation by Herb Aach, Van Nostrand Reinhold, 1971*

When the eye sees a color it is immediately excited, and it is its nature, spontaneously and of necessity, at once to produce another, which with the original color comprehends the whole chromatic scale. A single color excites, by a specific sensation, the tendency to universality.

To experience this completeness, to satisfy itself, the eye seeks for a colorless space next to each hue in order to produce the complemental hue upon it.

In this resides the fundamental law of all harmony of colors, to which every one may convince himself by making himself accurately acquainted with the experiments which we have described on the physiological colors.

If, again, the entire scale is presented to the eye externally, the impression is gladdening, since the result of its own operation is presented to it in reality. We turn our attention therefore, in the first place to this harmonious juxtaposition.

Goethe gives the complementary colors as: "yellow demands blue-red, blue demands yellow-red, red demands green.

We before stated that the eye could be in some degree pathologically affected by being long confined to a single color: that again definite moral impressions were thus produced, at one time lively and aspiring, at another susceptible and anxious....We now observe that the demand for completeness, which is inherent in the organ, frees us from this restraint; the eye relieves itself by producing the opposite of the single color forced upon it, and thus attains the entire impression which is satisfactory to it.....

Besides these pure harmonious, self developed combinations, which always carry the conditions of completeness with them, there are others which may be arbitrarily produced, and which may be most easily described by observing that they are to be found on the color wheel, not by diameters, but by chords, in such a manner that an intermediate color is passed over.

*Goethe completely misunderstood Newton's discoveries about color and much of the book is wasted struggling to refute Newton and establish his own observations as the foundation for understanding color.

The text is tedious and, although he demonstrated interesting and valid facts, a large part of his observations and pronouncements are negated by his lack of understanding fundamental facts.

Visual requirements

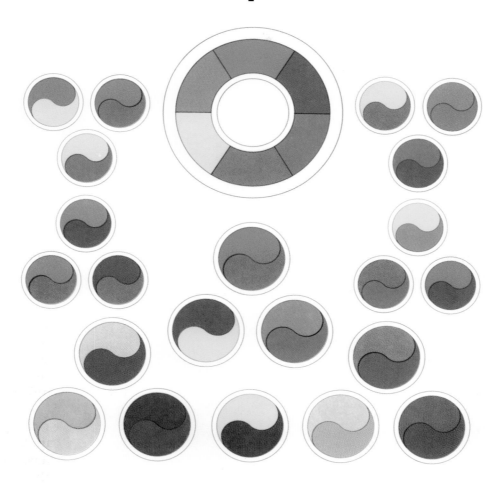

Illustration from Goethe's Color Theory

From **'Goethe's Color Theory',** Arranged and edited by Rupprecht Matthaei, translation by Herb Aach, Van Nostrand Reinhold, 1971

"Atop the middle is Goethe's color wheel. Below, in triangular order, the three harmonic color pairs, produced by colors placed opposite each other in the wheel. On the left next to the wheel in two triads, the characteristic combinations. Two Goethe-colors in the upper triangle, two Newton-colors in the lower one.

On the left of the wheel are six characterless tones that arise in each case as neighbours on the wheel. The remaining large disks at the lower edge of the diagram are purely developments of harmonic tones with the addition of black or white. In the left triangle, below left, both with white, and in the right both with black. Below, in the right triangle, purple and green, once with white, and once with black. Above this yellow, red and blue lowered with white and black. In the middle of the lower row are a saturated yellow with a blackened violet placed next to each other. Compare these seven color pairs with the pairs of highest possible saturation (the triads below the wheel) and Goethe's expressions will be confirmed".

Visual requirements

Goethe's Colour Theory : The Goethe-triangle

The colour theorists, Albers and Itten both commented on the Goethe-triangle, as follows:

Albers: "In presenting systems showing organised colour relationship, we usually start with the rarely published, beautiful Goethe Triangle".

Itten: "We divide each side of an equilateral triangle into three equal parts and join the points of division by lines parallel to the sides of the triangle.

This makes nine small triangles. In the corner triangles we place yellow, red and blue and we mix yellow with red, yellow with blue and red with blue, for the triangles midway between the corners.

In each of the remaining triangles, we place the mixture of the three colors adjoining it" (Itten did not mention Goethe.)

Visual requirements

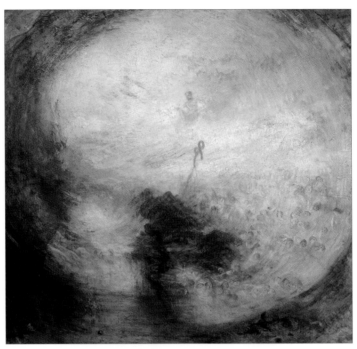

The Morning after the Deluge - Moses writing in the Book
of Genesis, 1843, J.M.W Turner
© Tate, London 2002

*Turner's diagram showing the three primaries. He
attached great significance to the primaries.*

The artist Turner, was a master of the interplay of light and dark. His fascination with the balance of light and shadow and his belief that they were fundamental to full colour expression led him to take an interest in the work of Goethe.

Although he was sceptical of many of the findings of Goethe he also drew on much of his work.

Whether or not he came to also believe that the eye required balance from colour pairings is not known.

Actually, I have just thought, If he did work with this in mind he achieved colour harmony and likewise if he didn't. At the end of the day much is down to the sensitivity and background of the artist rather than a system.

Visual requirements

"If we gaze for some time at a green square and then close our eyes, we see, as an afterimage, a red square. If we look at a red square the afterimage is a green square. This experiment may be repeated with any color, and the afterimage always turns out to be of the complementary color".

'The Art of Color', Johannes Itten, translation by Ernst van Haagen, Van Nostrand Reinhold Co. 1961, 1962, 1966, 1967, 1969.

"When people speak of color harmony, they are evaluating the joint effect of two or more colors. Experience and experiments with subjective color combinations show that individuals differ in their judgments of harmony and discord.

"The color combinations called "harmonious" in common speech usually are composed of closely similar chromas, or else of different colors in the same shades. They are combinations of colors that meet without sharp contrast....Such judgments are personal sentiments without objective force.

The concept of color harmony should be removed from the realm of subjective attitude into that of objective principle.

"Harmony implies balance, symmetry of forces. An examination of physiological phenomena in color vision will bring us closer to a solution of the problem.

"If we gaze for some time at a green square and then close our eyes, we see, as an afterimage, a red square. If we look at a red square the afterimage is a green square.

This experiment may be repeated with any color, and the afterimage always turns out to be of the complementary color.

The eye posits the complementary color; it seeks to restore equilibrium of itself. This phenomenon is referred to as successive contrast".

Itten's conclusion above, which he thought to be based on the facts of color vision turned out to be wrong. The eye does not seek to restore balance.

Afterimages and the effects of simultaneous contrast are part of the apparatus the eye and brain use to adjust for changes in illumination and to make objects distinct from one another. Itten based his color wheel on red, yellow and blue equally spaced in a 12 color circle. His complements are yellow-violet, blue-orange, red-green.

Visual requirements

Yellow is associated with four colors which are equal in brilliance.

Although we can argue with Itten's contention that the eye seeks a mid gray, much of his work was of great value to the artist. Particularly in areas where he drew attention to the way that one color will affect another.

In the diagram above, yellow is associated with four colors which are equal in brilliance. (Given the limitations of color printing).

The contrast between the yellow and the pale orange and the yellow and the green (both close to it on the conventional color wheel) is rather muted.

However, the contrast between the yellow and the blue violet and between the yellow and the red violet is much stronger.

As yellow and violet are basic visual complementaries and lie opposite each other on the color wheel, the diagram demonstrated the possible impact available through the complementaries.

Green is set alongside four other colors of the same brilliance.

In a similar exercise the green is set alongside four other colors of the same brilliance. Where it is against its close neighbours on the color wheel, blue-green and yellow-green they sit together easily.

However, when against red (the complementary of green) the contrast is intense.

As we will be discussing later, when colors lie closely together on the color wheel they can be harmonised with ease. As they move to opposite positions they can either be made to contrast strongly or give very subtle harmonies.

When Itten said "Harmony implies balance" I think he identified the situation exactly.

Visual requirements

Based on Goethe's ratios, Itten suggested that colours could be balanced by proportion. A certain area of orange set against a specific area of blue for example.

This is not the place to go into further detail except to say that it is an approach which can quickly become mathematical.

At the end of the day the artist will decide by eye whether or not the proportions of colour balance, it cannot be reduced to numbers.

'The Art of Colour', Johannes Itten, translation by Ernst van Haagen, Van Nostrand Reinhold Co. 1961, 1962, 1966, 1967, 1969.

Colour Harmony and Variations

"By colour harmony I mean the craft of developing themes from systematic colour relationship capable of serving as a basis for composition.....Colour chords may be formed of two three, four, or more tones. We shall refer to such chords as dyads, triads, tetrads, etc.

Dyads--in a 12 hue colour circle, 2 diametrically opposed colors are complementary. They form a harmonious dyad. The only requirement is that the 2 tones be symmetrical with respect to the centre of the sphere. (A tint of red with a corresponding green shaded in the same degree)

"Triads--3 hues selected so that they form an equilateral triangle. If one colour in the complementary dyad yellow/violet is replaced by its two neighbours, thus associating yellow with blue-violet and red-violet, or violet with yellow-green and yellow-orange, the resulting triads are likewise harmonious in character. Their geometrical figure is an isosceles triangle. (Equivalent to split complement). These equilateral and isosceles triangles may be thought of as inscribed in the colour sphere. They may be rotated at will. Provided the point of intersection of the bisectors of their sides lies at the centre of the sphere".

The outline above is reproduced in many forms today, from 'colour harmony' wheels to diagrams in books. It seems to have become the established approach.

Although we will be looking in greater depth later, for now I think we can say that 'dyads' or complementary pairings can be used as a colour group basis which many find pleasurable. To make one lighter and the other darker is just one approach to their use.

'Triads' are a little trickier. The triad arrangement is based on Itten's flawed theory that the eye seeks balance and that any three colour combination found this way harmonises because the eye will mix them into a neutral grey. As we will see later, any basic colour combination can be made harmonious. I do not feel that it is at all helpful to use a method which might or might not lead to arrangements that many find pleasing.

Visual requirements

Moses Harris

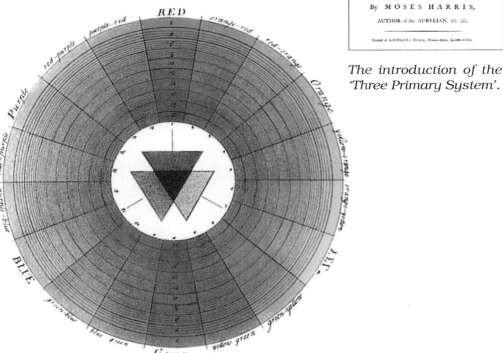

The introduction of the 'Three Primary System'.

The first subtractive colour mixing wheel. Thousands of variations have appeared since its introduction.

Newton's work had been to do with light, not pigments. He had designed a colour wheel showing the *spectrum.*

Le Blon worked with and wrote about the mixing of *pigments,* known as subtractive mixing.

Then Moses Harris came along and combined the two approaches (of Newton and Le Blon) by designing a subtractive mixing colour wheel.

This he published in a work entitled 'The natural system of colours'. The wheel was the first to show primary, secondary and tertiary colours, in various degrees of saturation.

In his publication he wrote at length on after-images and the colour of shadows. Although he did not concern himself with colour harmony in his publication, his colour wheel and mixing information inspired many an artist to start working with colour relationships.

Complementary, analogous or both?

Some define harmony as balance among contrasting colors and others believe it is evident only in analogous colors.

As we will be looking into these topics in detail later, I will give a very brief description at this stage.

 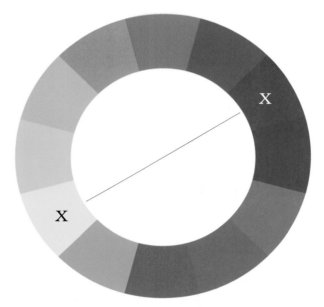

Analogous colors

Colors which lie closely together on the conventional color wheel are often described as being analogous. Such groupings have a common character or identity.

Where harmony is sought, the similarities between colors from the same group or family can be of value.

Whilst closely related colors can be readily harmonised (there is not a great deal that can go wrong), possible contrasts are limited.

Some claim that up to half of the wheel can be considered to be analogous, as we will discuss later, this might be stretching things a little.

Complementaries

Hues found opposite each other on the conventional color wheel can be coaxed into giving a wide range of color combinations which have been found to be pleasing over the ages and amongst many peoples.

Such pairings act on each other visually, each color enhancing the other.

Complementary pairings can be used over a wide range of values, from the palest of tints to the darkest of shades. Visual interest as well as subtle contrasts can be found.

However, when used without caution, strong contrasts can be set up which few would find harmonious.

Complementary, analogous or both?

The following should throw some light on the approaches which have been taken in this regard.

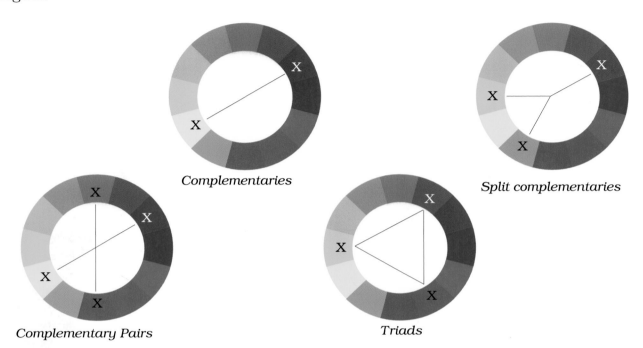

Complementaries

Split complementaries

Complementary Pairs

Triads

'Color: How to Use It' by Sterling B. McDonald, Follett Book Company, Chicago, 1940

This is an unusual book. It is very large with a heavy cover that opens out to reveal a set of metal callipers that can be set to point to different combinations of colors on a printed color circle.

"One color, like one note in music, does not create harmony, except as it may be harmonious to one's nature.

Several colors in the same key of yellow, but of varying values or tones, become harmonious because of resemblance, as would the same key played together in various octaves of the chromatic scale.

We see color assemblies simultaneously just as we hear musical chords played at the same time.

When we understand the laws of color harmony, we know the arrangements in which colors may be grouped effectively.

There are two basic combinations, one known as Harmony of Contrast, the other as Harmony of Analogy.

Harmony of Contrast

"Colors are in complete contrast when they are as unlike each other as possible. This contrast may exist between two colors or among more than two. They are described as complements, split complements, double complements and triads. In more subtle contrasts, two colors of a triad may be used, or a mutual complement to an analogous group provides harmony of contrast".

Complementary, analogous or both?

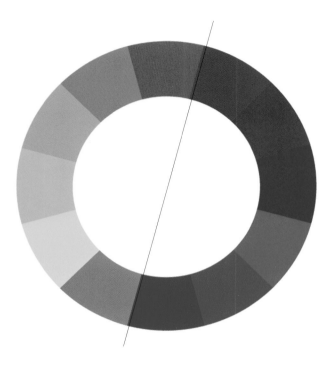

'An entire half of the color circle may be considered as an harmonious analogous group'.

'Colour: How to Use It' by Sterling B. McDonald, Follett Book Company, Chicago, 1940

Harmony of Analogy

"Relationship and Sequence: An entire half of the color circle may be considered as an harmonious analogous group, because each color is related to the adjacent color and at no place in the half circle are they in complementary contrast.

As soon as more than half of the circle is used - six on a twelve-color chart, or twelve on a twenty-four color chart - there would be a lack of balance by contrast.

A field of color from orange through blue-green is harmonious when used together, but if blue were added to that half circle of color, a complementary contrast with orange on the other end of the half-circle would be established, throwing the other colours in the half-circle out of balance because there is more than one dominant primary.

However, a mutual contrast to the original half-circle would maintain balance. In this case, the mutual complement would be red-violet.

Many sequence harmonies are found in alternates, adjacents, and tones of one color....

"Any blend of color is rhythmic and harmonious if the relationship is not too close, or if the change from color to another is not too great. The division of twelve hues creates steps as close together as most colorists will use".

Complementary, analogous or both?

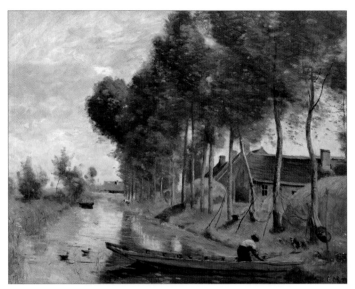

Landscape at Arleux-du-Nord, 1871, Jean Baptiste Camille Corot
© National Gallery, London

*'On the other hand, a Corot will paint an
admirable symphony in green greys'.*

'The Colorist': by J, Arthur H. Hatt, third edition 1908, 1913.

In the first part of the book Hatt describes and discusses additive and subtractive colour.

" Beauty in colour seems to depend largely on the taste of the beholder, and this taste is largely a matter of civilization.

"The child or the savage prefers brilliant or garish colors, and it must be confessed that the barbarian sometimes achieves wonderful results.

On the other hand a Corot will paint an admirable symphony in green greys, or a Whistler a beautiful combination of tinted greys....

"In an aesthetic sense beauty in colour consists of harmony of hue, or of analogous colour combined more or less with a great or limited variety of tone....

"Large areas of violently contrasting colors are in no sense beautiful. "Contrast and discord are synonymous in regard to colour as well as sound. "Brilliant contrasts are only useful when they serve to accent a colour composition, and should be used sparingly only for this purpose.

"We will sometimes see in pictures with a most pleasing colour composition good results attained by what appears to be the use of contrasting colors.

At first glance this would seem to upset our theory of harmony. It, however, brings us to the consideration of another law governing the use of contrasting colors and harmonious colors.

"This law relates to the amount of space or area occupied by the contrasting colors.

"A number of violently contrasting colors may be placed together in a harmonious composition, and a beautiful result will be obtained if these colors occupy a relatively small space in proportion to the whole and are not scattered over the whole area...."

31

Complementary, analogous or both?

'The Colorist': by J, Arthur H. Hatt, third edition 1908, 1913.

After describing a color wheel:

"It will be observed that contrasting colors are opposite each other, as yellow and violet, red and cyan blue, green and magenta. Now let us imagine that these colors gradually merge into each other. We may regard as in complete harmony all colors that fall within an arc of 75 degrees.

"We will find that the following general list of colors come within this range, and will in each case contain the hue elements of a harmonious color composition:

Harmony No.

1. Yellow green to orange

2. Yellow to red

3. Orange to scarlet

4. Red to magenta

5. Scarlet to purple

Please note: We have added the colors to the original text.

6. Magenta to violet

7. Purple to blue

8. Violet to cyan blue

9. Blue to turquoise blue

10. Cyan blue to green

11. Turquoise blue to yellow green

12. Green to yellow

"It will be understood that the author does not advocate the exclusive use of a two-color combination in plain bright or full hues.
Such combinations could be improved by gently merging or blending the tone of one or both of the colors, preferably of both....
"The above angle of division applies to pure colors or hues. These colors, or hues, however, are seldom used in works of art of any description".

Complementary, analogous or both?

"Although two flowers resemble each other, can they ever be petal by petal the same?"

.....was due not to the quality of the dyestuffs but to the subjective effect of optical mixture.

For analogous

According to an 18th century Turkish treatise:

"Who tells you that you ought to seek contrast in colors?

What is sweeter in an artist than to make perceptible in a bunch of roses the tint of each one?

Although two flowers resemble each other, can they ever be petal by petal the same?

Seek for harmony and not contrast, for what accords, not what clashes.

It is the eye of ignorance that assigns a fixed and unchangeable color to every object; as I have said to you, beware of this stumbling-block."

For contrast

Color harmony had come to mean particular sets of contrasts, a view given the greatest authority by the exhaustive experiments of Michel Eugéne Chevreul.

Called in the 1820's to improve the brightness of the dyes used in the Gobelins factory, Chevreul discovered that their apparent dullness was due not to the quality of the dyestuffs but to the subjective effect of optical mixture: adjacent threads of complementary or near-complementary hues were mixing in the eye to a neutral gray.

From 'Color and Culture: Practice and Meaning from Antiquity to Abstraction', by John Gage

Complementary, analogous or both?

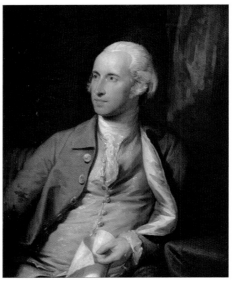

Benjamin West, 1781, Gilbert Stuart
© Tate, London 2002

'Hints to Young Painters' by Thomas Sully, 1783 - 1872. Introduction by Faber Birren

From the Introduction:

"Early American portraits are pretty well defined and confined by the limits of Sully's palette.....One curiosity is the general absence of a green pigment. Gilbert Stuart, for example, made use of Prussian blue, white, yellow, vermilion, crimson lake, burnt umber, and black - but no green. When greens were used by the Colonial and Federal painter, they often were composed of mixtures of yellow and blue.

Sully's palette did not provide a truly clean or pure yellow (brighter than ochre), a pure yellow-green, a turquoise blue, a magenta, or a rich purple.

The apparent reliance on yellow ochre for a pure yellow is difficult to understand. Yellow ochre has a tan or mustard-like tone; it is more of a pale gold that a yellow.

Yet in Sully's time - and for many decades earlier - clean yellows such as Cadmium Yellow and Naples Yellow were commonly available.

A partial explanation may be found in the fact that portraits in Sully's day were predominantly warm in tone, a principle which Sir Joshua Reynolds thought essential to the best art.

Blue, for example, was needed to form shadows and was not otherwise applied over a large area.

When green was needed, such as in natural backgrounds, a dull version could readily be mixed from ultramarine and yellow ochre.

If gold predominated, rich, luminous beauty was assured."

Note: Only the natural form of Cadmium, Greenockite, was available until the 1800's.

Complementary, analogous or both?

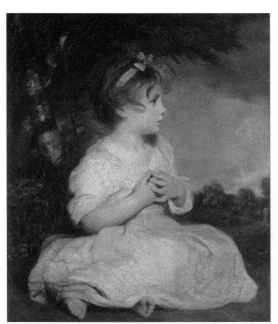

The Age of Innocence, 1788, Sir Joshua Reynolds
© Tate, London 2002

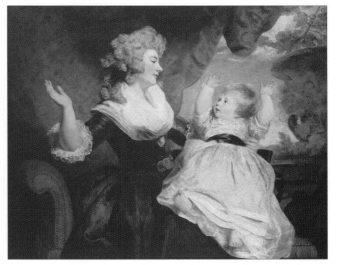

Georgiana, Duchess of Devonshire and her Daughter,
Lady Georgiana Cavendish, 1784
Sir Joshua Reynolds
Chatsworth House UK/Bridgeman Art Library

" It ought, in my opinion, to be indispensably observed that the masses of light in a picture be always of a warm, mellow color, yellow, red or a yellowish-white".

Interest to our story from the previous page lies in the following; *....'portraits in Sully's day were predominantly warm in tone, a principle which Sir Joshua Reynolds thought essential to the best art'.*

(A range of 'warm' or 'cool' colors will be found if one side of the conventional color wheel is used. Up to half of the wheel has been considered to be in an analogous relationship).

Possibly with the painting 'The Age of Innocence' in mind, by Sir Joshua Reynolds gave the following as the formula for the 'correct' use of color.

" It ought, in my opinion, to be indispensably observed that the masses of light in a picture be always of a warm, mellow color, yellow, red or a yellowish-white, and that the blue, the gray, or the green colors, be kept almost entirely out of these masses and be used only to support and set off these warm colors.

And for this purpose a small portion of cold colors will be sufficient. Let this conduct be reversed; let the light be cold and the surrounding colors warm, as we so often see in the works of the Roman and Florentine painters and it will be out of the power of art, even if in the hands of Rubens or Titian, to make a picture splendid and harmonious".

35

Complementary, analogous or both?

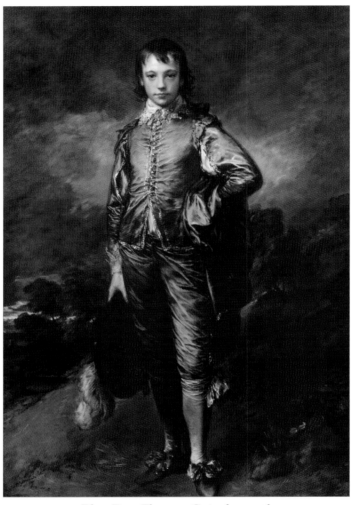

Blue Boy, Thomas Gainsborough
Henry E. Huntington Library and Art Gallery,
San Marino, California, USA

Sir Joshua Reynolds had a skilled and knowledgable rival in Thomas Gainsborough, an artist of great talent.

It is thought that Gainsborough painted 'Blue Boy' to counter the approach put forward by Reynolds that *"........the masses of light in a picture be always of a warm, mellow color, yellow, red or a yellowish-white, and that the blue, the gray, or the green colors, be kept almost entirely out of these masses......."*

In many ways 'Blue Boy' takes the opposite stance, cool colors predominating.

Not only was the theory put forward by Reynolds disputed but the idea that there might be a 'correct' use of color was also put to one side.

As we will see, a universally accepted method of selecting color combinations has proven impossible to find. This is indeed fortunate as we are all free to use and manipulate color as we choose.

Color harmony and evolution

An intriguing concept is that the ability to recognize harmony, defined as a perceived relationship between colors, has survival value and is thus part of our evolutionary background. This is an incredibly complex area which, I feel, deserves further study.

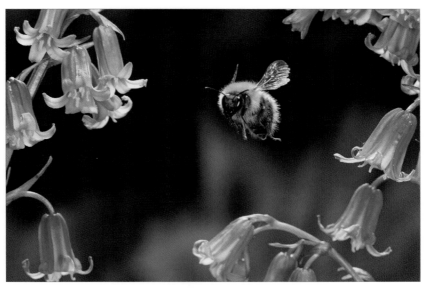

Bumblebee and Bluebells, Stephen Dalton
National History Photographic Agency

'The Colorist': by J, Arthur H. Hatt, third edition 1908, 1913.

"Due to a liking for color on the part of animals, and in consequence, plants displaying the brightest colors were best fertilized by the living creatures and were able to outgrow their rivals that displayed less brilliant colors.

It will be noticed that the function of bright colors in the plant was not aesthetic in its nature...

"The beginning of the appreciation of the aesthetic value in colors may be said to start from the acquirement of colors by the various forms of animal life for the purpose of sex attraction in mating; here the principal reason for the use of color was not especially to attract attention from a distance, but to please by the beauty of the combination itself; these combinations show real and beautiful variety when their choice was not restricted by fear of attack...Many of the animals of prey show exquisite combinations of color which lend themselves to concealment, as well as beauty....

The pink color of the rose offers a vivid contrast with very bright green foliage, and Nature, which seemingly is always striving after the true and beautiful, tries to mitigate the sin against harmony in the use of pink and green by toning the leaf to a very dark or gray green.

Nature also endeavours to make amends for the pink-and-green combination by the wonderful variety of gradations in the pink tints of the rose, than which there could be nothing more to be desired in the beauty of the variety displayed."

The scientific approach

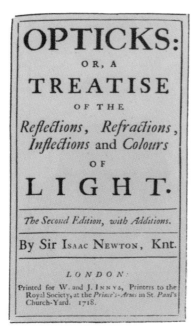

Cover for Isaac Newton's 'Opticks' from Light and Vision

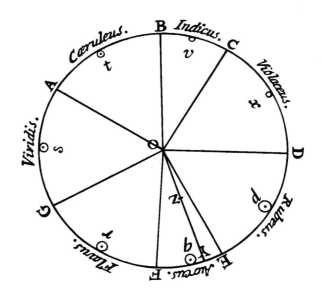

Newton's monumental work on the nature of light and color caused a storm of controversy when it was published in the early part of the 18th century.

His color circle was the forerunner of the color wheels that we use today. To form the circle he took the straight line of prismatic colors and bent it into a circle, joining the ends.

Parallel with the themes so far covered has been the steady development of knowledge about human color vision.

How the progressive development of this understanding has affected these themes is another interesting aspect.

The fact of the opponent nature of color vision (pse. see page 40), has not yet had much effect on artists or the ideas relating to color harmony. The developing understanding of deeper pathways in the brain may or may not be important to artists.

There are three main streams feeding understanding of color. The first, and by far the oldest, is the result of subjective perception and close observation — the tools of artists and early philosophers.

Great art works were certainly created based on those insights and the accompanying emotions.

It was not until Isaac Newton's work in the 1600's that people began also studying color objectively, carefully separating the part of the perception of color that is due to the physics of the outside world and the part due to interior visual mechanisms, (The eye and the brain working together).

This scientific approach to understanding color branched later into vision research and what is termed 'colorimetry,' the measurement and specification of color.

Each stream has constructed its own language and communicates largely within its own discipline, but both have developed information of interest to the artist.

The scientific approach

Chevreul

During the later part of the 1800's, with the advent of the portable easel and the collapsible tube, painters started to leave their studios and work directly from nature, simultaneously leaving behind many preconceived ideas about the nature of color.

Previously, the cornerstone of all theories had been that every object had a 'true' color and little allowance was made for the influence of reflections from nearby objects.

More importantly, by working in a studio the artist had been largely unaware of the effects that changes of light had on color.

The chemist Michel-Eugene Chevreul, with a background in science, came onto the scene. Published in 1839 his major book, 'The Law of Simultaneous Contrast of Colors' is considered by many to be one of the greatest of all works on color.

This was the first comprehensive study of the effects of colors on one another through simultaneous contrast.

Without a doubt earlier artists and observers had noted that one color could affect another. Gold was found to look more attractive on a blue background than on white and purple took on a different appearance when placed on black as opposed to white.

These general observations were about to be taken much further.

Chevreul was able to draw on the experiences he had gained and observations he had made as Director of Dyes at the famous Gobelin Tapestry Works. He had been appointed to the position in 1824.

The difficulties of accurately matching colors led Chevreul into a study of the relationship between colors, particularly of those applied side by side. This interest was almost certainly sparked off by the fact that he had been appointed in order to introduce brighter colors to the tapestry works.

Assimilation, Chevreul

He had discovered that the dyes already in use were not dull in themselves, but were made dull when placed alongside certain other colors.

His work inspired the changes which led eventually to the Impressionist painters. He is a vital figure in our search for color harmony.

The scientific approach

'Color for Philosophers: Unweaving the Rainbow'
by C. C. Hardin, Hackett Publishing, 1988.

A short extract concerning color vision.

"To the nineteenth-century scientists, it also seemed natural to suppose that all color experiences were the result of the neural outputs of the three types being proportionately (additively) mixed as the three primary lights were mixed (in their experiments) and, therefore, to label the three cone types as, respectively, the 'blue,' 'green," and 'red' cones.

This usage persists among many color scientists a well as the educated public, although the assumptions on which it once rested have proved highly questionable.

The chief critic of the emerging nineteenth-century consensus was Ewald Hering (1929-1964), who pointed to many fundamental facts that went unexplained by the model, which called only for additive mixtures of the outputs of the three receptor types to be sent to the brain.

For instance, purple seems to have both reddish and bluish constituents in it, and is readily describable as reddish blue or bluish red. It could thus plausibly be the result of mixing 'red' light and 'blue' light to give 'purple' light. But yellow, which is generated by mixing 'red' light with 'green' light, does not seem to be a reddish green or a greenish red.

Indeed, there are not reddish greens. On the (then) accepted model, how could one account for the perceptually unitary character of yellow and the perceptually composite character of purple, when the model calls for them to be produced by similar processes, red-blue neural mixture on one hand and red-green neural mixtures on the other?

And how could the perceptual absence of reddish greens and yellowish blues be explained?

In Hering's view, the phenomenology of color appearance suggested that there are not three but four fundamental chromatic processes and that these are arranged in opponent pairs, like muscles or a multitude of other physiological elements. (Hering was a physiologist).

The 'red process' (i.e., the process giving rise to the sensation of red) is opposed to the green, so an increase in the one must be gained at the expense of the other, and the yellow process is, in a similar process opposed to the blue.

In addition, there is an achromatic pair, in which black is opposed to, and produced solely by the inhibition of, the white process.

The phenomenal characters of purple and yellow thus reflect their neural representations. The phenomenally complex color purple is represented by the joint occurrences of red and blue processes, and the phenomenally simple color yellow is represented by non-composite yellow process, the red and green processes in this case being in neural balance".

As we have looked briefly at the main approaches to the selection of colors which look well together, perhaps we should hear a little of what the artist has to say on various aspects of the subject:

Pindar and Ictinus, 1867, J.A.D Ingres
© National Gallery, London

The Death of Sardanapalus, 1827, Eugene Delacroix
Louvre, Paris, France/Bridgeman Art Library

Line v color

"In painting and sculpture, the design is the essential thing....The colors which give brilliance to the sketch are part of its charm and they may, in their own way, give an added liveliness to what we are looking at. But they can never, in themselves, make it beautiful."
Quoted from Immanuel Kant, **"Critique of Judgement,"** *published in 1790.*

Jean-Auguste Dominique Ingres, the neo-classicist painter (1780-1867) agreed with this approach to color by stating that "drawing is the probity of art."

Insisting that good drawing was far more important than the choice of coloring he went on to state that "A thing well drawn is always well enough painted".

He also declared that "Rubens and Van Dyke may please the eye, but they deceive it, they belong to a bad school of color, the school of falsehood".

Ingres, backed by the establishment and the classical approach fought Delacroix and Romanticism.

The victory, which went to Delacroix, was one of color over form, line and design.

Line v color

Study for Homage to the Square:
Departing in Yellow, 1964, Josef Albers
© Tate, London 2002, © DACS 2002

"A painter wants to formulate with or in color. Some painters regard color as a concomitant of form, and hence subordinate.

For others, and an ever-increasing proportion, color is the chief medium of their pictorial language. Here color attains autonomy.

My paintings represent the second trend. I am particularly interested in the psychic effect, an aesthetic experience that is evoked by the interaction of juxtaposed colors".

Josef Albers in the introduction to the portfolio *Ten Variants*, 1967.

Bright v grayed

The English connoisseur Sir George Beaumont, neatly summed up the European attitude toward color when he succinctly remarked, "A good picture, like a good fiddle, should be brown."

In this engraving, 'Time Smoking a Picture', William Hogarth illustrated the feeling of the time that only dull, dark paintings were ever worth considering by art dealers and critics.

Then there is Eugéne Delacroix's famous quote, "Give me mud and I will make the skin of Venus out of it, if you allow me to surround it as I please". A positive use of 'mud'.

The Hay Wain, 1827, John Constable
© National Gallery, London

The Hay Wain (made grimy), 1827, John Constable
© National Gallery, London

Constable said, "Had I not better grime it down with slime and soot, as he is a connoisseur, and perhaps prefers filth and dirt to freshness and beauty?...Rubbed out and dirty canvases...take the place of God's own works."
Attributed to Ernst H. Grombrich, 'Art and Illusion: A Study in the Psychology of Pictorial Representation,' Princeton Un. Press, 1960.

Delacroix

The Death of Sardanapalus, 1827, Eugene Delacroix
Louvre, Paris, France/Bridgeman Art Library

'The World of Delacroix 1798-1863.' by Tom Prideaux & Editors of Time-Life Books,

"One of his friends reported that the picture (*Sardanapalus)* was originally much darker, but that Delacroix was so bewitched by Myrrha's luminous flesh that he lightened the whole picture to match her radiance. If true, the story strikingly exemplifies the tenacity of his belief that a picture should create a harmonious unit, with every part fitted into the whole. No white body should stand out unduly; no separate element, no matter how beautiful, should steal the show. This sense of unity, he believed, should govern every brush stroke, every color tone, and dominate—even obsess—the artist's mind."

From Journal: "Contrary to common opinion, I would say that color has a more mysterious and perhaps more powerful influence; it acts, as one might say, without our knowledge."

"Fine works of art never age, because they are remarked by genuine feeling. The language of the passions, the impulses of the heart, are always the same; what inevitably gives the stamp of age, and sometimes mars the greatest beauty, are formulae which were fashionable at the time of creation."

"Artists who seek perfection in everything are those who cannot attain it in anything."

"Especially in the *Hay Wain,* Delacroix was struck by Constable's touches of different shades of green, yellow and brown, side by side, to create the effect of trees and grass seen in the natural light of outdoors.

These dabs of bright color reflected light in a way no smoothly blended pigments could, creating the flickering, vibrating sensation of real sunlight on real greenery."

Delacroix

Dante and Virgil in the
Underworld *(detail)*, 1822
Eugene Delacroix
Louvre, Paris, France/
Bridgeman Art Library

*The water drops referred to are
on the woman, bottom right.*

The Arrival of Marie de Medici in Marseilles,
Peter Paul Rubens
Louvre, Paris, France/Bridgeman Art Library

The sea nymphs of Rubens

'The World of Delacroix 1798-1863.' by Tom Prideaux & Editors of Time-Life Books,

"Looking back on his work in later years, Delacroix declared that the drops of water which he painted on the figures in the foreground (in the painting *Dante and Virgil in the Underworld*) were his starting point as a colorist.

They were inspired, he said, by the sea nymphs of Rubens and by a careful study of the rainbow. When scrutinized closely, Delacroix's drops reveal that they are each composed of four bands of pigment: red, yellow, green and white. But from a little distance they blend into a unit, a single drop, that glistens with light..."

Matisse

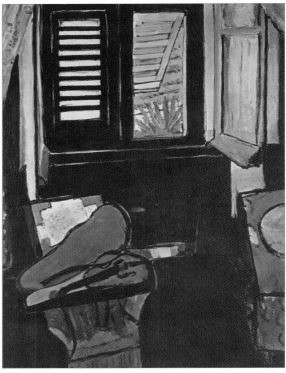

Interior with a violin, 1917-18, Henri Matisse
© Succession H Matisse/DACS 2002

"Color is not given to us in order that we should imitate nature. It was given to us so that we can express our own emotions".

From **'The World of Matisse',** by John Russell and Time-Life Editors.

"Matisse said to a friend. "Color is not given to us in order that we should imitate nature. It was given to us so that we can express our own emotions."* Matisse played the violin and another quote is, "I wanted to work with areas of flat color, and I wanted to place those areas of flat colors as a composer places his chords."

At one point Matisse seriously considered Pointillism, "He tried to adapt himself to the method but found that he could no more curb his brush to conform to arbitrary laws of optical mixture than he could contain no sense for color within 'scientific' guidelines." He spent a summer with Signac in the south of France and afterwards he completed one painting in the Pointillist style, *Luxe, Calme et Volupté,* 1904-1905, but he was not pleased with it and did not work that way again.

Matisse certainly did not have a theory for arriving at his colors. He struggled with color until the end of this life. Every art work he did required many preliminaries and revisions as he adjusted colors and shapes to achieve simplicity and impact. Matisse speaking of his late cutouts,

"Sometimes the difficulty appeared; lines, volumes, colors were put together, and then the whole thing collapsed, one part destroying another.... It is not enough to put colors against one another, however beautiful; the colors also have to react to one another. Otherwise, cacophony results....""

* Matisse was probably echoing the words of Gustave Moreau, under whom he studied at one time.

Moreau had said 'Think color! Know how to imagine it." Then, as now, most realist painters tried to depict nature exactly. Moreau decided that this was impossible. It was quite pointless to strive for effects of light which compared with nature's.

Instead it is better to imagine light and imagine color with such intensity that the viewer of the painting would see the artist's interpretation of the world rather than 'a scene through a window'.

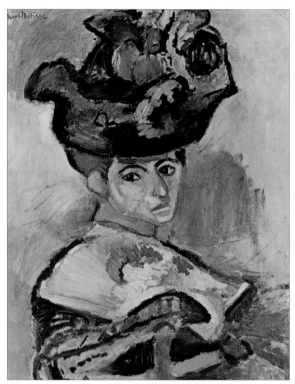

Woman in A Hat, 1905, Henri Matisse
© Succession H Matisse/DACS 2002

The color arrangement chosen by Matisse enraged the public when this painting of his wife was exhibited at the Salon d'Automne in 1905. So angry were they that Matisse made only one visit to the show. Whether they judged his work fairly or not, at least they were passionate about it. Nowadays we tend to mutter to ourselves when displeased and move on.

From a 1908 article in the magazine *La Grande Revue* entitled, **'A Painter's Notes'** by Matisse, regarding the color theories of Signac and his friends, "When I choose a color it is not because of any scientific theory. It comes from observation, from feeling, from the innermost nature of the experience in question."

" I relish the mind that doesn't understand color. I respect the one that thinks it does. A system of color is as good as the character of mind involved in the logic of its making."
Harvy Quaytman

"I have developed three systems of color. The first system is based on color opposites, primarily red/blue-green; the second system uses spectral color and changes from warm to cool; the third system relies upon consecutive color of close value, such as blue/green/ chartreuse and is essentially cool. All these serve as a framework for the transmission of aesthetic or emotive information. They allow me to deal with three different feeling states, to establish and then break down form, and to manifest a wide range of direct sensations based on a central or female core."
Judy Chicago

This book is about the selection of color combinations which many find attractive or even beautiful.

However, color can have very strong emotional influences which override the simpler idea of attractive color arrangements.

The following are just a few of the many influences which mould our ideas about certain colors or color combinations.

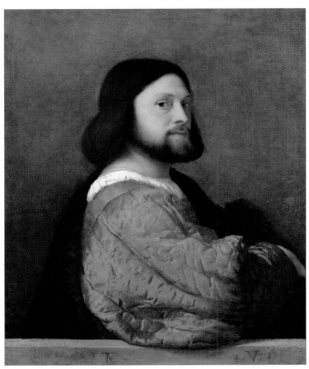

Portrait of a Man, 1512, Titian
© National Gallery, London

The Yezidi would not have been impressed by this painting, particularly as the sitter was also wearing jeans.

From **'Color: basic principles and new directions'**, by Patricia Sloane

... "And where strong symbolic connotations, or strong color prejudices exist these prejudices will determine people's reaction far more than any particular qualities of color itself.

A monochromatic combination of various blues may, for instance, be planned by use of the Munsell or Ostwald systems.

Such a monochrome combination of blues may also be planned in several other ways, including the intuitive. But regardless of the method employed—whether simple or complex, intuitive or systematic—no monochromatic combination of blues will ever, under any circumstances, find favour with the Yezidi, a people who live in the Caucasus and in Armenia.

The Yezidi dislike the color blue intensely-so intensely that they curse their enemies by saying 'May you die in blue garments'."

Egyptian wall painting of Te. Nineteenth Dynasty from the Tomb of the Two Sculptors near Thebes.

The ancient Egyptians are said to have attributed significance to the color which appeared to be the most prominent in a dream.

If the color appeared mixed with black (in stripes, checks, or patterns), the dream acquires the reverse significance of that attributed to plain color: thus, brilliant red signifies ardent love, but brilliant red mixed with black signifies hatred.

¹ Black - death of someone close to dreamer.
¹ Dark blue - success.
¹ Royal blue - an order will be imparted to dreamer.
¹ Pale blue - happiness.
¹ Brown - sadness and danger are imminent.
¹ Light green - a bad omen.
¹ Dark green - serenity, gaiety.
¹ Purple - sadness.
¹ Brilliant red - ardent love.
¹ Dark red - violent passion.
¹ Light red - tenderness.
¹ Deep violet - the dreamer will acquire power.
¹ Pale violet - the dreamer will acquire wisdom.
¹ Deep yellow - jealousy and deceit.
¹ Pale Yellow - material comfort.
¹ White - happiness in the home.

Color and Alchemy have long been linked. Of great influence from antiquity was the fact that when the two constituents of the mineral Cinnabar, (one of the earliest red pigments) were extracted and recombined, a brighter red emerged. The two elements involved were Mercury and Sulphur.

The re-synthesis of the two materials into a superior color led many to believe that they were the 'parents' of all materials. Within them might lie the secret to the production of gold from base metals.

The interest in this particular area extended to other fields of alchemy, with colors playing a very definite role.

In the illustration above the alchemical process of black to red to white is shown. This all meant more to them than it does me.

However, when so linked, individual colors took on a greater power and associated meaning, influencing the way that they were regarded.

Such associations possibly influenced people's ideas when it came to regarding certain color arrangements as either being harmonious or otherwise.

Effects of Good Government
in the Countryside (detail), 1338, Lorenzetti
Palazzo Pubblico, Siena, Italy/
Bridgeman Art Library

'...peasants and serfs must dress only in
black or brown'.

January: banquet scene by the Limbourg Brothers
Tres Riches Heures du Duc de Berry (early 15th c)
Victoria and Albert Museum, London, UK/
Bridgeman Art Library

'Art and Physics: Parallel Visions in Space, Time and Light', by Leonard Shlain.

"Civilizations strive to channel behaviours toward a common goal. Throughout the ages, people in authority have considered it prudent to regulate color.

For example, in the late medieval period, color was considered so important it was the subject of "sumptuary laws" that determined who could wear what costume and in what color.

The nobility and the church reserved for themselves the right to dress in colorful clothes. They mandated that peasants and serfs must dress only in black or brown.

Royalty alone could wear purple. Red, gold, and silver were reserved for the king's councillors, the next tier of importance.

The colors worn by knights, squires, even archers, as well as their wives, were as much a badge of rank as their insignia and uniforms.

Grudging exception was made for doctors and lawyers, who, while not members of the nobility, were allowed to dress in colored clothes.

The first estate jealously guarded its rights and sumptuary laws were primarily designed to prevent members of the upstart merchant class from engaging in the practice of wearing audacious clothing.

Judging by the frequency with which sumptuary laws were revised, it is probable they had limited success."

On the left Kurt Wehlte arranged the 'colors in spectral order'.

On the right the same colors are arranged in a random fashion, resulting in 'entirely different color effects.'

'The Materials & Techniques of Painting: with a Supplement on Color Theory'
by Kurt Wehlte, English edition, 1975.

"Color philosophy and color symbolism are special fields that have nothing to do with objective color science. But what about the theory of color harmony?

"It is now generally recognized that the perception of color harmony depends on: (1) race; (2) geographical location; (3) historical period. For instance, the sense of harmony of the Chinese and the East Indians differs from that of Europeans.

Fine differences of national characteristics between northern and southern Europeans can be recognized in their respective attitudes toward color harmony.

Differences in sensibilities between central Europeans and Americans were demonstrated by the civilian dress of members of the Occupational forces.

Radically determined differences in color concepts are also shown in the use of so-called symbolic colors denoting mourning, joy and various rituals.

It has already been mentioned that human color vision is undoubtedly more differentiated today than centuries ago.

By the same token, the human sense of harmony has not remained the same throughout history and continues to change more rapidly than ever before, in keeping with current trends.

The ideas of harmony of the Biedermeier period were quite different from those of the Gothic, and it is well known that the harmonies of the Art-Nouveau style differed from those of expressionism.

These periodic changes of our sense of harmony are by no means confined to fine art but extend into all areas of applied art, fashion and interior design.

The increased importance of color, especially with regard to certain color combinations, is well known to every manufacturer of consumer goods and every car dealer."

American Aspen Trees, Rod Planck
The Natural History Photographic Agency

*'By common consent the color combinations
of nature are considered harmonious'.*

'The Materials & Techniques of Painting: with a Supplement on Color Theory'
by Kurt Wehlte, English edition, 1975.

"Furthermore, it has been discovered that women choose different colors than men, a factor that can be added to the classification including race, geographical location, and historical period. Color in interior design will be dealt with separately in another section.

All this clearly shows that there can be no universally valid laws governing color harmony, at least not scientifically recognizable at the present time.

One fact should not be overlooked—namely, that by common consent the color combinations of nature are considered harmonious, unless man has bent nature to his will, as in arbitrary flower combinations in gardens or artificial hybrids among plants and animals.

Even the strangest, most exotic color combinations of a butterfly wing do not offend the eye.

The validity of simple rules of thumb does not affect the foregoing statements. Color combinations such as yellow shades together with different browns are always acceptable. The same applies to all shades within a certain region of the color circle or color solid, Commercial decorators use divided books of color samples, which enable them to judge the effect of any two colors upon each other. One or more of these books can provide the basis for quite interesting experiments that can be of value in various fields or applied art.

Fine art has its own 'laws,' which cannot be defined absolutely. There can be no doubt that here, too, race, geographical location, and historical period play great roles.

In art, even conscious dissonances can express much that cannot be said in words, and unconscious dissonances can betray even more."

53

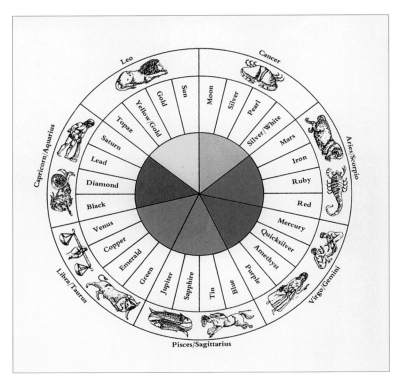

The zodiac will almost certainly have affected many people's ideas on the power and importance of certain colors. In turn this will possibly have had an impact on what was found to be harmonious.

'Color', an Architectural Digest book, Editor, Helen Varley, The Knapp Press, Los Angeles, 1980

"In medieval times, colors had the power to conjure up a whole chain of associations. Most important, perhaps, was the correspondence of seven hues with the seven planets: yellow or gold belonged to the sun, white or silver to the moon, red to Mars, green to Mercury, blue to Jupiter, and so on.

The correlation of the signs of the zodiac with the planets was a later, and largely artificial, scheme which meant that ten of the signs were forced to share a color.

Planets and their colors also possessed a mysterious (perhaps alchemical) affinity with metals and precious stones, so that a Sagittarian, for instance, ruled by Jupiter, might benefit from the magic power of a sapphire amulet.

A ruby possessed something of the power of the red planet, mars. The virtues and qualities of heraldry were also included in the scheme: for example, black stood for penitence, red for courage, blue for piety, green for hope, and purple for majesty and rank.

This interrelation of color provided a way of classifying the world, of relating different areas of experience - yellow is to white, for instance, as the sun is to the moon, as gold is to silver, as godliness is to purity."

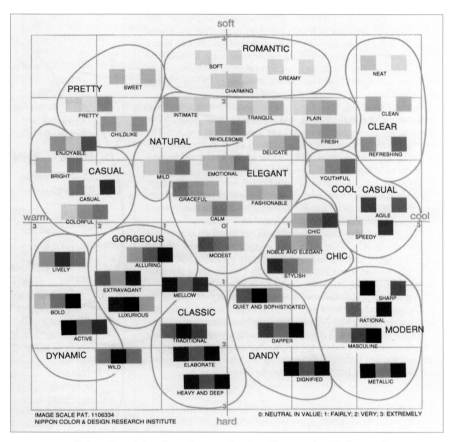

Color Combination Image Scale, Shigenobu Kobayashi
from 'Color Image Scale'*, 1990

The Japanese have been the most persistent in trying to associate particular colors with specific emotions, and to use that connection in art and design.

This book* is one of several by Japanese authors that tackle this problem. The Japanese made the Munsell color system their Industrial Standard at the end of World War II and it continues to be used.

The book endeavours to create a color space built on color impressions to be used by commercial businesses to present a particular image in their products.

"The first step toward a more effective use of color is to systematize and classify colors through key words that express their meanings and through images that express the differences between them."

The author selected 130 colors and combines them in sets of three colors. "A color of a contrasting tone is placed between two colors in order to separate them—a weak tone between two strong tones or a strong tone between two weak tones." The relationship to the Munsell system is shown by the hue name abbreviations, i.e., R, YR, Y, GY, G, BG, B, PB, P, RP; and the divisions into vivid, strong, brilliant, pale, very pale, light grayish, light, grayish, dull, deep, dark, dark grayish, which come from the NBS-ISCC work.

Then the author has further divided color space into regions such as Romantic, Pretty, Elegant, Gorgeous, Classic, Dandy, Modern Chic, Cool and Casual, etc. In addition 180 image words are assigned to the individual colors, such as, abundant, active, bitter, calm, dapper, earnest, happy, innocent, etc.

These various terms must lose some meaning in translation; but, although supposedly based on human studies, they also apply only to tastes in one culture at one point in time. Or perhaps, I would suggest, only to one person.

Phillip Otto Runge

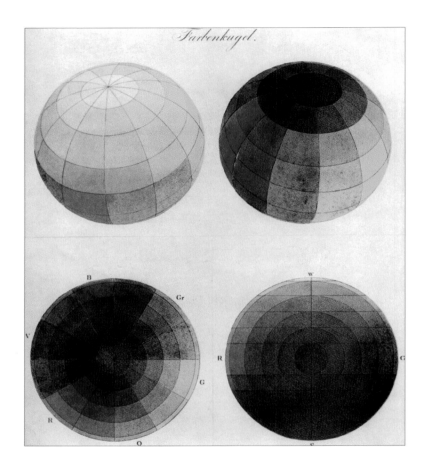

Farbenkugel.

*'Runge had taken the radical approach of forming
colors into a sphere rather than a flat wheel'.*

In the same year that Goethe's 'Farben Lehre' was published, (see page 20), the German artist and color theorist Otto Runge published a very important work of his own, 'Die Farbenkugel (The Color Sphere).'

As the title suggests, Runge had taken the radical approach of forming colors into a sphere rather than a flat wheel.

As shown above, pure hues lie on the 'equator' with white at the top and black at the bottom.

Neutrals and grays lie within the sphere.

A painter of the Romantic School, he broke from the academic way of thinking based on classicism, as had Delacroix. They both rebelled against an approach which saw color being thought of more as a means of 'filling in between the lines'.

He sought to bring life and color into painting through a fresh approach.

His work with the color sphere still holds good today and is the basis of many a color order system.

Phillip Otto Runge

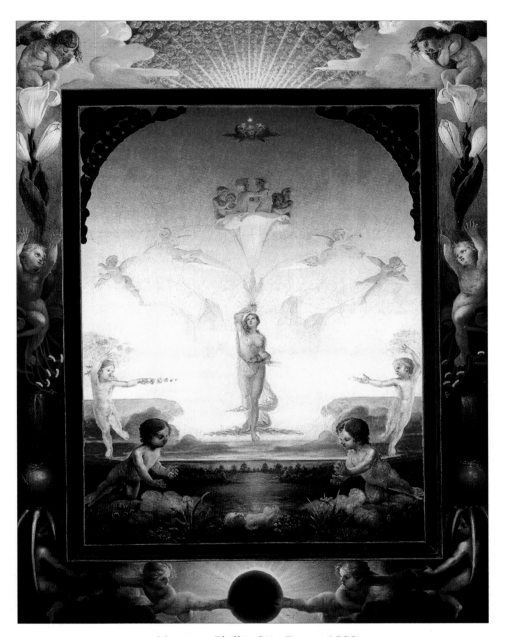

Morning, Phillip Otto Runge 1808

His interest in color led Runge to produce a series of painting in which color was the dominant feature.

The series, 'Times of day - Morning - Noon - Evening and Night' followed various color schemes. Shown above is 'Morning' with red featured heavily as the color representing the 'dawn of life'.

Wilhelm Ostwald and Albert Munsell

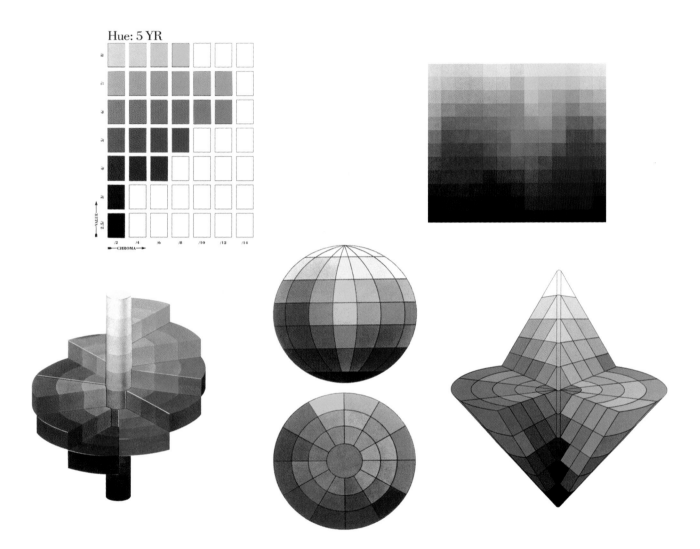

There have been many attempts to organise colors into a system. For a variety of reasons they tend to fall somewhat short of their intention.

The authors of all color systems have several goals, one is to construct a model that includes all colors and places them systematically in the correct relationship to one another; a second is to create a useful tool for working with color, a third is to demonstrate color harmony.

As anyone quickly sees who has ever taken a random pile of colors and started to sort them by hue, or by lightness, or by saturation or by any other regular attribute, that the colors look more attractive.

So all color systems necessarily involve color harmony and most contain ideas about how to make colors harmonious, even though the attributes vary with the system.

It is not appropriate for this book to include full details of the various systems, but I will highlight a few of the major points of the most important color systems.

The two most influential designers of color order systems have been Wilhelm Ostwald and Albert Munsell.

Wilhelm Ostwald

Panting for a Corner (commenced 1948), Ben Cunningham

This is an example of a painting produced with the aid of a color system. Ben Cunningham owned a color harmony manual which was based on Ostwald's color system.
The painting, designed to fit into a corner, anticipated the shaped canvases of the 1960's.

Wilhelm Ostwald (1853-1932), was a German chemist with a wide range of interests. He somehow found time to include studies on the technique of painting and color theory in his busy life. His book on color, 'Farbenfibel' (Color Primer), ran to 15 editions. As late as 1930 colors (dyed papers, dyed wool and powdered tempera) based on his system were available in Germany.

His letters to a painter were published in English as 'Letters to a Painter on the Theory and Practice of Painting'. In the letters he described his ideas on color perception and the physics of painting. However, he did not go into color theory. A detailed description of the Ostwald system is probably not of interest for this book. What is important is that it is yet another example of the fact that when colors are arranged in any regular order they are perceived as being more harmonious.

In his case Ostwald believed that it was the correlation of the amount of black or white in a color that is the most important element of color harmony.

It is also of interest that the Ostwald system was based on Hering's opponent theory of color vision (page 40).

The form of Ostwald's 3-D system, based on a double cone, was similar to that proposed by Ogden Rood. A scale of 15 evenly spaced grays runs through the centre of the solid beginning with white at the top to black at the bottom.

Ostwald pointed out that although there are an infinite series of grays there is a perceptual threshold below which the lightness differences cannot be perceived. He assigned letters to each gray from **a** through **p**, skipping the letter **j**, which he thought could be confused in transcription.

Albert Munsell

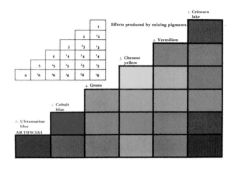

The work of theorists such as Ogden Rood assisted Munsell in his color research.

The Munsel 'Color Tree'

Albert Munsell, one of the better known color theorists, patented his color sphere in 1900 and went on to write 'A Color Notation' in 1916. His work was aimed towards those who used color in a practical way.

Munsell knew and met the German theorist Wilhelm Ostwald.

For his work he could not only draw on the findings of great color theorists such as Chevreul and Ogden Rood but was assisted by the fact that the first instruments for measuring wavelengths were available.

His findings, after much updating, are still in print. *'The Munsell Color System, A Language for Color'* by Joy Turner Luke, adds greatly to our understanding of this complex subject.

Albert Munsell

'A Color Notation' by Albert H. Munsell, 1923 and 1946 editions.

Color HARMONY
Rhythmic Composition
"Attempts to define the laws of harmonious color have not attained marked success, and the cause is not far to seek. The very sensations underlying the effects of concord or of discord are themselves undefined.

The term harmony, from associations with musical harmony, presents to the mind an image of color arrangement, - varied, yet well proportioned, grouped in orderly fashion, and agreeable to the eye.

Musical harmony explains itself in clear language. It is illustrated by fixed and definite sound intervals, whose measured relations form the basis of musical composition.

The musical analogy gives us the clue, that a measured and orderly relation underlies the idea of harmony.

Instead of theorizing let us experiment. As a child at the piano who first strikes notes at random and widely separated notes, but soon seeks for the intervals of a familiar air, so let us, after roaming over the color globe and its charts, select one color familiar to us and study others that will combine with it to please the eye.

PATHS
Here is a grayish green stuff for a dress. What colors may be used with it? First let us find it on our sphere, so as to realize its relation to other degrees of color.

Its value is 6/,- one step above the equator (middle value). Its hue is green, and its chroma /5. It is written G 6/5.

Color paths lead out from it in every direction. Where shall we find harmonious colors, where discord, where those paths more frequently travelled? Are there new ones still to be explored?

There are three typical paths: one vertical, with rapidly changing value; another lateral with rapid change in hue; and a third inward, through the neutral centre to seek the opposite field.

The vertical path finds only lighter and darker values of gray-greens, - "self colors or shades," they are generally called, - and offers a safe path, even for those deficient in color sensation, avoiding all complications of hue, and leaving the eye free to estimate different degrees of a single quality.

The lateral path passed through neighbouring hues on either side. In this case it is a sequence from blue, through green to yellow. This is simply a change of hue, without change of value or chroma if the path is level, but, by inclining it, one end of the sequence becomes lighter, while the other darkens.

It thus becomes an intermediate between the first and second typical paths, combining at each step a change of hue with a change of value. This is more complicated, but also more interesting, showing how the character of the gray-green dress will be set off by a lighter hat of Leghorn straw, and further improved by a trimming of darker blue-green."

Albert Munsell

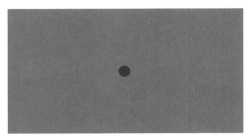

"A spot of strong reddish purple is balanced and enhanced by a field of gray-green".

'A Color Notation' by Albert H. Munsell, 1923 and 1946 editions.

AREAS

"...small bits of powerful color can be used to balance large fields of weak chroma. For instance, a spot of strong reddish purple is balanced and enhanced by a field of gray-green.

"So an amethyst pin at the neck of the girl's dress will appear to advantage with the gown, and also with the Leghorn straw. But a large field of strong color, such as a cloth jacket of reddish purple could be fatal to the measured harmony we seek.

"This use of a small point of strong chroma, if repeated at intervals, sets up a notion of rhythm; but, in order to be rhythmic, there must be recurrent emphasis, "a succession of similar units combining unlike elements." This quality must not be confused with the unaccented succession, seen in a measured scale of Hue, Value, or Chroma.

"Change of interval immediately modifies the character of a color sequence. The variations of color sequences are almost end-less; yet upon a measured system the character of each effect is easily described, and if need be, preserved by a written record.

"Experiments with variable masks for the selection of color intervals soon stimulate the imagination, so that it conceives sequences through any part of the color solid. The color image becomes a permanent mental adjunct. Five middle colors, tempered with white and black, permit us to devise the greatest variety of sequences, some light, some dark, some combining small differences of chroma with small intervals of hue, and so on through a well-nigh inexhaustible series.

"As this constructive imagination gains power, the solid may be laid aside. We can think of color consecutively. Each color suggests its place in the system, and may be taken as a point of departure for the invention of groups to carry out the desired relationship."

Munsell also believed that a picture should be balanced, but his criteria was more flexible than the section reproduced here suggests.

He did not believe that all colors had to balance to gray, in several examples he balances colors on a colored background.

Although he did not insist that all colors had to mix to a gray in order to harmonise, he did paint his colors on a globe and spun it to show that his colors all combined to form a gray.

He used this demonstration in the art classes he taught and carried the globe to be shown to people like Denman Ross, Ogden Rood and, probably, Ostwald.

Everyone was looking for order and balance.

The Swedish Natural Color System

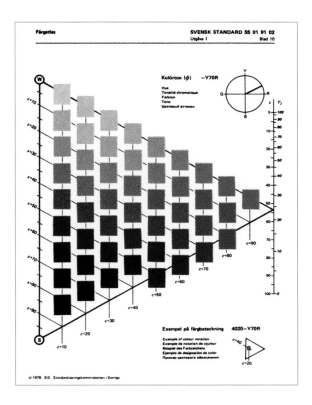

The 'Swedish Natural Color System' (NCS), is based on Ostwald's work and Hering's opponent color theory.

The point of the triangles are theoretically pure colors so no color chip is shown. The Swedish color scientists also dropped the use of letters and designated color with numbers that represent hue (example: **Y10R**), chromaticity (**c**) and blackness (**s**) content.

Colors, instead of being located where diagonal blackness and whiteness lines cross, are located where the vertical **c** lines cross the diagonal **s** lines.

A problem I would suggest is that neither the Ostwald or Natural Color System (NCS) have a separate designation for lightness, which is probably the most fundamental aspect of color.

The depiction of form, sharpness of edges, the amount of contrast between colors depends almost altogether on the lightness difference between the colors. Black and white photography and artists' pencil sketches establish how important lightness differences are in any picture or graphic. In the second edition of the NCS, lightness is indicated but the color chips do not fall on those lines. You cannot select a color and then change its hue without altering its lightness and saturation, as you can in the Munsell system.

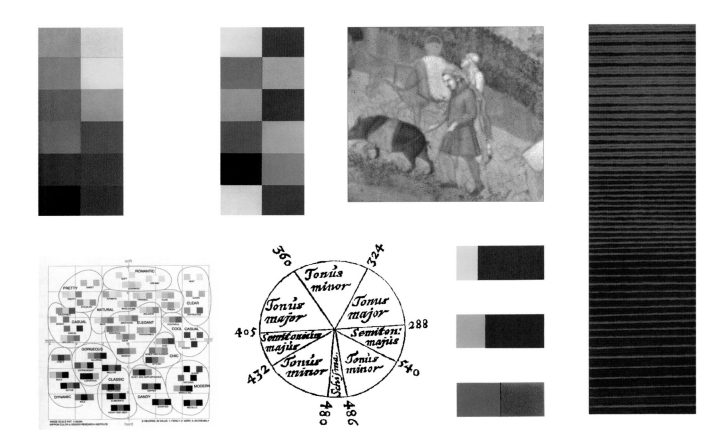

We have looked at what might seem to be a confusion of ideas about color harmony:

Is the answer to be found in the ancient ideas of beauty? Are music and color linked in some way? Is the solution to be found in nature? Are only analogous colors harmonious or is further contrast required? Could it be to do with evolution? Can science show the way? Perhaps a color order system is the solution?

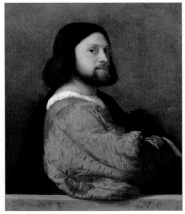

Portrait of a Man, 1512, Titian
© National Gallery, London

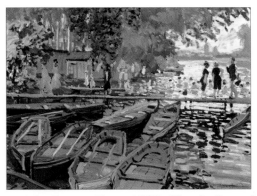

Bathers at La Grenouillere, 1869, Claude Oscar Monet
© National Gallery, London

During the Renaissance and during the Impressionist period the whole attitude towards art changed as ideas percolated into the art world from scientific discoveries.

My task now is to try and sort it all out and to offer a working guide to finding harmonious color arrangements.

This, actually, would be a good time to quit, but here goes:

I think that we can discount the music-color link. If it were there, the color to note or chord relationship would have been worked out by now and we could look to a favourite piece of music for an analysis of the colors to use.

Science has had a key role to play but has not provided all the answers. Art does not get better; however, at the times that information developed by scientists reached practising artists, *art was transformed.*

During the Renaissance and during the Impressionist period the whole attitude towards art changed as ideas percolated into the art world from scientific discoveries.

Areas of modern science of potential interest to the artist are probably too complex to be of practical use. But many earlier discoveries are still of value.

My own thoughts vary between 'there is probably no such thing as universal color harmony' to 'its in there somewhere, a bit of this and a bit of that'.

Many years ago, in the services, I once asked a disinterested cook what the brown liquid in a container was. 'Is it soup or gravy'? 'It's what you want it to be' he said. I tend to think that color harmony (and art), can be described in much the same way.

During the rest of this book I will be offering combinations which many have found to be harmonious. Combinations which, in part, are based on some of the themes that we have discussed.

The original sources might be well hidden. A red-orange/green-blue combination, for example, might have been made popular by certain artists after the scientific world explained why those two colors might look well together.

After having been found a place by science the red-orange/green-blue relationship might have then found its way into a color order system.

We might then find that the same pairing was in use hundreds of years earlier because it had visual appeal, it simply looked good.

The combinations that we will be exploring have come together over many centuries, from all parts of the world and for a variety of reasons.

If there is a common theme relating to the perception of color harmony amongst individuals I believe that nature holds the key. As well as recording many of the arrangements which have been used in the quest for color beauty, I will be exploring our relationship with the colors in nature.

The Petit-Bras of the Seine, Claude Monet
© National Gallery, London

So infinitely variable is the effect of one color on another and so subjective is color perception, that we will never be able to lay down hard and fast rules on color harmony.

Guidance is, unfortunately, still too often based on a formalised approach. We are given lists of color combinations and told that this, or that will happen, and for clearly laid down reasons. Such an approach should be met with caution.

I believe that we can only say that color is entirely within our brain, that it is always on the move and that color perception would seem to vary between individuals for a variety of reasons.

Because color perception is so elusive, we ought to concentrate on what for us actually appears to happen when one color is placed alongside another and assume that similar changes might be apparent to others around us.

The combinations we will look at are those which many people seem to have found harmonious. The evidence for this comes from their widespread use in paintings, craft work, tapestries, woven items, interior decoration etc.

From now on, instead of talking about 'colors which many find harmonious' I will simply use the term 'harmonious'. I feel that I have made clear that the word comes with severe limitations. If you disagree on any arrangement that I suggest might be 'harmonious', remember that we will both be right.

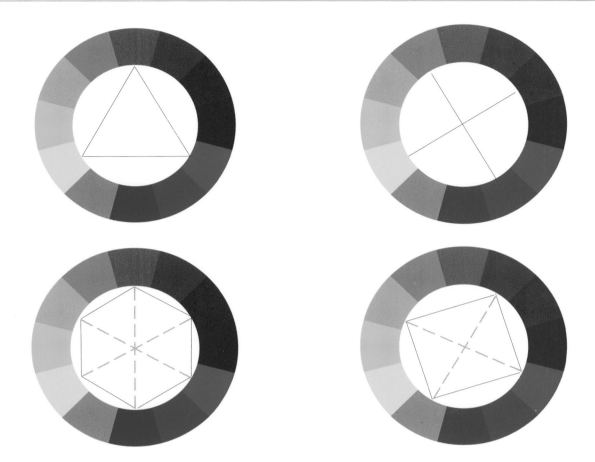

Diagrams such as these are frequently offered to the artist, together with some rather complicated instructions. My only objection to them is that they are accompanied by the message; 'these colors harmonise - they are the correct ones to use'.

The often presented 'rules' of color harmony and discord do not have a scientific or mathematical basis.

The individual will have developed certain feelings towards colors over time that are based on that persons make-up and experiences.

Cultural influences such as long familiarity with color groupings that find social acceptance might well have a strong impact, as might the familiarity brought about by exposure to changing fashion.

The individual must trust his or her own sensibilities rather than rely on any rigid system of rules.

Yet we still find the widespread use of 'color wheel recipes', whereby the painter is told that a particular two, three or four color combination *will* harmonise; that this or that combination is *'correct'*.

I am sure that you are familiar with this approach. It causes confusion and puts many a would-be colorist off the subject.

The message would be accurate if it was; 'these colors can be encouraged to harmonise for many if they are used as the base hues for an arrangement, meeting the skills and sensitivity of a creative and knowledgeable person'. Because this is the description for *any* color combination.

1.
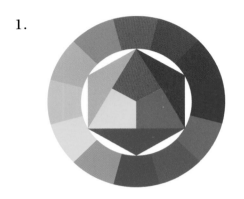

2.

Basic color wheels commonly show twelve equally spaced hues.

3.
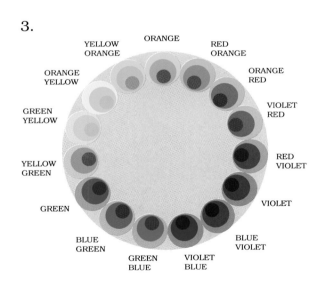

YELLOW ORANGE
ORANGE
RED ORANGE
ORANGE YELLOW
ORANGE RED
GREEN YELLOW
VIOLET RED
YELLOW GREEN
RED VIOLET
GREEN
VIOLET
BLUE GREEN
BLUE VIOLET
GREEN BLUE
VIOLET BLUE

4.
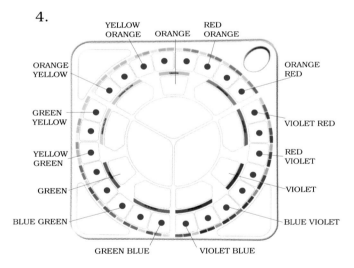

YELLOW ORANGE
ORANGE
RED ORANGE
ORANGE YELLOW
ORANGE RED
GREEN YELLOW
VIOLET RED
YELLOW GREEN
RED VIOLET
GREEN
VIOLET
BLUE GREEN
BLUE VIOLET
GREEN BLUE
VIOLET BLUE

Color wheels can be a great help if they are used for general guidance only. Using a very small number of basic hues to represent the several million colors that we can perceive has obvious limitations.

Basic color wheels commonly show twelve equally spaced hues (1 & 2 above). These, I feel are rather limiting if the wheel is also to be used as a color mixing guide.

For such purposes I believe that fifteen is the very minimum for practical use (3 above). These fifteen, together with various inter-mixes have been incorporated into our Color Coded Mixing Palette (4) and will be used as the 'color-type' reference throughout the book. I have used our palette as it also provides color mixing guidance and many readers will already use it in their work.

Colors shown liked as above indicate that the same hues can be applied into either mixing well. The 'inner' colors are not in addition to the outer.

The violet, green and orange wells are for mixing guidance only. The violet, as with the orange and green wells, represent the two colors immediately behind it.

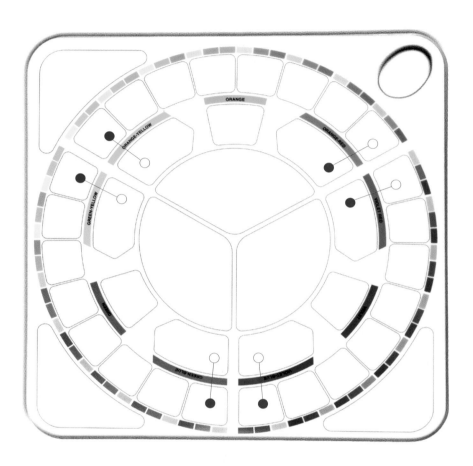

When I designed our color mixing palette I also had in mind the selection of colors which can lead towards color harmony. It is the basis for the color mixing tips that I will be giving, You do not, however, need to use the palette in order follow the suggested color arrangements. As a diagram it can be treated as a conventional color wheel and the information provided on color mixing will be sufficient for any palette that you care to use.

As with all color wheels, use it for guidance only. Guidance is the word, it can be a mistake to rely too much on such devices.

Color mixing tips are given throughout the book. However, if you would like further help in mixing your colors, our book, 'Blue and Yellow Don't Make Green' might be of help. Contact details for the School of Color can be found on the final page.

Swatch 41 Cadmium Yellow Light and mixed bright Violet

1	2	3	4	5	6	7	8	9	10
A	A	A	A	A	A	A	A	A	A
B	B	B	B	B	B	B	B	B	B
C	C	C	C	C	C	C	C	C	C
D	D	D	D	D	D	D	D	D	D
E	E	E	E	E	E	E	E	E	E

Throughout the book I will be referring to the mixing swatches which start on page 403. They are reproduced from our 'Color Mixing Swatch Book'.

The mixes shown to the right (and at top left of page 77), can be found on swatch 41 at the back of the book. As in the example above, numbers and letters have been assigned to each color for ease of identification.

The swatch number is shown first, in this case 41. This is followed by the numbered color from the top row and then the lettered tint (where applicable).

Therefore, color 41/1C (circled above), is to be found on swatch 41. After finding swatch 41, go to the color numbered 1 (top left), then down to C. The three colors shown at right 41/1C, 41/4B and 41/3 have been circled above.

It will be a good idea to take a few moments to familiarise yourself with this system as I will be using it throughout the book.

Orange-yellow (Cadmium Yellow Light)

41/1C 41/4B 41/3

Desaturate the orange-yellow with white, with a touch of the complementary violet plus white, or just with the complementary violet; as per color swatch 41 at the back of the book.

Strictly speaking, a blue-violet should be used as it is closer to the complementary of the orange-yellow. However, the differences will be very slight and are not worth worrying about.

Reproduced from page 77 top left.

70

Introduction

Artist unknown

Without a doubt the easiest way to achieve color harmony is to use only one color. Risks are certainly minimised.

A large solid area of color presents little that can go wrong but would be extremely bland.

Actually we rarely come across an area of single, unadulterated color. Even a painted wall will show colors reflected from other objects, shadows and possibly light from a window, gradually weakening over distance.

When used in painting, the approach would be to deliberately alter the base color to give variety. To give a wider range to work with, the color can be desaturated in various ways.

A color is desaturated when it is altered in intensity. A new pair of jeans, for example, are usually a *fully saturated* blue. As they fade the blue becomes less intense, or *desaturated*.

Desaturation can be achieved in several ways.

1. White can be added, the more white the more the color becomes desaturated.

2. Black can be added to desaturate a color.

71

3. If another color is added it will also desaturate the original.

The addition of yellow takes the blue away from being a fully saturated hue.

Adding blue moves the red away from a fully saturated state.

The complementary red will desaturate the green and vice versa.

4. The addition of its complementary will also desaturate a color. If taking the monochrome approach, only a tiny amount of the complementary should be added at a time as the color can be quickly changed.

When chosen carefully, the complementary will desaturate the color whilst keeping it *close to its original character.* This is important in monochrome painting, otherwise, of course, we would have several colors on the go at once.

In the examples shown here, only the first four, or possibly five mixes should be used. Much past that and the approach becomes one of 'working with a complementary pair'. An area that we will be coming onto later.

The tints from such mixes, produced either by adding white or allowing the background to show, have a valuable contribution to make.

A single color

The same hue group

A monochrome scheme involves the strict use of a single color. One of two approaches can be taken:

A single color
The complete painting to be composed of a single color such as Ultramarine Blue, with variations in its saturation.

Whatever the base color, the saturation can be varied either by adding white or a touch of the complementary color. *Or both at the same time.* Strictly speaking, the option of desaturation by adding another color (illus. 3. previous page) does not exist. Otherwise you would not be working in monochrome (one color).

But why be strict? The painting comes before any definition and this would certainly be a close option.

The same hue group
Alternatively, several variations of a single hue, for example, Ultramarine Blue, Cerulean Blue and Phthalocyanine Blue can all be worked closely together, as above.

Such arrangements can be harmonised with ease but a risk is taken as the results can be rather bland and lack visual interest.

Although 'moods' can be set without difficulty, it is less easy to persuade any one of the color variations to play an important role, as they are all rather similar.

Use of a single color and white

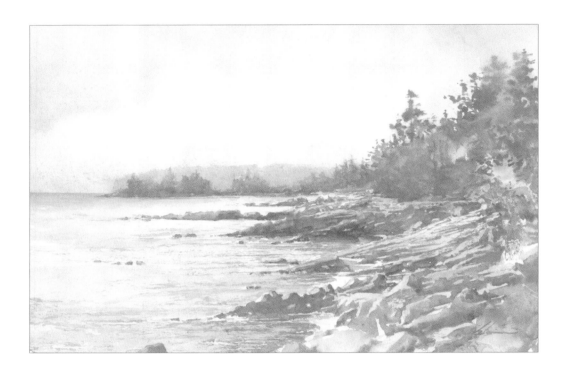

A popular method of working in monochrome is to desaturate a *single color* using white. It is a straightforward and simple method of working

An important consideration, particularly for the landscape painter, is that if only one color is being used and that is desaturated only with white, which of the possible colors will be used for the areas that are low in value (dark)?

Generally speaking, the areas which are commonly lowest in value (the darkest) in a landscape will be the shadows.

If white is used to desaturate the base color, the lowest areas in value (darkest) will always be the most saturated (the richest in color). An immediate problem arises;

Saturated colors tend to advance and desaturated colors appear to recede.

By using the most saturated color in the shadows, as you would almost certainly be obliged to, the situation could arise where the shadows tended to advance in the painting - a reversal of the usual order.*

Actually I am working against myself here. In a future book/course I will be pointing out that on a clear, bright day the most saturated areas in nature <u>are</u> often the shadows. However, such contrast of saturation can be very subtle and would be difficult to show in a monochrome painting.

Yellow-green

9/4D 9/4B 9/4A

Mixed from green-yellow and green-blue. White has been added to give a working range of saturations. As far as color harmony is concerned, this is a safe but perhaps rather bland approach.

Green-blue

9/9E 9/9C 9/9A

Green-blue with a touch of green-yellow. From here the color is used with or without white.

An easy way to achieve harmonious color combinations.

Neutralised (dulled) orange

48/10D 48/10B 48/10A

The dulled orange shown here is Burnt Sienna used at varying saturations. The only method of desaturating the color has been the addition of white.

Neutralised (dulled) orange

48/8D 48/8B 48/8A

A touch of violet-blue has been added to the Burnt Sienna to darken it. This new (single) color has then been desaturated with white in the manner of sepia prints or photographs.

Please note: The color swatch examples as shown above will be used throughout the book. *They are intended to give very general guidance only.*

Such a vast range of colors can be mixed that I would be doing you an injustice were I to go into great detail about each and every mix. The degree to darken or lighten a color for example, or the area over which to use it.

I do not wish to contribute to an approach which suggests that the use of color can be reduced to a 'system'.

The color mixing information and exercises which are part of this book should give you the necessary skills to use the swatches as guidance only. This, together with the fact that color printing is severely limited as far as accuracy is concerned, leads me to suggest that you glance over the swatches but decide on the actual mixes yourself, putting them into practice as you see fit.

As you will notice, the 'mini picture swatches' have been varnished to give an indication of their appearance as oil or acrylic studies. The 'brush strokes' have been left unvarnished to show their appearance as watercolor paints. Colors become richer when varnished, this factor should be taken into account.

Orange-yellow

15/1E 15/1C 15/1A

The artist's paint 'Cadmium Yellow Light' has been used here as the orange-yellow. In practice, any orange-yellow can be employed, whether it be a wall emulsion, a colored thread, a silk dye or a colored pencil.

Violet-red

21/3D 21/3C 21/3B

It is important to understand that I am not suggesting that any of these combinations harmonise, it is up to you to decide that. What I am putting forward are arrangements which have been used in the quest for color harmony.

Orange-red

35/10D 35/10C 35/10A

Cadmium Red Light has been used as the orange-red in this example. In other forms of work any orange-red can be employed, from a house paint to patches of colored material as used by the quilt maker.

Neutralised (dulled) yellow-orange

30/3D 30/3C 30/3A

Yellow Ochre (a dulled orange-yellow), with a touch of orange-red to take it towards a yellow orange. You can take any 'Yellow Ochre' type colorant and add a touch of orange-red to achieve similar results.

Color is color and the examples shown above will be applicable for any use. The artist might use the information in a painting and then further to decorate a room. A combination found to be pleasing might be used in a piece of stitch-work or in the design of clothing.

If you vary the use of the information do bear in mind that the area of a color can have a vital bearing on the end result.

The light/medium/dark combination shown in any of these color arrangements might look well in a painting or piece of decorative work but may not balance when used in room decoration, for example.

It might well be that the lighter colors have to be used over far greater areas than shown here. Everything depends on the use to which the information is put, the color arrangements are shown to give ideas, no more.

Use of a single color's tints, shades and tones

Orange-yellow

41/1C 41/4B 41/3

Desaturate the orange-yellow with white, with a touch of the complementary violet plus white, or just with the complementary violet, as per swatch 41 at the back of the book.

Strictly speaking, a blue-violet should be used as it is closer to the complementary of the orange-yellow. However, at this end of the range the differences will be very slight and are not worth worrying about.

Neutralised Blue-green and (dulled) orange

38/1D 38/2B 38/2

Again desaturate the base color, the blue-green with white, with a touch of the complementary orange-red plus white, or just with the complementary orange-red, as per swatch 38 at the back of the book.

As with EVERY color combination shown throughout the book, these are just random selections, they are not offered as suggestions in any way.

Green-blue

44/9D 44/8A 44/10

To desaturate the green-blue add white, a touch of the complementary orange plus white, or just the complementary orange, as per swatch 44 at the back of the book.

Again it must be emphasised that these *are not suggestions,* they are taken at random and many other combinations from the same swatch would work together equally well.

Yellow-green

36/1D 36/3B 36/2

Desaturate the yellow-green with white, with a touch of the complementary violet-red plus white, or just with the complementary violet-red.

To add visual interest we can desaturate a color in several ways, not just by adding white.

Desaturate the base color by either adding white, desaturating (darkening) with its complementary or adding both white and the complementary.

Atmosphere can be created very easily with this approach but the results can be rather dull if over-worked. In these examples, only three variations are given as general guidance.

Obviously a far greater range is available, as indicated at right.

The color mixing swatches (page 403) will help to identify the mixes should you wish to try them in your work.

The diagram to the right (from page 415), illustrates the 'yellow-green' color arrangement directly above.

Use of a single color's tints, shades and tones

Violet

41/10D 41/8 41/7B

Earlier color combinations where the base color was only desaturated with white gave interesting but rather bland arrangements. Interest is added if the color is also desaturated with its complementary.

Orange

45/2C 45/3B 45/2

In these examples we are not only desaturating with white but also with the complementary. In addition, *and it is a very important addition*, we are also modifying with the complementary *and* white.

Orange-red

38/8A 38/8C 38/9E

When a color is darkened, in these examples by the use of the complementary, the result is known as a *neutralised* version of the original color. The term *shade* is often used instead of neutral.

Violet-blue

45/10C 45/8A 45/8

When a neutralised hue (a color desaturated with its complementary), is further desaturated with white it is known as a *tone*. Such colors have a very valuable role to play.

45/10 45/10C

Tints are lighter versions of a color. Lightened with white or by allowing a light background to show through.

45/10 45/8

Neutrals (often called shades), are 'darker' versions of a color. The ideal way to darken a color is to add its complementary.

45/8 45/8C

Tones start off as darkened colors (neutrals) which are then lightened with white or by allowing a light background to show through.

Tints, tones and *shades* used together add far more visual interest than would be available from a single color desaturated only with white.

Use of a single color's tints, shades and tones

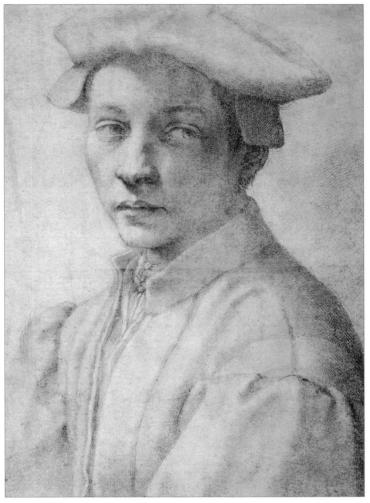

Portrait Study of a Young Boy by Michelangelo (1475-1564)
British Museum, London, UK/Bridgeman Art Library

The use of a single hue at varying strengths is a safe way to achieve color harmony. Some caution should be used when combining widely differing strengths of color. Varying the proportions can help in this respect.

For example, if working with a green (as above), you might use small touches of the color in a relatively saturated form against areas of the same hue desaturated with white and/or with the complementary red.

The same hue group

Blues

45/10E 46/1A 47/1B

The three blues used here, transparent violet-blue (Ultramarine), opaque green-blue (Cerulean Blue) and transparent green-blue (Phthalo blue) can be worked together with ease.

Greens

11/6C 16/8B 20/1

A variety of greens, whether single colors (as with the Phthalocyanine Green) or mixed, can, if used with care, be readily combined. The brighter greens should be used with caution.

Yellows

41/1C 53/10B 30/1

Bright orange-yellow (Cadmium Yellow Light), dulled orange-yellow (Yellow Ochre) and very dull orange-yellow (Raw Sienna) are relatively easy to place together.

Browns

41/4C 44/2B 47/10A

Either the natural earth colors, such as Burnt Sienna or mixed browns (darkened reds, yellows or oranges), can be used in this type of composition.

The use of various members of the *same hue group* will give a wider range and still provide the unique feel and mood that a monochrome painting is able to convey.

We have looked at one example, the use of various blues, Ultramarine Blue, Cerulean Blue and Phthalo Blue (please see page 73).

Any similar close group can be used, such as Cadmium Yellow, Raw Sienna and Yellow Ochre.

Working in monochrome is very safe in terms of harmony as there is very little that can go wrong. It is difficult to achieve a discordant result with just one color type.

The results can, however, be rather boring, unless extra attention is paid to possible contrast.

The colorist is therefore obliged to rely more on design than on the impact obtainable through the wider use of color.

The ultimate in monochrome as far as the number of colors involved is probably the use of light and dark in arrangements similar to the above.

If you look anywhere on the diagram you will most probably see a range of soft, flickering colors appear; violets, pinks etc.

I say *probably* because not everyone experiences this sensation.

The above technique, using lines, dots or dashes, was employed by certain 'Pop' artists, notably Bridget Riley.

It seems that the colors appear due to a confusion in the visual system when presented with light and dark, evenly and closely spaced. The messages between the eye and the brain possibly become muddled as to whether hues are being discerned or light and dark.

Aboriginal artists, Northern Australia

Where there is a limit on the range of available colors, monochrome can be the only method of working. In such circumstances the artist becomes very aware of the contrast of saturation and of value (light and dark).

When working in monochrome a strong light/dark contrast can be introduced to increase visual interest, as in the paintings of the hands, above.

In fact, working in monochrome can be a very useful way for an artist, or anyone working with color, to come to terms with the balancing of values before moving on to more complex color arrangements.

The Nativity, c.1305 (fresco) by Giotto di Bondone (c.1266-1337)
Scrovegni (Arena) Chapel, Padua, Italy/Bridgeman Art Library

Sections of earlier wall paintings, 'frescoes', were often painted in monochrome. The method of working involved the application of a pigment/water mix to freshly applied damp plaster. It was a difficult method of working and the simpler the color arrangement the better.

In the above example, several pots of a brown pigment, mixed with water at different strengths, would have been prepared beforehand.

The Wash House, 1905, William Orpen
National Gallery of Ireland

An interesting variation on the theme is to work in monochrome over almost the entire painting, introducing tiny splashes of 'outside' hues for added interest.

In the above painting the small touches of red at the bottom of the work as well as the more subtle use of this hue in the face and arm add visual interest.

As does the sparing use of yellow. It could be argued, and quite rightly, that this is not a monochrome painting as other colors are involved.

However, the overall appearance is one of monochrome and the painting illustrates the concept of monochrome with tiny touches of 'outside' color.

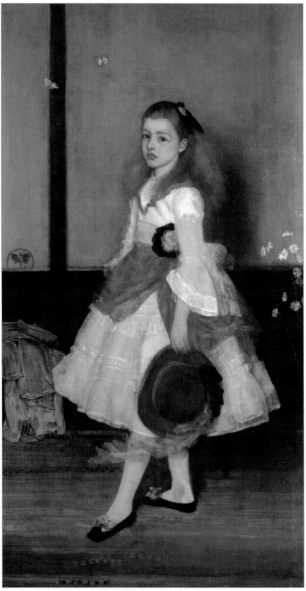

Miss Cicely Alexander: Harmony in Gray and
Green, 1872-4, J.A.M. Whistler
© Tate, London 2002

Once again the overall appearance is one of monochrome. Whereas the painting on the previous page employed tiny touches of 'outside' color to add visual interest, in this painting larger areas, the face, hair and arm have been 'set aside' to carry the 'outside' colors. But it is still, I feel, predominantly a monochrome painting.

Introduction

Light against dark Dark against light Similar in value

The background color to any composition is of vital importance to the end result, more so than is generally realised.

The light/dark contrast often has a greater bearing than the actual colors used.

If the background is either lighter or darker than the object or feature it will be perceived by most as being acceptable. A background similar in value to the object or feature will be seen as being *unpleasant* by most.

I am talking here about the background to an *object*. These observations do not apply where an object or objects, as such, are not involved. The various colors in an evening sky, for example, need have little or no light/dark contrast to be considered beautiful.

If seeking color harmony where objects *are* involved, it is almost essential that a feature stand out from the background and be easily recognised.

The difference does not have to be dramatic, in fact, if it is too pronounced, the stronger contrast can upset the balance.

The sex of the observer can also make a difference. Women tend to favour 'warmer' background colors (based on reds, oranges and yellows), whereas men usually prefer the 'cooler' colors; blues, greens etc.

Such colors need not be particularly strong (saturated). In fact, desaturated colors often make the better background color.

In practice, there will be many occasions when an object does not follow any of the above. As in the illustration to the right, the central flower alternates between being light against dark and dark against light. In some areas it approaches a similar value to its background.

The artist, however, has the final say and should (I believe) feel completely free to alter the balance. You might wish to emphasise the object, lose it in the background or make it of general interest. A great deal can be done by varying the background color.

A variety of object/foreground relationships often occur together. This is fortunate as it lends the possibility of extra visual interest.

In the illustration to the left, the variety of relationships does, I feel, add such interest. Most of the wheel is light against dark. The background to the right becomes lighter but so do the spokes on that side.

If the actual scene had been a light wheel against a pale background, or dark against dark, contrast could always be added or emphasised by the artist.

I feel that it is important for the painter to know that an object which is not immediately obvious is actually found to be unpleasant to many.

The main reason that we prefer to see something as either light against dark or vice versa is to do with our need to quickly recognise the different things that surround us.

Color is an enormous help in this regard. When living closer to nature we had a need, for example, to quickly recognise insects and animals which might be a danger to us. Color also helps us to place items in space.

Such factors, it would seem, have led us to prefer objects which stand out from their background.

Please bear in mind that we are talking about the background color to an *object*. This should not be confused with general color work.

In the illustration to the right, for

example, the colors of an evening sky do not need to be clearly separated from each other in value to be acceptable. There are, of course, many other instances where this will be the case. It is for this reason that many of the color swatches to be found in the book are composed of colors similar in value.

1. Background is from swatch 44/1

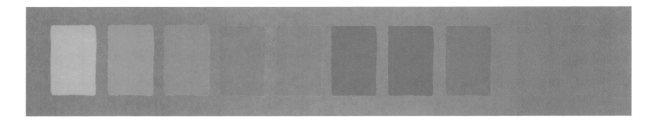

2. Background is from swatch 44/10

3. Background is from swatch 44/5

The background hue can also have a major influence on our perception of a color. In the above examples, a strip of colors mixed from orange and green-blue are set against different backgrounds. The background colors being taken from the actual 'strip' of mixes.

In the first example, (1), the strip against the orange; the orange end will look rather insignificant as it lacks contrast. The green-blues will look sharp and bright when set against the

orange. The opposite effect occurs when the arrangement is reversed, (2), the oranges now becoming bright against the green-blue and the blues 'dimming'.

Such effects are particularly strong when complementary colors are involved.

If using such a range in a piece of work, a more balanced effect can be achieved if a color from around the centre of the strip is introduced as the background (3.)

Background is 44/5

Background is 44/5A

Background is 44/5C

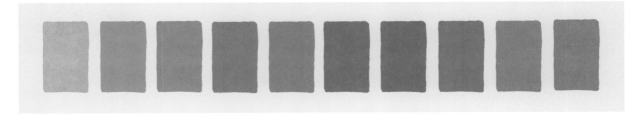

Background is 44/5D

The examples covered over the previous two pages can be combined to give an overall appraisal.

The same strip of mixes from the previous page can be set against light, medium and dark backgrounds. The backgrounds coming from the same orange/green-blue mix used in the diagrams on the previous page.

The mixes on this and the previous page have been taken from swatch 44, page 418.

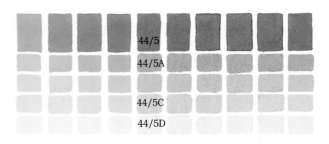

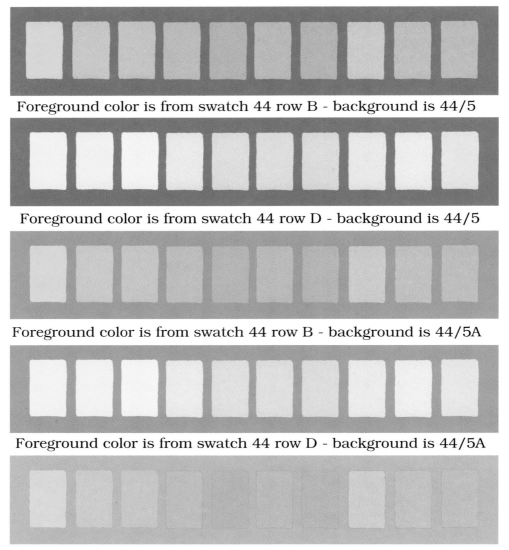

Foreground color is from swatch 44 row B - background is 44/5

Foreground color is from swatch 44 row D - background is 44/5

Foreground color is from swatch 44 row B - background is 44/5A

Foreground color is from swatch 44 row D - background is 44/5A

Foreground color is from swatch 44 row B - background is 44/5B

Instead of fully saturated colors against varying backgrounds, we can take tints (lighter versions), of the same colors and surround them with various degrees of light and dark. Once again the background is taken from the same mixing swatch.

Any of the color mixing swatches can be used this way. Each can become a powerful guide towards color harmony.

You will notice that as the values of the foreground and background approach each other, the lack of contrast makes each foreground mix less suitable as an object color. Fine for general use but not for objects.

PS. Do not let the various color descriptions shown above put you off. It will be worth looking at the particular swatch and working it all out slowly over a nice cup of tea.

1. A strong contrast which might be a little overpowering for a particular subject.

2. A single mix of the object and background colors will reduce contrast.

3. The entire background, over a larger area can be painted with the same mix.

If the color in the foreground contrasts too sharply with the background color, *inhibiting harmony,* steps can be taken to reduce the contrast without having to alter the two colors in question. Row 1 shows a combination which might be too strong for many applications.

In row 2, the background and foreground colors are mixed and applied between the two to reduce contrast.

In row 3 the foreground color is mixed with the background and applied between the two over a larger area. *The original background color resuming some distance away.*

Alternatively, several additional mixes can be produced and applied progressively between the two colors, as at right.

Some unusual effects can result from this approach.

The object can appear fuzzy and indistinct. It can also look slightly three dimensional and appear to radiate.

Apart from reducing contrast, this is a technique in its own right.

The Virgin and Child with St. John, 1495, Michelangelo
© National Gallery, London

Another approach to the creation of an harmonious background/foreground relationship is to combine the two *throughout* the painting.

In the above example, the artist first applied a dull green paint layer, probably Terre Verte. (In the days when good qualities were still available, unlike many of today's inferior substances).

The 'warmer' foreground colors were then applied as a series of thin, transparent glazes, leading to a blending of the foreground and background.

The influence of the background would occur all over the painting, especially where the upper layers were particularly transparent.

Glazing, of course, is simply another method of color mixing. The green/reddish combination leading to 'colored grays' in the same way that a pre-mix of the two would. This approach, in fact, was a favourite with many of the Masters as it could lead to very realistic skin tones. In much the same way, a thin layer of transparent paint *over* an otherwise finished painting can bring a certain unity.

Introduction

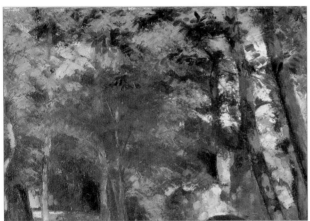

Often described as being *analogous*, colors which lie closely together on the color wheel can be made to harmonise quite readily.

Such groupings have a common character or identity. Although we enjoy variety in colors and employ their *differences* to give contrast, where harmony is being sought, the *similarities* between colors from the same group or family can be used to advantage.

Whilst closely related colors can be made to harmonise quite easily, *(there is little room for discord)*, possible contrasts can be somewhat limited.

93

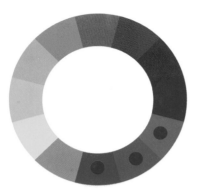

It obviously depends on the type of guidance wheel in use just how many colors can be employed in this approach.

On the commonly used twelve color wheel (as above), two or three hues together are normally considered analogous.

Including the secondaries; green, violet and orange, we will be working with a total of twenty seven basic colors. This is necessary, I feel, as we are also concentrating on the mixing of the colors and are using the palette as a guide to both mixing and to the selection of harmonious color arrangements.

Please note: Not every color on the wheel has been mixed with its complementary and shown in the color mixing swatches. (From page 403).

With any of the following color arrangement diagrams, if you wish to desaturate a color with its complementary, simply look opposite on the color wheel for its mixing partner (as above).

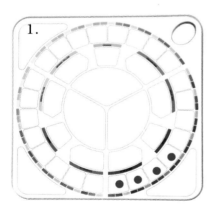

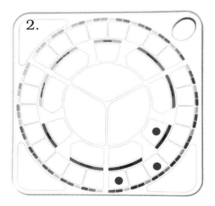

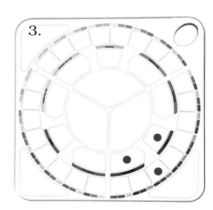

On our guidance wheel we will be working with four neighbouring colors (diag. 1 above). Rather than 'clutter up' the color swatches, I have selected just *three* out of each four in order to give an idea of the possible results.

These arrangements can be altered in any way that you wish, they are, after all, only suggestions.

Rather than use either of the two hues behind each of the secondary colors, I have used the secondary color (violet, orange or green), itself.

(diag.2). This is because examples have been given in the color mixing swatches (from page 403) of these colors mixed with their complementary partners. If you prefer to use either color behind a secondary, the latter is easily adjusted. I could not show every possible combination and only *general* guidance is actually intended.

In addition I have used the main arrow shaped mixing wells in order to identify colors (diag.3).

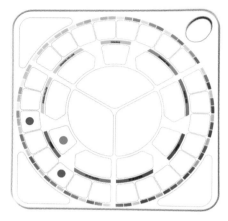

9/8C 9/6A 9/3A

1. A well balanced arrangement?

9/6A 9/3A 9/1B

2. Is the yellow-green very slightly out of place here? Such judgements, of course, are entirely subjective. It means nothing that I might find the top arrangement 'sits together' slightly better than the lower. Its what you feel that matters.

When choosing a related group of colors, a useful starting point is to select a *secondary (green, orange or violet)* and use the colors on either side as supports.

These groupings, where the key or central color is important to the composition, usually seem better balanced than the alternatives, which we shall discuss.

Green, (a secondary color), supported by blue-green and yellow-green (1) is seen by many as being more related than does the yellow-green backed by green and green-yellow (2).

In the first example, (top), the key color *green*, is enhanced by its neighbours, blue green and yellow-green, which are both similar in character.

The yellow-green of the lower example is ably supported by the green, but the green-yellow seems somehow ill at ease and ready to clash with its neighbours. Particularly if made any brighter.

Of all colors, the eye is most sensitive to green. The yellow-green (a type of green), even if it is particularly yellowish, will be identified as a green rather than a yellow.

The green-yellow (a type of yellow) and the greens will seem separate in character to many. This is the most extreme example of a related group which does not always work well. It is extreme because of our sensitivity to green. This might need to be read several times to become clear. And then you might not agree with any of it and be justified in doing so.

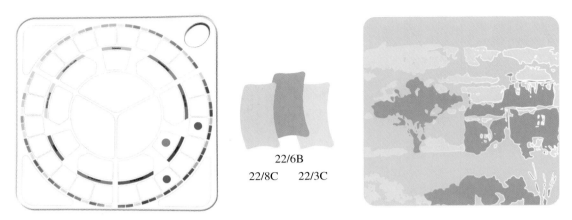

1. Violet supported by blue-violet and red-violet.

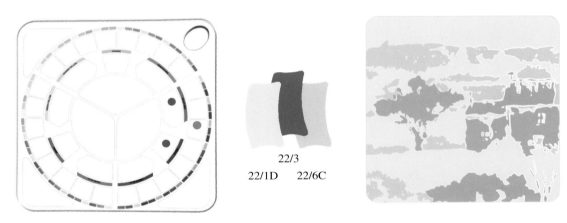

2. Red-violet flanked by violet-red and violet.

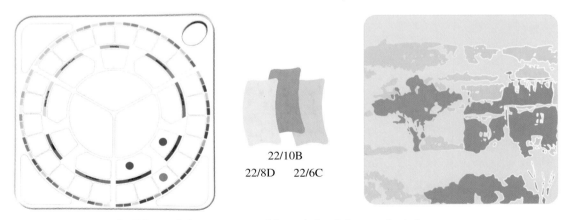

3. Blue-violet supported by violet-blue and violet

Another example of this approach is to use a violet supported by blue-violet and a red-violet, as in 1, above.

Some find that the groups either side; red-violet, violet-red and violet (2), or blue-violet, violet-blue and violet (3) do not seem to be quite so solidly based. They can be used quite successfully but with perhaps a little more care. This is an entirely subjective issue but might be worth considering.

Tints, shades or a combination

1. Tints of the three main colors can be used together

2. Neutralised hues (shades) can be used together.

3. Tints, tones and neutralised hues will work together.

With a little care, any of the possible groupings can be worked together and remain harmonious. An added bonus is that further interest can be aroused through the contrast of saturation.

A safe approach, as far as achieving harmony is concerned, is to work within the *desaturated* ranges.

1. If the various *tints* of the three main colors are used together they can be harmonised easily and with little danger of disruption.

2. In the same way, *neutralised colors* can be used together.

A wider range is available if *tones* (colors desaturated with their complementary plus white) are also introduced.

3. With a little care, *tints, tones* and *shades* can be used together. This will provide a wider range of values of course, adding more potential for interest. Also, more potential for stronger contrasts, which can upset an otherwise harmonious arrangement.

It is all a juggle really; you can either work in very safe areas and risk producing rather bland work, or employ a wider range of colors and add interest (and with a little care retain harmony).

As you will remember, tints are lighter versions of a color. Lightened with white or by allowing a light background to show through.

Neutralised colors (or shades), are 'darker' versions of a color. The ideal way to darken a color is to add its complementary.

Tones start off as neutralised colors (which are then lightened with white or by allowing a light background to show through.

'Warm' or 'cool' moods can be set with ease

Higashiyama Kaii by Quelle am Hain

Related color groups in the main contain either 'warm' or cool 'colors'. The exceptions are the borderline groups such as *yellow-green, green-yellow* and *orange-yellow* or the combination *orange red, violet-red* and *red-violet,* which contain colors leaning in both temperature directions.

A painting which conveys a feeling of warmth or coolness will have a strong emotional quality. Moods are therefore easily set.

Finding the combinations

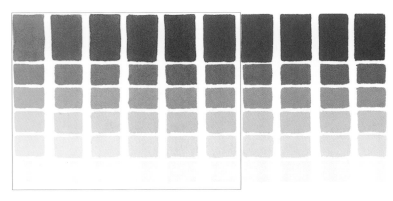

One possible source for the combination violet-red, red-violet and violet would be the mixes available from violet-red (Quinacridone Violet) and violet-blue (Ultramarine). Page 409.

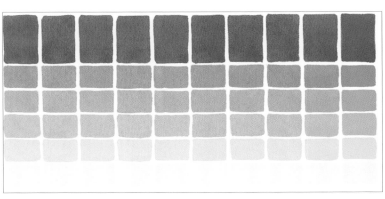

One of the many ways to obtain the range green-blue, blue-green and green would be to work with a combination of green-blue (Cerulean Blue) and mid-green (Phthalocyanine green). Pg. 406.

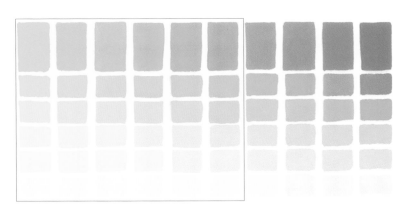

Orange-yellow (Cadmium Yellow Light) and orange-red (Cadmium Red Light) will provide the range orange-yellow, yellow-orange, orange. But it is only one possible approach. Page 411.

The various color combinations to be found under this heading can be obtained in an almost endless number of ways. The above illustrates just a few of the possibilities.

The color mixing information provided with each color swatch on the following pages will indicate a few of the other approaches which can be taken.

The Nativity, Moscow School late 17th century
National Gallery of Ireland

White added to orange-red will take the color towards the type of reddish orange shown here.

This particular combination can be very difficult to handle. Although of value when used in part of a painting, when the entire composition comprises these three it can look a little too rich for many.

More common on earlier religious pieces than in todays work.

Orange-red, violet-red and red-violet

The orange-red can be desaturated with white, with the complementary *blue-green*, or with white *and* the complementary.

The mixing partner, or complementary of the violet-red is a *yellow-green*, that of red-violet a *green-yellow*.

Mixing complementaries will be used here and there throughout the book, together with the various other ways to produce a particular hue.

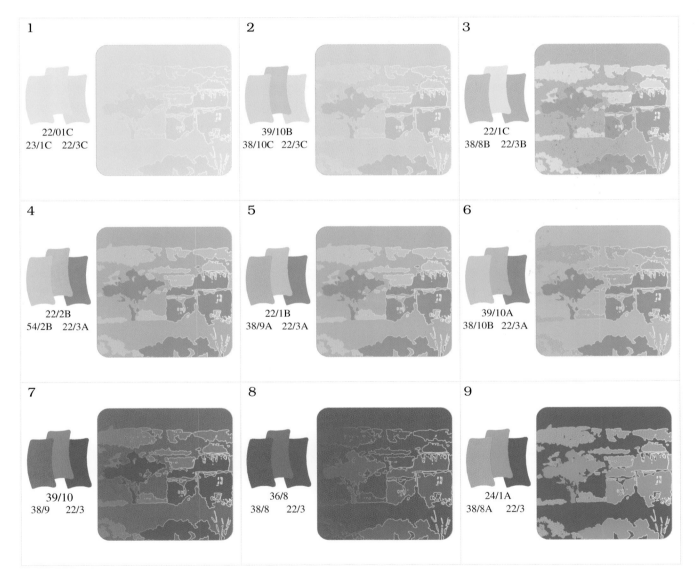

1
22/01C
23/1C 22/3C

2
39/10B
38/10C 22/3C

3
22/1C
38/8B 22/3B

4
22/2B
54/2B 22/3A

5
22/1B
38/9A 22/3A

6
39/10A
38/10B 22/3A

7
39/10
38/9 22/3

8
36/8
38/8 22/3

9
24/1A
38/8A 22/3

Related colors can be worked together successfully because they have much in common.

In these examples the violet red in the centre tends to hold the group together. Even so, it might be better to use the orange red in a desaturated form and over smaller areas as the two types of red do not sit well together if used at strength. Reds and violets together can evoke feelings of luxury and sumptuousness in many people. The more saturated versions (9) need to be used with some caution in most settings. When made lighter (1,2,3) or darker (8) these three can be made to sit together with ease.

101

Echo and Narcissus, 1903 by John William Waterhouse (1849-1917)
Walker Art Gallery, Liverpool, Merseyside, UK/Bridgeman Art Library

Although other colors appear in this painting, they are used in a subdued way; the violet red, red-violet and violet being the dominant hues. These three do need a little space, to this end they were often presented as separate areas of color in early religious paintings.

In this example, the quite definite areas of violet-red and red-violet in the clothing is offset by the desaturated violet of the tree trunks and stones. Being based on violet, a hue not to everyone's taste, this combination has not enjoyed widespread popularity.

Violet-red, red-violet and violet

The mixing partner, or complementary of violet-red is a *yellow-green*, that of red-violet is a *green-yellow*.

Violet can be desaturated with either type of yellow, (green-yellow or orange-yellow). White, of course, can be used to desaturate any of the mixes. As mentioned, various methods will be used to produce the colors shown in the swatches. They will not necessarily be mixed with their complementary.

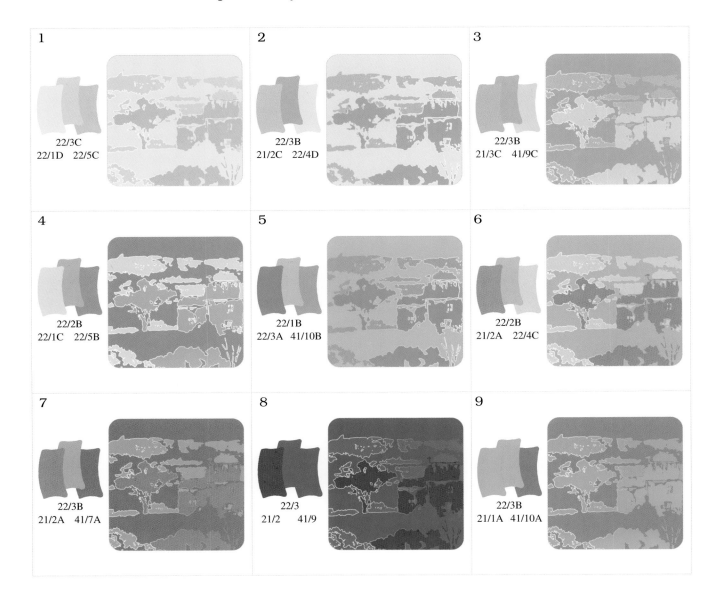

1	2	3
22/3C 22/1D 22/5C	22/3B 21/2C 22/4D	22/3B 21/3C 41/9C
4	5	6
22/2B 22/1C 22/5B	22/1B 22/3A 41/10B	22/2B 21/2A 22/4C
7	8	9
22/3B 21/2A 41/7A	22/3 21/2 41/9	22/3B 21/1A 41/10A

The great cost of violet dyes in antiquity led to the color being decreed suitable only for the elite. It has been associated with royalty ever since. Having much in common, the range of colors from violet red to violet can be harmonised quite easily. (For those who relate well to violet that is).

The brighter, saturated colors need to be used with some caution if you are seeking harmony.

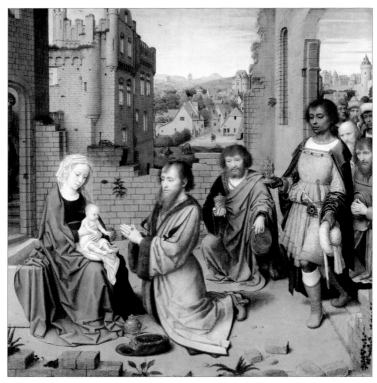

The Adoration of the Kings , 1515-23, Gerard David
© National Gallery, London

Perhaps for use as small color harmony 'side shows' in a painting, these three are seldom called upon to provide the entire range. As in this example, they are applied as quite separate areas of color surrounded by more neutral 'colored grays'.

Blue-violet, in the form of genuine Ultramarine Blue seems to have been almost a requirement of earlier Christian paintings. This is almost certainly to do with the fact that the pigment was extremely expensive. At one time worth more than gold by weight.

This factor allowed the Church to display its wealth; 'Hey look, we can afford to pay for Ultramarine Blue'.

Because of the high cost of the pigment it was seldom adulterated through mixing and usually appeared as an isolated area of rich color. Violet, the color of majesty, made the ideal companion.

Red-violet, violet and blue-violet

To darken a red-violet add a little green-yellow, the violet can be desaturated with either the green-yellow or the orange-yellow and the blue-violet will darken down with orange-yellow. White can be added to any of the mixes to create either tints (lighter colors) or tones (light grayed colors).

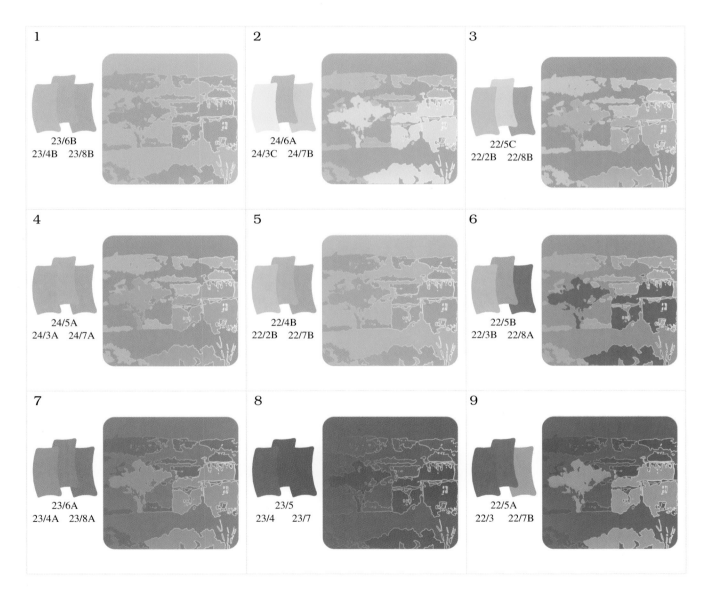

1

23/6B
23/4B 23/8B

2

24/6A
24/3C 24/7B

3

22/5C
22/2B 22/8B

4

24/5A
24/3A 24/7A

5

22/4B
22/2B 22/7B

6

22/5B
22/3B 22/8A

7

23/6A
23/4A 23/8A

8

23/5
23/4 23/7

9

22/5A
22/3 22/7B

The central violet is particularly effective at holding its neighbours together. They unify readily, particularly when made lighter (2 & 3) or darker as in 7 & 8.

As one color is made quite a lot lighter than the others, as in (9), harmony can start to diminish at the gain of the contrast of light and dark. The overall effect starts to 'cool' slightly as the blue violet is introduced to its 'warmer' partners.

This very slight contrast in temperature can add a subtle interest.

Red-violet, violet and blue-violet

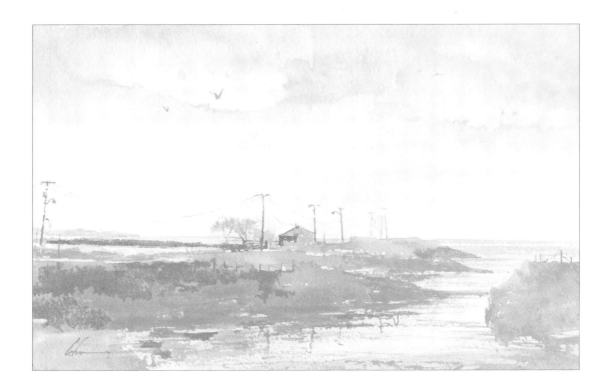

Color swatch No. 1 on the previous page might not look a particularly good starting point for a piece of work. But when it is broadened by the addition of white to create further tints, its potential can start to be realised.

The white can be added in the form of paint or by allowing a light background to show through.

23/6B
23/4B 23/8B

Very important note

Please accept that the swatches shown throughout the book are offered as possible *starting points*. Some could be used as they stand but most will require further modification to be viable for many types of work. If selecting a particular color swatch for a piece of work, use it only to gauge the 'mood' or the 'essence' of part or all of the final piece. Once the basic colors suggested are produced on the palette many will need to be made lighter or darker to give a wider range. This is where your skill, as the artist, comes in. I might be able to suggest a few 'chords', it is up to you to make the music.

As mentioned, the swatches should be regarded as starting points only. They are necessarily static and can only offer the basic hues, not their further intermixing.

If using one of the swatches as a base, most artists will mix the colors further, often making them lighter. Most importantly, many will introduce small areas of white.

This might be done by allowing the white of the background to show through or by applying touches of white paint.

To give an indication of how the base colors will appear with this influence, white has been used to separate the colors in the first half of each swatch, from right to left.

The outlines diminish gradually, allowing for the basic hues to be seen with and without white.

A change in background color

24/6
24/7B 24/4B

24/6B
24/7B 24/4B

24/6D
24/7B 24/4B

The background color can have a vital bearing on whether or not a particular composition might be considered to be harmonious. By changing the color of the larger background area, the 'feeling' of the arrangement can be altered dramatically.

I would suggest that the left hand illustration is reasonably well balanced.>

The differences in value are not too pronounced and add a certain visual interest.

In the centre, the lighter background makes (to my eyes) the composition a little bland.

Contrast is increased in the final diagram, perhaps at the expense of harmony. If the stronger color was used over smaller areas it could perhaps work better. What do you think?

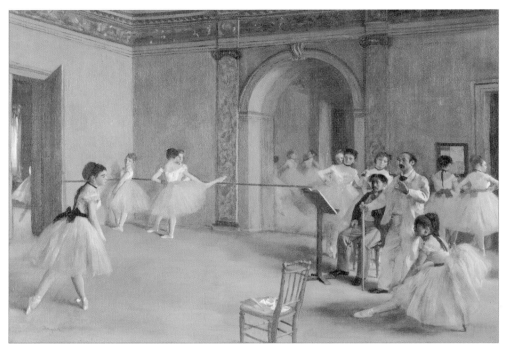

The Dance Foyer at the Opera on the rue Le Peletier, 1872
(oil on canvas) by Edgar Degas (1834-1917)
Musee d'Orsay, Paris, France/Bridgeman Art Library

With additional mixing and manipulation, Quinacridone Violet and Ultramarine Blue will give a solid base on which to work.

As with earlier arrangements centred around violet, these three are also rather limited in application. Used as a 'side show', detail at right, they can be very versatile, but they are limited when it comes to providing the colors for an entire piece of work.

Violet, blue-violet and violet-blue

The mixing partner of the violet is yellow (either the green or the orange-yellow). That of blue-violet is orange-yellow and to darken the violet-blue add a little mid-orange or yellow-orange. The addition of the mixing partner is only one of the ways in which a color can be altered.

1

22/7E
22/5C 22/9C

2

23/8C
23/6A 23/10C

3

23/8A
41/7B 23/10C

4

22/7A
22/5B 22/10B

5

22/8A
22/5C 22/10B

6

22/7A
22/5 22/10C

7

23/9
23/7A 23/10B

8

23/8
23/5 23/10

9

23/8A
23/6B 23/10D

These three hues can give well balanced arrangements which offer a very slight contrast in temperature. As the color arrangements become closer in value, (either all darker or all lighter) they tend to harmonise well but can be rather uninspiring. Interest can be added by working with a variety of values, light to dark, as in swatch 9 above.

Violet, blue-violet and violet-blue

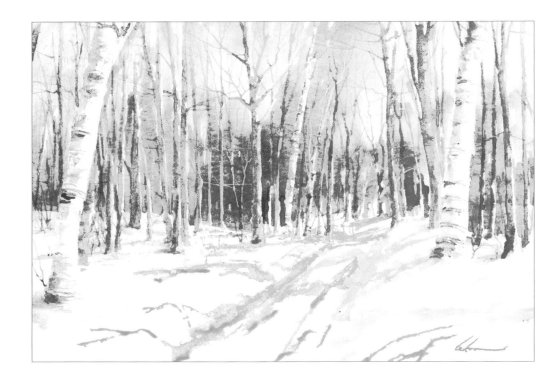

At first sight color swatch No 9 from the previous page might look a rather awkward combination.

As with any color swatch it can be no more than a starting point and should be used as such.

The three colors shown plus their tints were used in the painting above.

23/8A
23/6B 23/10D

Violet, blue-violet and violet-blue

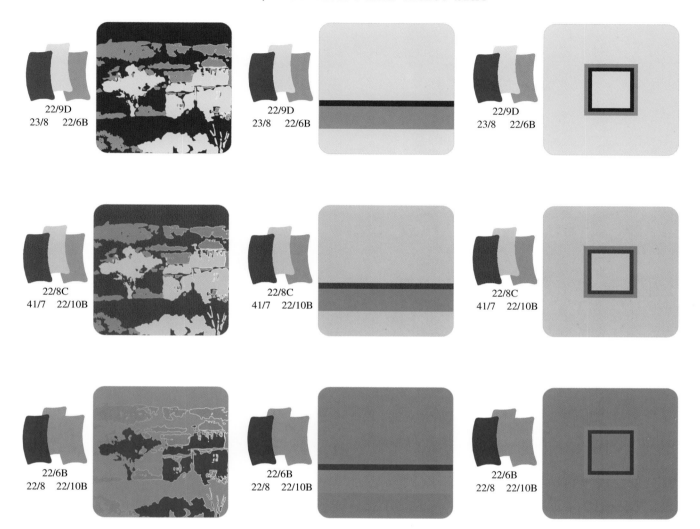

22/9D
23/8 22/6B

22/9D
23/8 22/6B

22/9D
23/8 22/6B

22/8C
41/7 22/10B

22/8C
41/7 22/10B

22/8C
41/7 22/10B

22/6B
22/8 22/10B

22/6B
22/8 22/10B

22/6B
22/8 22/10B

In order to give an indication of the way that certain color arrangements might work together, I have provided the small 'brush stroke' swatches to the left of each diagram.

As you will find, when made into a pattern the same colors can take on a different mood.

These same hues, used in further arrangements, as in the centre and right hand columns, give rise to other visual reactions. The results can be more or might be less harmonious than the original patterns in the left column.

I have shown the above in order to demonstrate that these pages are meant to give no more than very general guidance.

They are intended to show that once the basics of color mixing have been mastered, it is a case of deciding on a certain approach and then juggling areas, saturations and values with pre-determined goals in mind.

It can never, I believe, come down to saying that these two, three or four colors *will* harmonise. That this or that 'system' should be followed. So much depends on the interpretation of the colorist.

This is indeed fortunate as it allows for freedom of expression rather than the restrictions which would be applied if there were such a thing as 'correct' color use.

111

Study for the Wheel of Fortune, c.1870, Burne-Jones
Tullie House Museums and Art Gallery

Not commonly used together, these three basic hues need considerable manipulation if they are not to look too 'heavy'.

In this painting, the artist varied the saturation with white rather than, it would seem, by the addition of the complementary.

Blue-violet, violet-blue and green-blue

To darken the blue-violet add a little orange-yellow. Yellow-orange will darken the violet-blue and a little reddish orange (or a mid orange) will desaturate the green-blue.

White (by either means), into any of the mixes will desaturate the color even further.

1

22/10D
22/8B 44/10C

2

22/10C
22/8B 44/10B

3

22/10C
22/7C 44/9D

4

23/10B
23/8B 44/9A

5

22/10B
22/8B 44/9A

6

22/10C
22/7B 44/9A

7

23/9B
45/8A 44/10A

8

23/8A
45/8 44/09

9

23/10C
23/8B 44/10

The introduction of green-blue will 'calm down' the overall effect of these arrangements when compared to those on page 109. (Green-blue has now been exchanged for violet).

This combination of colors can be very versatile and have many applications.

The stronger, more saturated colors shown with weaker neighbours should ideally be used sparingly.

Perhaps small touches of the saturated color against larger areas of its desaturated neighbours.

Blue-violet, violet-blue and green-blue

When using the color swatches please regard them as no more than starting points. It would obviously be impossible to show all further tints, shades and tones.

The three colors shown to the right (color swatch No 2 from page 113), *plus further tints* were used in the painting above.

I have deliberately selected a wide range of painting styles and skills to illustrate the varying use of color throughout the book.

22/10C
22/8B 44/10B

Can you see how the individual color swatches can be used to give the 'feel' of the final piece, or a segment of it?

The addition of further mixes, tints etc. to the individual swatches would allow them to give a better indication of their potential but would require a huge range of reference mixes. No more than one swatch per page would be possible. This is where the eye and the imagination of the artist must come in to play.

Swatch No 44

Swatch No 22

If you wish to try any of the suggested color arrangements, the Color Mixing Swatches, starting at page 403, will provide guidance to the mixing of the various hues.

The two excerpts above show the colors selected for the example to the right. As you will see, I have only selected a very small number of the potential arrangements, and then only in a random fashion. I have left you, the reader, to decide what you find harmonious or otherwise.

Please remember, these pages are *not* suggestions as to what harmonises. I cannot know what you might find to be pleasant.

44/8

22/6B 22/10B

A variety of people were shown the examples and each was found pleasing by at least one person.

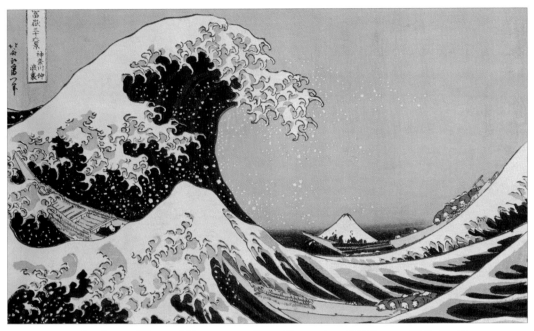

The Great Wave of Kanagawa, from the series '36 Views of Mt. Fuji'
('Fugaku sanjuokkei') pub. by Nishimura Eijudo (woodblock print) by
Katsushika Hokusai (1760-1849)
Private Collection/Bridgeman Art Library

It is difficult with such an old print to be certain of the actual colors that were used.

All of the hues, particularly the green-blue of the boats, might well have been more prominent at the time of printing.

I say this because the color of the support (the paper), appears to have deteriorated over time. This, in turn will alter the printed colors to a certain extent.

Rich violet-blue against green-blue and blue-green were often employed by Japanese artists at this time. It is for this reason that I have chosen to show this particular piece.

So please try to ignore the discoloration of the paper and imagine the inks freshly applied. It is all part of trying to learn from the work of other artists from all parts of the world.

116

Violet-blue, green-blue and blue-green

Violet-blue will darken with a little yellowish orange (or a mid orange). Reddish-orange (or a mid-orange) will desaturate the green-blue and orange-red will darken the blue-green.

White (by either means), into any of the mixes will desaturate the color even further.

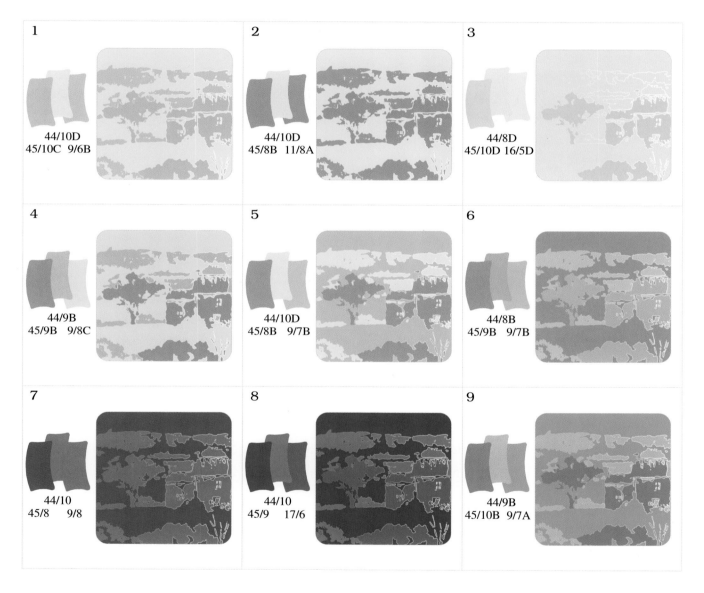

1
44/10D
45/10C 9/6B

2
44/10D
45/8B 11/8A

3
44/8D
45/10D 16/5D

4
44/9B
45/9B 9/8C

5
44/10D
45/8B 9/7B

6
44/8B
45/9B 9/7B

7
44/10
45/8 9/8

8
44/10
45/9 17/6

9
44/9B
45/10B 9/7A

Combinations of violet blue, green blue and blue green are often to be found on early pieces of oriental art. Used with skill they can provide very subtle harmonies of hue.

These particular colors tend to 'sit together' better when all three are softened with white. Stronger combinations have to be used with care as they can look rather 'hard'.

117

Portnoo, Co. Donegal by John Coyle
John Martin of London, London, U.K./Bridgeman Art Library

1.　　　　　　　　2.　　　　　　　　3.

When working with this arrangement, the green-blues (1) can be reduced by red-orange (a type of orange). Orange-red (a type of red) will desaturate blue-green (2.) and either type of red (3), will neutralise the various greens. Each basic color will have its range of colored grays on offer.

This is not to suggest that the mixes shown above have necessarily been used in the painting, as so many variations of these basic hues are available before mixing commences.

A vast range of contributory hues and their mixes can be employed in this approach. The possible combinations are almost endless.

118

Green-blue, blue-green and green

A reddish orange (or a mid-orange) will darken the green-blue and orange-red will darken the blue-green. Use either type of red, the violet-red or the orange-red to desaturate the mid green. White will soften the neutralised colors.

Using the mixing partner, with or without white is, of course, just one way to take a color in a different direction.

1

9/7C
9/10C 9/5B

2

16/6C
16/1D 16/10B

3

9/7C
9/10B 9/4B

4

38/3A
44/8B 21/8B

5

39/2A
44/10C 21/10B

6

11/7B
11/10B 11/5A

7

38/2B
44/9B 21/9B

8

17/7
16/1B 17/10

9

11/8C
11/10A 11/6A

Many describe blue green as a color of conformity. Cool and uncomplicated (as some of us are). These particular three can be harmonised with ease if care is taken with the more saturated colors. The green, in particular, can be difficult when at or near full strength. Soft, cool colors, they can be worked together very well and have many applications.

Green-blue, blue-green and green

Color swatch 2 on the previous page provides limited information in the three 'brush strokes'. The semi-abstract pattern in the box gives further clues as to the potential.

But it is not until the color range is actually broadened through additional tints and used in a piece of work that its value can be realised. And then *only in one* form, that of the particular painting. Countless millions of possible arrangements will still be available.

16/6C
16/1D 16/10B

16/6B
16/9C 16/2C

16/6B
16/9B 16/2C

16/6B
16/9A 16/2C

As has been mentioned, the green can be troublesome in this arrangement if it is close to, or is, fully saturated. This is particularly the case when its companions are desaturated with white, with their mixing partner (the complementary) or their mixing partner plus white.

As the composition above moves from left to right the additional strength of the green can upset the balance.

The Little Bridge, Pontoise, 1875 by Camille Pissarro (1831-1903)
Stadische Kunsthalle, Mannheim, Germany/Bridgeman Art Library

It would appear that the darks of the trees, river bank and underside of the bridge have been mixed from the blue-green and its mixing partner orange-red.

I think that we can be fairly certain that 'outside' darks would not have been used.

We can, I believe, learn from this. So many painters introduce colors such as Paynes Gray, Neutral Tint, various browns and pre-mixed darks into their work when such colors can be mixed from the hues already in the painting.

By deliberately mixing such colored grays from the hues already in use, you are half way to achieving a harmonious composition. Its such an easy step to take, but so effective.

These particular hues can be rather difficult to use over an entire painting and often benefit from the introduction of a close relation, such as the dulled yellow chosen for this painting. The overall theme however, is based on the three hues we are working with here.

Blue-green, green and yellow-green

The various greens require various reds to darken them. Blue-green will desaturate well with its close complementary, an orange-red. For the mid green use either type of red depending on the work in hand. Darken the yellow-green with a violet-red. In these examples the greens have simply been mixed from yellows, blues and Phthalocyanine Green. The only exception being swatch 8, 21/9 where the green was darkened by the addition of a red.

1

11/6C
11/8C 11/4C

2

9/6A
9/8B 9/4A

3

9/6A
9/7B 9/4A

4

16/9B
16/6A 15/4

5

9/5A
9/7A 9/3

6

13/6C
13/9C 13/4A

7

9/6A
9/8 9/4

8

21/9
9/8 9/4

9

20/1D
20/4A 14/5C

Seen by many as an introspective, calming color, green has also been described as suggesting defensiveness, envy, obstinacy and inexperience. (It's how you think really).

When lightened or darkened, these colors are easily worked together. If any are used fully saturated the result can be a little overpowering. To overcome this tendency, use saturated colors in small touches against their desaturated neighbours.

123

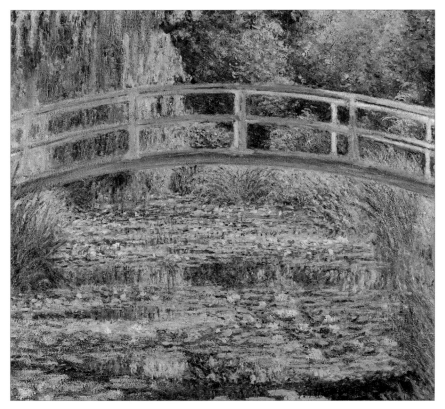

The Water-Lily Pond, 1899, Claude-Oscar Monet
© National Gallery, London

Although other colors are present, such as orange and violet-red, the color scheme is predominantly green, yellow-green and green-yellow. The color mixing swatch to the right offers one possible starting point. Other yellows, blues and greens can be introduced and of course, any of the hues can be desaturated one way or the other.

The work of one of the great colorists, we can learn a great deal by studying the way that one color has been used against the next and the way that all three basic hues are repeated around the painting.

Hansa (Lemon) Yellow and Cerulean Blue. This is just one of the possible starting points when using this approach to color harmony.

124

Green, yellow-green, green-yellow

The general mixing complementary of green is red. Although there will be differences, either type of red will desaturate the green. If you happen to be using a particular red elsewhere in the painting, it should be the one chosen in order to keep the number of colors to a minimum. The red and the desaturated green will also be that much closer, aiding color harmony.

1
14/6E
14/10E 14/1D

2
14/3D
14/7D 14/1D

3
14/3C
14/8D 14/1C

4
14/6B
14/7B 14/1C

5
14/4B
14/9C 14/1B

6
14/4A
14/10B 14/1A

7
14/4A
14/7 14/1A

8
14/5
14/8 14/1A

9
14/3
14/10 14/1

The color of new plant growth, yellow-green is often described as the color of youth. It is also often associated with sickness, so take your pick.

As with all color association, its in the mind of the individual rather than a science.

Together, these three colors can look particularly fresh. They tend to work better when all three are subdued with white rather than darkened or used fully saturated. Use with some caution, particularly the green-yellow as it is not to everyone's liking.

A Favourite Custom, 1909, Alma-Tadema
© Tate, London 2002

A delicate arrangement of soft, calm colors, balanced one against the other with great care.

At strength these three can be difficult to work with. By desaturating the basic hues with their complementary partner and then further desaturating with white they have been made workable.

I never seem to be invited to take part in these customs. Perhaps I should go out more often.

Yellow-green, green-yellow and orange-yellow

If required, desaturate the yellow-green with violet-red, the green-yellow with red-violet and the orange-yellow with blue-violet. Whereas the colors shown here are simple mixes in the main, the orange-yellow (41/2b) swatch 2 has been desaturated slightly by the addition of violet. Although a blue-violet would have been the closer mixing partner, in effect the difference between using violet or blue-violet at this scale is negligeable. Exact practice in color mixing can be rather limiting when it comes to creativity. Once the 'basics' are mastered they can be used or adapted.

1

9/1C
9/3B 12/2C

2

14/1C
14/4B 41/2B

3

9/1B
9/3A 41/3B

4

42/2B
15/4C 12/1A

5

14/1B
14/4C 41/3B

6

9/1B
9/3A 41/3A

7

9/1A
9/4A 41/2B

8

10/1
10/2 41/2

9

13/1
14/3 41/2

The 'cool' yellow-green gives a contrast of temperature against the 'warmer' orange yellow. Depending on how it is used the green-yellow can diminish or neutralise this contrast.

Not everyone finds that the two yellows sit well together. This can be an awkward combination if used without care. The painting opposite does, I feel, show what can be done with these three.

The Golden Stairs, 1880, Burne Jones
© Tate, London 2002

Green-yellow can be desaturated with red-violet or a mid violet.

Orange-yellow can be desaturated with blue-violet or a mid violet.

Yellow-orange is best desaturated with blue-violet.

The three basic hues used in this arrangement can be desaturated with ease, giving neutrals, tints and colored grays.

I have not come across many examples of such extensive use of these three hues. To be balanced successfully they benefit from being desaturated one way or the other, only appearing in a saturated form here and there.

Although other colors are present, they support rather than compete with the overall theme. Many of the darks will have come from the intermixing of the principal hues with their general or close complementary.

128

Green-yellow, orange-yellow and yellow-orange

The green-yellow can be desaturated with white, with the complementary *red-violet*, or with white *and* the complementary.

The mixing partner, or complementary of the orange-yellow is a *blue-violet*, that of yellow-orange is a *violet-blue*. Alternatively, use a mid-violet with both yellows. The differences will be minimal.

1	2	3
29/1B 11/1C 26/3A	26/1C 09/1B 26/5A	28/1B 42/1C 28/3A
4	5	6
41/2 9/1A 26/3B	30/1B 27/1B 30/3B	41/1 27/1B 27/3
7	8	9
41/2 27/1A 26/3A	30/1A 29/1B 30/3A	26/1C 27/1 27/4

Orange-yellow is a cheerful color in many people's eyes.

The 'cooler' green-yellow can have a slightly disruptive influence on the 'warmer' colors. It might be better to restrict its use somewhat.

When set against the orange-yellow, in particular, it can look rather awkward. It is one of the few color pairings that many find unpleasant. In order to allow them to be worked together the saturation of one or both might need to be lowered, either with white, with the complementary or with both.

Poster for the Royal Mail Line, 1839-1924
by Austin Cooper (1890-1964)
Private Collection/Bridgeman Art Library

1. 2. 3.

Orange-yellow (a type of yellow), can be desaturated with blue-violet or with violet. In either case a range of neutralised orange-yellows and deep colored grays will emerge.

Yellow-orange (a type of orange), can be reduced with violet-blue and the orange can be matched with either type of blue.

I feel that a green-blue such as Cerulean Blue has been used to desaturate the orange in the work. Not only are the neutralised oranges and colored grays available from such a mix, but a thin strip of green-blue similar to Cerulean Blue appears in the design.

At full saturation these hues could be overpowering. When softened, as above, they can be encouraged to work very well together.

Orange-yellow, yellow-orange and orange

Desaturated with white, with the complementary or with white *and* the complementary. For orange-yellow add blue-violet, for the yellow-orange mix in a little violet-blue and for orange add either type of blue.

1
26/4C
12/1D 26/6C

2
27/4D
28/1B 45/3B

3
28/3B
41/1C 45/1C

4
26/2A
41/2B 26/5B

5
30/2C
28/1B 27/6A

6
26/3A
26/1B 26/7B

7
29/2C
18/1C 28/4A

8
30/2A
26/1B 45/1

9
30/2A
41/2A 44/1

Warm 'sunny' colors, they can have an enlivening effect in many settings. A note of caution: fully saturated orange can tend to dominate the other two hues unless used with some caution. Smaller touches can work well or alternatively, try reducing the saturation by one means or another. When made lighter or darker it tends to be more acceptable.

Greek Warriors: Early Greek pottery

Although the early Greeks invented many brightly colored pigments, such as Vermilion, we do not have any examples of their work utilising such colorants. As far as I am aware, not one example of a panel painting has survived.

What we do have are many examples of their colored pottery.

In the piece above, three hues which can be difficult to work together have been very well handled. Notice how each individual color is repeated around the work.

132

Yellow-orange, orange and red-orange

Yellow-orange can be reduced in intensity (desaturated) with violet-blue, with or without white. Orange with either the green-blue or the violet-blue and red-orange with green-blue.

1
29/5B
29/3C 29/6C

2
27/5C
27/3C 27/8C

3
26/5B
26/3D 26/7B

4
28/4C
28/3B 28/5B

5
26/6A
26/4B 26/8B

6
27/5B
27/3A 27/8B

7
26/5A
26/3A 26/8A

8
27/6
27/3 44/2

9
26/5
26/3 26/8

Many people react poorly to bright orange, it is one of the least popular colors. Therefore it is advisable to use it sparingly. When desaturated by any means, however, it has an important role to play.

Desaturated colors, even when taken to an extreme can still be of great value. For example, the orange in this instance could be made extremely pale and used over large areas. Or, alternatively, made very dark. In which case it could still be used over large areas but smaller touches might be preferable.

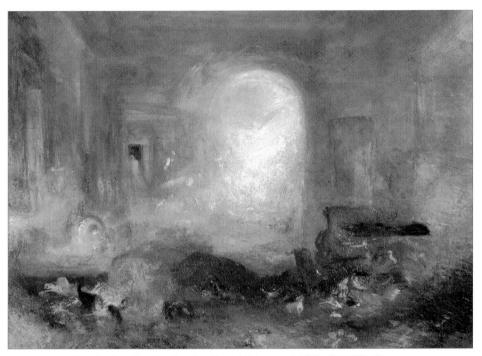

Study for the Sack of a Great House, 1830, J.M.W. Turner
© Tate, London 2002

Three rather difficult hues to work with, particularly over large areas of a painting.

Turner, that great painter of light, was able to about get away with it, just, (as far as color harmony is concerned), by greatly desaturating all three hues.

When made very pale these colors can be worked together but the introduction of further hues can often help.

This combination is perhaps more of value in smaller areas of a painting, rather than for overall use.

134

Orange, red-orange and orange-red

The orange can be desaturated in various ways; with white, with either type of blue, or with white *and* either blue.

To desaturate red-orange either add green-blue or white, or both at the same time.

The complementary of the orange-red is a blue-green.

1
26/6D
27/8C 27/10C

2
27/9D
27/5D 27/10E

3
30/8D
44/3D 30/10D

4
30/9C
30/5C 38/9D

5
30/7C
45/2A 38/8B

6
26/8B
26/5A 26/10B

7
26/8A
26/5C 35/9

8
30/8B
26/5A 38/7A

9
26/8
44/2A 26/10C

The ranges available from orange to orange-red are the 'warmest' of the palette. When used at full strength (or fully saturated), these colors are often employed more as accents rather than over larger areas. They can be very powerful unless moderated.

The Beheading of Saint John the Baptist, 1869, Puvis de Chavannes
© National Gallery, London

*Orange-yellow (Cadmium Yellow Light)
and orange-red (Cadmium Red Light).*

*Orange-red (Cadmium Red Light) and
violet-red (Quinacridone Violet).*

As red-orange is made lighter, (circled above) it moves to the color shown throughout this painting; the flesh of the figure on the left, the legs of the kneeling figure etc. It is also worked into the background.

Orange-red appears very strongly in the cloak and is noticeable in the mixes of the tree behind the central figure and, in particular, behind the figure to the left; who looks as if he could be dangerous.

Touches of violet-red appear in the cloak and in the clothing of the figure behind the cloak. It also used, in a weakened form, in the headdress of the executioner and in his clothing and, very delicately applied, in the torso of the central figure. (As circled above). These three hues can be difficult to work together without the benefit of a neutral background, such as this. By their repetition around the painting they help to hold it all together.

Red-orange, orange-red and violet-red

Desaturate the red-orange with white, with the complementary *green-blue*, or with white *and* the complementary green-blue.

The mixing partner of the orange-red-red is a *blue-green*, and that of violet-red a *yellow-green*. The mixing swatches starting on page 403 will give guidance on the mixing of the colors used in the following random examples.

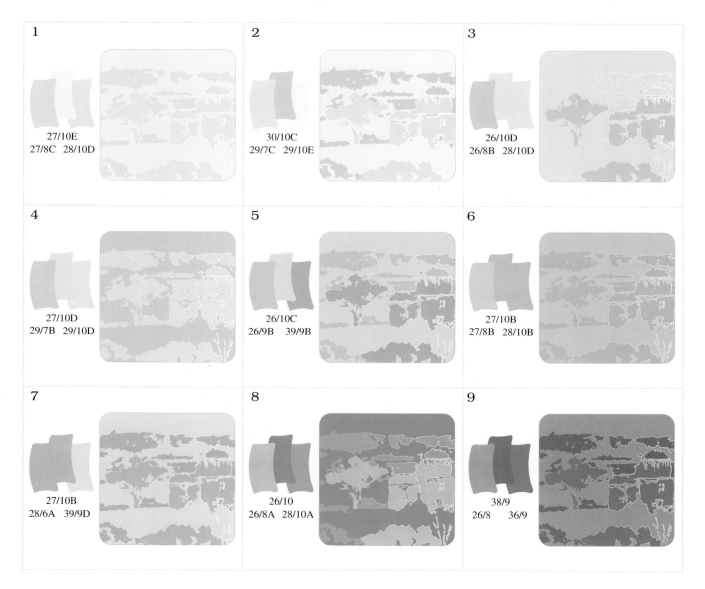

1

27/10E
27/8C 28/10D

2

30/10C
29/7C 29/10E

3

26/10D
26/8B 28/10D

4

27/10D
29/7B 29/10D

5

26/10C
26/9B 39/9B

6

27/10B
27/8B 28/10B

7

27/10B
28/6A 39/9D

8

26/10
26/8A 28/10A

9

38/9
26/8 36/9

As the 'cooler' violet-red is introduced an element of 'temperature' contrast can add further interest, particularly if the hue is not too strong. These three colors tend to harmonise better when desaturated with white or with white and the complementary.

When simply darkened or used at full strength they do not always work so well together. Orange-red and violet-red together can be difficult as they tend to look awkward side by side. When separated by a neutral color, as in the painting to the left, they are more flexible.

Introduction

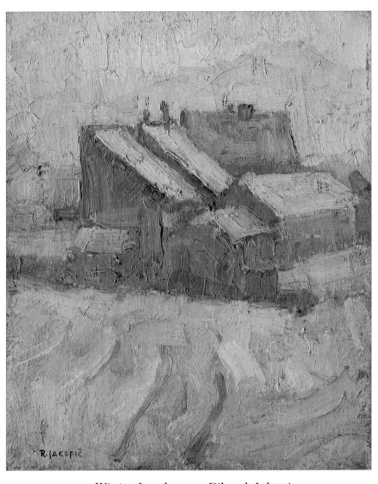

Winter Landscape, Rihard Jakopic
The National Gallery, Ljubljana, Slovenia

As we have seen, up to *four* neighbouring colors on the color wheel that we are using can be harmonised with a little care.

This range can be extended up to *seven*, as shown above, but extra care needs to be taken in balancing the arrangement.

A word of caution. What I am describing is a fairly common approach, the use of neighbouring colors on the color wheel.

However, it depends very much on the wheel that is in use.

Many color wheels employ *twelve* colors, the primaries, secondaries and tertiaries, whereas we are using *twenty four* (plus the secondaries), for greater subtlety.

Seven colors on the conventional twelve color wheel does not leave very much out and would certainly be difficult to harmonise.

When using such a wheel, around five colors would normally be suggested as a wider family group.

Although up to seven colors at a time are shown on the color wheel that we are using in this book, in practice five to six colors are often easier to manage.

Whatever number you choose, it is best to work on the various levels of saturation, either making colors lighter or darker. At full strength such combinations can be difficult to harmonise.

Blue green, yellow-green and orange-yellow. As featured on the following page.

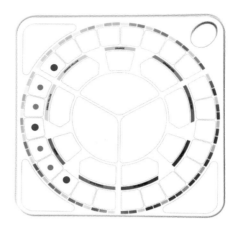

For the sake of clarity, the color swatches on the following pages show just *three* of the possible colors which can be employed in 'wider family' arrangements. >

The 'missing' colors •(as far as the following color swatches are concerned), can also be used in a composition based on this approach. In practice, if using any of the following swatches as a base, many 'missing' hues will occur naturally, through mixing, as you work.

In the limited space available I can only shown a few of the possible combinations available. As we are working with any seven adjacent colors, and varying the number from five to the full seven, a vast range of possibilities exist, as hinted at above.

The purpose of the color swatches on the following pages is to give general guidance only.

You might find that one of the arrangements shown above might suit your requirements, or any of the other possible combinations.

Sally Douglas, Leaves

Similar colors to those used by the artist can be mixed with ease by bringing in the complementary of each basic hue. I say 'similar' deliberately, because, as with all of the paintings shown, I have not attempted to find or produce the *exact* mixing swatch.

Flexibility is lost as soon as we try to match up colors to this degree. What would be the point?

Its knowing where to start that is important, then the final leaning of a mixed color can be adjusted as the artist sees fit.

Blue green, yellow-green and orange-yellow

The mixing partners of these three hues are: For blue-green an orange red, for yellow-green a violet-red and for orange-yellow a blue-violet.

1 9/3A 9/7D 11/1C	**2** 11/4C 11/7C 11/1D	**3** 11/3B 11/8C 11/1C
4 11/4A 11/7B 11/1B	**5** 11/3A 11/7B 41/2B	**6** 12/4A 12/1B 12/7D
7 11/4 11/7 11/1	**8** 9/3 9/7 11/1A	**9** 12/4 12/7 12/1

The 'warm' orange-yellow will contrast with its 'cooler' partners. This change in 'temperature', together with a change in character can create a strong contrast. This need not upset harmony but could limit the use of the yellow at full saturation.

141

The Death of Marat, 1793 (oil on canvas) by Jacques
Louis David (1748-1825)
Musees Royaux des Beaux-Arts de Belgique, Brussels,
Belgium/Bridgeman Art Library

Yellow-green has often been used to depict ill health - and you don't get much iller than this!
Difficult hues to place together, these three are more often to be found in early religious paintings where a similar scene to the above is depicted. They have often been used to set a particular mood, usually based around the yellow-green.

Yellow-green, orange-yellow and orange

The mixing partners, which will desaturate the base hues, are found opposite each on the color coded mixing palette or on a full color wheel. In this case they are:

Yellow-green/violet-red; orange-yellow/blue-violet and orange/either type of blue.

1
11/1D
9/3A 28/3A

2
12/1B
13/4C 26/5D

3
30/1D
13/3B 30/5C

4
11/1B
9/2C 26/5A

5
12/1B
12/4A 45/2A

6
11/1B
13/4A 26/5B

7
41/3A
9/3 26/6

8
41/2B
12/4A 45/5A

9
41/2B
11/3A 45/2A

The rather powerful orange can cause discord unless it is reduced with white, desaturated with its mixing partner or with white and the partner. I would suggest that you use fully saturated orange with caution as many dislike it. Harmony can be achieved using these three basic hues, but each needs to be modified or used in very small touches.

143

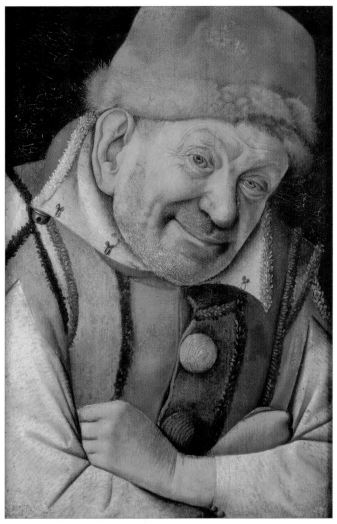

Gonnella, The Ferrara Court Jester, c1445 (panel)
by Jean Fouquet (c.1420-80)
Kunsthistorisches Museum, Vienna, Austria
Bridgeman Art Library

With a little further modification, similar colors to those used in this painting can be obtained by desaturating the base hues with the complementary and/or white.

The bluish green might well have been used to reduce the intensity of the orange-red before being employed itself. Although blue-green is present, the 'warmer' colors dominate.

144

Orange-yellow, orange and orange-red

Desaturate orange-yellow with blue-violet (or a mid-violet), the orange with either type of blue and the orange-red with a blue-green. Add white with or without the complementary.

1
26/6D
20/1E 26/10D

2
44/3C
26/1D 38/7C

3
26/5B
12/1C 26/10C

4
30/5C
41/3C 30/10D

5
30/5C
41/4D 38/8C

6
26/6B
41/4C 26/10B

7
44/3A
41/2A 26/10A

8
44/2
41/2 38/9

9
45/2A
26/1 26/10A

Used at near full strength these hues will give a definite feeling of warmth. If you are seeking harmony rather than contrast you will need to reduce intensities.

Adding white to the saturated color, the neu-tralised versions or the colored grays will not only make them lighter and duller, but also slightly 'cooler'.

Some bright, striking color combinations are available from these base hues.

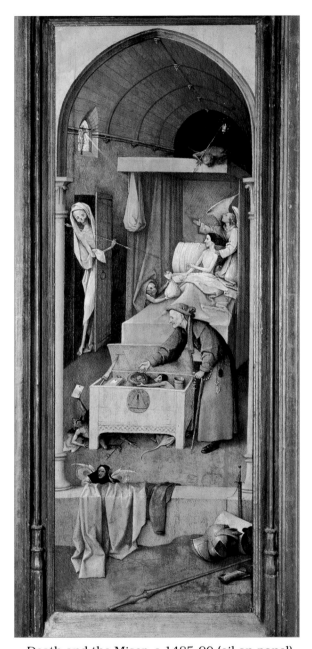

Death and the Miser, c.1485-90 (oil on panel)
by Hieronymous Bosch (c.1450-1516)
Kress Collection, Washington D.C., USA/Bridgeman Art Library

Where potentially bright hues such as these three are used together, it often pays to offset them against desaturated (darkened or lightened) versions of themselves.

This was a common practice in Medieval times. A liking for bright, strong colors is evident in much work from this period of European art.

Orange, orange-red and red-violet

Desaturate orange with either type of blue, orange-red with blue-green and red-violet with green-yellow. White will further desaturate.

1
26/10D
26/5C 24/3C

2
27/10C
27/5C 24/4C

3
27/10C
27/6C 24/3B

4
27/10B
27/6B 22/2B

5
30/10A
30/7C 22/3C

6
23/1B
28/4A 23/4A

7
26/10C
26/6 22/3

8
26/10
26/6 22/2

9
30/10B
30/6 23/4

Desaturate one way or the other and you can produce some very unusual and interesting combinations from these three basic hues.

If anything, the red-violet should be modified or used in small touches rather than over larger areas.

Sleeping Couple, 1997 (oil on canvas) by Julie Held
Private Collection/Bridgeman Art Library

1.

2.

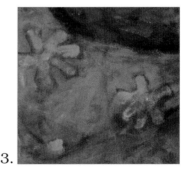
3.

I have shown this painting to various artists. Reaction to the use of color has varied from 'no, I don't like that very much' to 'fantastic'.

I mention this to illustrate the fact that color is an entirely subjective matter. There is no such thing as 'correct' color use.

This does not prevent us from learning via the work of others and then making our own decisions,

The following tips can, I feel, be picked up from this painting:

1. Where the orange-red is applied in a reasonably saturated form, it has been separated from the red-violet by an area of desaturated color. This is possibly because the two hues do not always sit well together.

2. The pattern is formed with a tint of the background color.

3. Touches of orange-red have been intermingled throughout the blue-violet area. Such repeated color helps to hold a painting together.

Orange-red, red-violet and blue-violet

The orange-red can be desaturated with blue-green, red-violet with green-yellow and the blue violet with orange-yellow. Add white as required to the already desaturated hues or when fully saturated. There are of course, many other ways to alter a color. Where the hues are all taken from just one mixing swatch, as in No 2, they are not only easier to work with, coming from just two mixing colors, but tend to sit together very well. An aid towards color harmony.

1

24/3C
25/1E 22/6D

2

23/4B
23/1C 23/8C

3

22/2C
23/1C 22/8C

4

24/3B
38/9B 23/7B

5

22/3B
38/9B 22/7B

6

24/3A
38/9A 24/7A

7

22/2
23/1A 22/7A

8

22/2A
38/9 23/8A

9

22/3
23/1A 22/6

Color groupings which include 'warm' hues such as orange-red and 'cool' colors can be difficult to work together due to 'temperature' contrasts. The contrast of 'temperature can be modified by reducing the intensities of one or all colors by desaturating one way or the other. Used with care these combinations can be very effective.

April Love, 1855-56, Hughes
© Tate, London 2002

Although these three basic hues can be balanced one against the other to give very pleasing results, I have found few examples of their use together.

This is possibly because they can be rather "heavy going' when used without the support of other colors. But when so supported (as above), and used more as a 'side show' they can be very versatile.

Notice how the rich, sumptuous combination of red-violet and blue-violet, at the bottom of the skirt, have been separated from the equally rich, saturated greens of the foliage.

They might have been a little 'too much' had they been placed close together.

In fact, the entire area of rich color in the skirt has been surrounded with neutralised hues. A valuable lesson.

Red-violet, blue-violet and green-blue

The complementary partner will always be found on the opposite side of the mixing palette. For red-violet select a green-yellow, desaturate blue-violet with an orange-yellow and use red-orange to reduce the strength of green-blue. Add white to further reduce. Again, where all selected colors are found on the one mixing swatch, as in Nos 6 & 9, they are easier to work with (just two colors on the palette) and relatively easy to harmonise.

1

24/8C
24/3E 24/10D

2

22/7E
22/2D 11/10C

3

23/8D
22/3D 46/3E

4

22/9C
24/3C 11/10D

5

22/8C
24/2B 20/10D

6

24/8C
24/4B 24/9B

7

22/07C
22/4B 44/10B

8

22/8B
22/3C 20/8B

9

24/8B
24/3A 24/10C

The red-violet which earlier was 'cool' against the orange-red, now becomes 'warm' when compared to the green-blue. Blue-violet makes an excellent modifier.

These three hues can be worked together very satisfactorily, particularly when desaturated further with white.

When lightened (made into tints), such hues can be used over large areas, the lighter the larger.

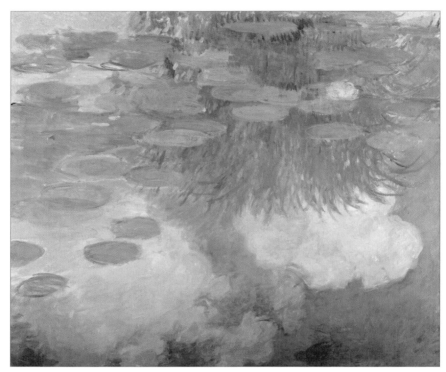

Waterlilies, 1914-17 (oil on canvas) by Claude Monet (1840-1926)
Musee Marmottan, Paris, France/Bridgeman Art Library

When selecting the paintings to use in this book, I did not try to find examples depicting *only* the colors under scrutiny, because that would be too restricting. It would not allow for the fact that it is the overall theme that is important.

In the painting above, the touches of 'warm' color in the reflected clouds do not alter the 'color mood' of the piece.

In fact, as with all of the color combinations suggested, please take it that they can be used either for passages in a painting or for the entire work. Several quite different color schemes can be used in the one piece.

I used to look at paintings by great colorists such as Monet and think, 'It isn't fair, how could they use color in such an amazing way? It shouldn't be allowed when I haven't a clue where to even start'.

But you know, when you have a basic understanding of color and can *follow the thinking* of such artists, it opens the door for similar color work. As you will find.

Just as you cannot learn how to play a piano by simply watching a pianist at work, so you cannot use color in an advanced way by simply looking at paintings. It's quite different when you know what is going on.

Blue-violet, green-blue and green

To desaturate the blue-violet add orange-yellow, for the green-blue mix in a little red-orange and to desaturate the green add either type of red. The swatch pages you will give guidance on the mixing of the colors used in the examples.

Very pale combinations such as No. 2 are unsuitable to depict objects (see page 86) but can be invaluable when depicting the shifting properties of light.

1
09/10D
22/8D 9/5C

2
11/10D
23/8D 11/5D

3
13/10D
24/8B 13/5D

4
13/10C
23/8C 13/6C

5
11/10C
22/7D 11/5B

6
16/3C
22/7B 16/7D

7
24/10
24/8 21/10A

8
44/9
22/9B 33/9

9
9/10
22/8 9/5

As all three colors come from the 'cool' area of the color wheel they can be harmonised with ease. The blue-violet could be considered to be the 'odd one out' as the other two hues are based on green. As such it should be used sparingly, especially at full strength.

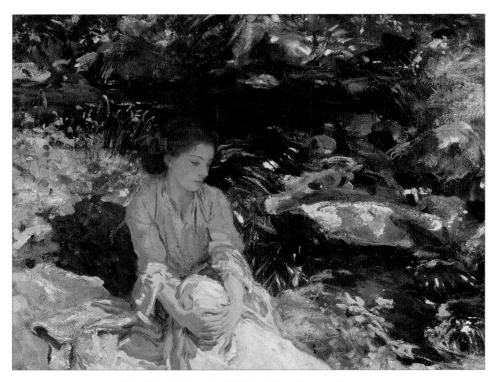

The Black Brook, 1908, John Singer Sargent
© Tate, London 2002

The three central hues, used in a much subdued form, have been worked together in the young lady's clothing.

These same colors, applied in a slightly brighter form (but still all together), have then been repeated throughout the painting.

This approach is, I believe, a vital element to consider when trying to encourage color harmony within a painting. It is to be seen almost everywhere in nature.

A hedgerow might appear to be simply green at first, then touches of dull red might be observed, but they will usually be repeated over the entire area.

The light reflected from leaves will be a common theme as will poppies in a field, the sparkle in water, reflected blue from the sky. And so I could go on. Most scenes in nature are based on very few basic hues but a myriad of saturations, repeats and reflections.

Green-blue, green and green-yellow

The mixing partner of the green-blue is red-orange. To desaturate the green use either type of red and for the green-yellow mix in a little red-violet to desaturate. As already mentioned, it can be useful to obtain all three color types from the one mixing swatch. This could have been the case in No. 4 but I wanted the green-yellow to be dulled slightly. This was achieved with a touch of violet. Red-violet would have been the closer mixing partner but the results would have been virtually the same. Violet or red-violet, both will dull a green-yellow.

1
9/6C
9/10C 9/1D

2
14/7D
46/2D 42/2C

3
32/10C
44/9D 10/1C

4
9/5D
9/10B 42/2B

5
21/7C
46/2B 10/1B

6
14/10A
46/2B 42/3B

7
14/10B
46/2B 42/3A

8
21/9B
46/3B 42/3B

9
9/5
9/10 9/1B

Unless modified by being considerably lightened or darkened, the green-yellow can be unsettling to its partners. An 'acidic' color, it should be used with caution when set against these particular hues.

A strong light/dark contrast is easily set up, as in No. 9. Such contrasts can move a composition away from harmony but often have their own attraction. The contrast could be reduced by darkening the green-yellow.

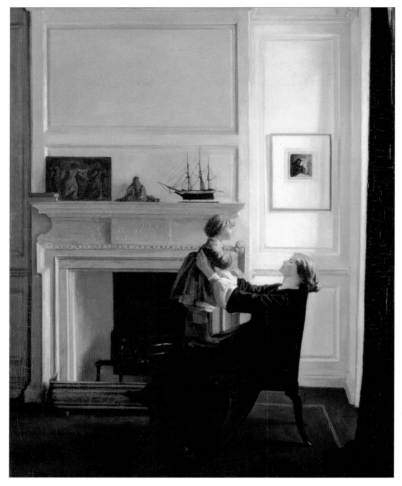

Mother and Child, 1903, Sir William Rothenstein
© Tate, London 2002

This combination occurs frequently in nature and can give pleasing results when used with care.

Without a doubt these hues can look rather awkward together when used at strength, but they all reduce well, particularly with white.

The slight temperature contrast between the 'cool' green and green-yellow and the 'warmer' yellow-orange can add a subtle interest.

Although other colors appear in the painting above, the main theme is that under discussion.

Green, green-yellow and yellow-orange

The green can be desaturated with white, with either type of red or with white *and* either red. The complementary of the green-yellow is a *red-violet*, that of the yellow-orange a *violet-blue*.

Some of the contrasts, such as between the green-yellow and the yellow-orange in No. 3 might be very slight but they can bring a 'mysterious' subtlety to a piece.

1
9/1E
9/5B 27/4C

2
10/1C
10/5B 27/4B

3
14/1D
14/10D 26/4C

4
9/1A
9/5A 26/3B

5
13/1A
13/5A 29/3

6
14/1C
14/9C 28/3A

7
10/1C
10/6 27/4A

8
14/1
14/7 28/3

9
13/1
13/5 29/3A

These particular hues can give very pleasing and unusual harmonies, especially when they are reduced with white. When used at or near full strength they become discordant to many.

When applied with care the green-yellow is able to hold the other two hues together quite well, despite the fact that they are dissimilar in character.

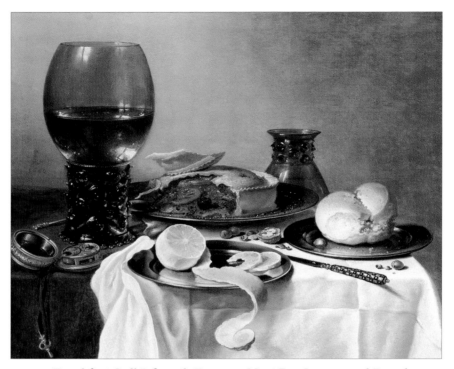

Breakfast Still Life with Roemer, Meat Pie, Lemon and Bread
by Pieter Claesz (1597-1660)
Harold Samuel Collection, Corporation of London,
UK/Bridgeman Art Library

When used together these three are helped by the introduction of other colors. In this case the green works very well as it is only a short step away from the green-yellow.

The red-orange, which could easily have upset the balance had it been applied in a bright form, has been carefully reduced. This has almost certainly been achieved through the addition of its complementary.

When treated with care, as in this painting, these basic hues can be very effective, giving soft contrasts and harmonies.

Green-yellow, yellow-orange and red-orange

To desaturate the green-yellow add a touch of red-violet or white. Alternatively add the red-violet as well as white. Violet-blue will desaturate the yellow-orange, as will white and to reduce the strength of the red-orange add a touch of blue-green and/or white.

1
27/4B
27/1D 27/8C

2
28/3B
42/2E 28/6D

3
29/3A
29/1C 29/7C

4
29/3B
29/1C 29/7B

5
27/4B
27/1D 27/9B

6
28/3A
29/1D 28/5B

7
29/3B
29/1A 29/7A

8
29/4
29/1 29/7

9
27/3
27/1 27/8

Some very subtle arrangements are possible with these hues. The character difference of the 'cool' green-yellow can add an interesting contrast when modified with white and/or its complementary.

As you will see, unless these particular hues are made either lighter of darker they tend to contrast strongly. This contrast can easily upset harmony. If using such hues at strength it will help if they are applied in small 'touches'.

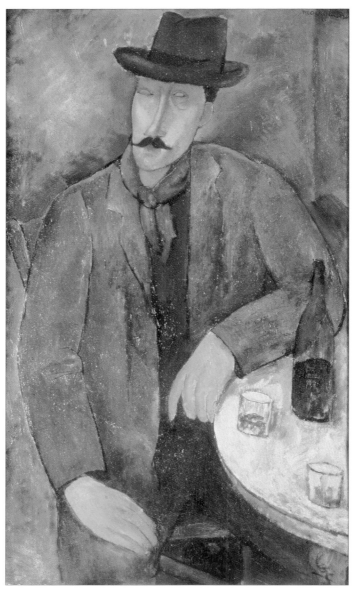

A seated man leaning on a table by Amedeo Modigliani (1884-1920)
Jesi Collection, Milan, Italy/Bridgeman Art Library

Orange-yellow (Cadmium Yellow Light) and
violet-red (Quinacridone Violet).

A touch of an orange-red such as Cadmium Red Light has probably been added to the range shown left.

Instead of the 'warm' orange-yellow a 'cool' yellow such as Hansa or Lemon Yellow could have been used as the starting point.

You will notice that the strong, relatively saturated hues have been set against desaturated versions of themselves. Not of 'outside' colors, but of *themselves*.

160

Yellow-orange, red-orange and violet-red

Violet-blue will desaturate the yellow-orange, green-blue the red-orange and yellow-green will reduce the intensity of the violet-red. As I have mentioned, there are advantages to taking all mixes from just one mixing swatch, as in Nos 2, 3, 5 and 6. Only two colors need be used on the palette (one might have to be pre-mixed), and harmony is easy to achieve. However, this approach is not always possible or desirable. Understand color mixing and keep your options open.

1
27/9C
27/4C 28/10C

2
29/7C
29/4C 29/10C

3
28/6C
28/2C 28/10B

4
26/9B
26/4B 28/10B

5
29/6
29/3 29/10B

6
29/7A
29/3B 29/10

7
29/7
29/4 36/9A

8
27/9
27/4 36/9

9
28/5
28/3 28/10

The violet-red is 'cooler' than its partners, but not dramatically so.

This subtle contrast can add interest as well as harmony when used with care. The contrast of temperature is covered later in the book.

If a color arrangement does not harmonise easily, try using the stronger colors as accents. Small touches here and there. The reduced contrast can add interest and still allow color harmony.

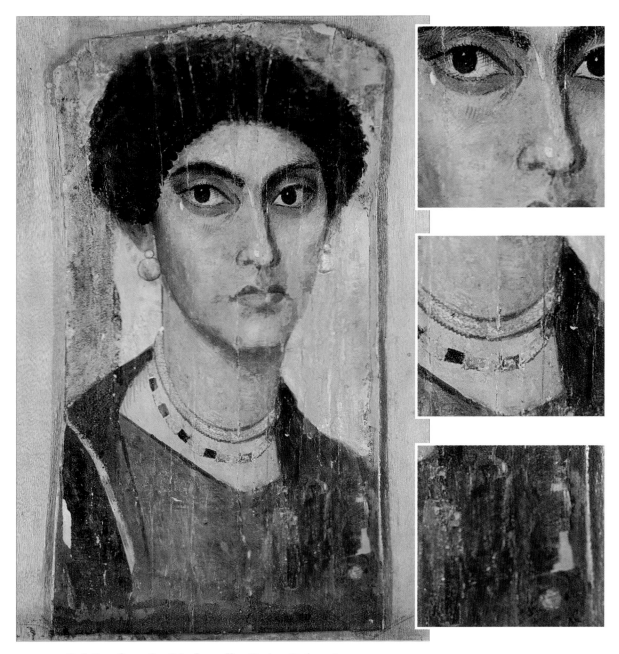

Painting from the lid of a coffin, 2nd or 3rd century.

Encaustic painting, where wax is the binder, as opposed to the gum in watercolor paints or the oil in oil paints was very popular in early times. As the wax did not deteriorate in color, many of these earlier works remained in good condition.

The above painting, from a Roman coffin lid found in Egypt, has kept its color very well.

It does, I feel, show that many of the combinations that we have been examining have been experimented with over the ages and around the world.

Red-orange, violet-red and violet

Note the almost imperceptible difference between the violet-red and the violet in No 3. Such slight shifts in hue, to be found in many an Impressionist painting, can bring a subtle, almost hidden beauty. In practice, a slight touch of a violet-red (such as Quinacridone Violet), into the mixed violet will give the desired result.

1
22/1C
28/6B 22/4D

2
21/2E
26/8B 23/5C

3
22/1C
29/7C 22/4C

4
24/1D
26/8A 24/5A

5
22/1B
26/8B 22/5C

6
21/2B
26/9B 42/7B

7
22/1A
26/9A 22/4A

8
21/2
29/7A 41/7

9
21/2A
30/8 24/5

A strong contrast can be set up between the very 'warm' red-orange and its 'cooler' neighbours. This contrast can impair harmony if care is not taken. By either lightening or darkening the colors, the contrast in saturation can be modified. Alternatively very small touches of the red-orange can be employed to play down the contrast.

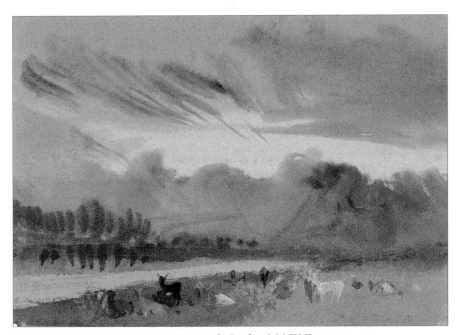

Deer in Petworth Park, J.M.W Turner
The Whitworth Art Gallery, The University of Manchester

*Each of the three basic hues appear to have
been desaturated in two distinct ways.*

Although they certainly offer potential, I have rarely found these three hues used together. In the painting above, all three appear to have been desaturated in two distinct ways.

With the complementary to give darks and with the complementary and white to give the pale, grayed colors. As per the three details above.

Violet-red, violet and violet-blue

To reduce the intensity of the violet-red add a little yellow-green. With violet add either green-yellow or orange-yellow. With violet-blue add a touch of yellow-orange. Add white to such mixes or directly to the original fully saturated hues.

1

41/8B
36/9E 48/4D

2

42/10E
21/1D 22/10D

3

41/10C
36/10E 22/10D

4

41/10D
33/4D 45/10C

5

41/7B
36/8D 45/8C

6

42/7B
21/3C 22/10C

7

22/5B
22/1B 22/10C

8

41/8A
33/4 22/10B

9

41/10A
36/7 48/1B

A subtle contrast is set up via the violet-red which is comparatively 'warm' against its 'cooler' partners. The word 'comparatively' is all important here as violet-red in isolation would not normally be considered a particularly 'warm' color.

These three basic hues can be harmonised successfully unless one or the other is applied too strongly. If anything, the violet should be modified or used in small touches rather than over larger areas.

Newly discovered violet dyes caused an upsurge in the use of violets and mauves during the 1800's. These once very popular hues can add an 'old fashioned' look.

Childe Hassam (1859-1935) The Silver Veil and the
Golden Gate, 1914 (oil on canvas)
Sloan Fund Purchase, Brauer Museum of Art, Valparaiso
University. Photograph © Brauer Museum of Art

A simple but very effective approach. I would imagine that the base colors, violet, violet-blue and the blue-green would have been carefully selected and placed on the palette.

Perhaps a touch of complementary was introduced here and there to initially reduce the colors, but in the main they were desaturated with white.

When a color has been reduced in this way it can be used over comparatively large areas. More so than a saturated color could. (If color harmony is sought, that is).

It is worth making a particular note of the fact that each base color appears in one form or another in every part of the painting. As they might in nature.

166

Violet, violet-blue and blue-green

The violet can be desaturated with white, with the complementary yellow (either type), or with white and the complementary.

The mixing partner of the violet-blue is yellow-orange and that of blue-green, an orange-red.

1
23/10D
23/6C 11/8D

2
45/9D
41/10E 11/7B

3
22/10C
22/4C 09/7C

4
23/10B
23/6B 10/8B

5
22/10B
22/5B 9/7A

6
45/9B
22/5A 13/8B

7
22/10
22/5A 11/8

8
45/8A
41/7 13/8A

9
45/8
41/7A 13/8

Unless the blue-green is reduced in intensity, ideally with white, it can easily dominate its partners. Darkening makes it more workable.

When used with care, these hues can be very effective, giving unusual and attractive arrangements (to many eyes).

If using any of these hues at or near full strength it might be better to apply them in small touches as larger areas can prove rather distracting.

This approach was taken in the work shown on the opposite page.

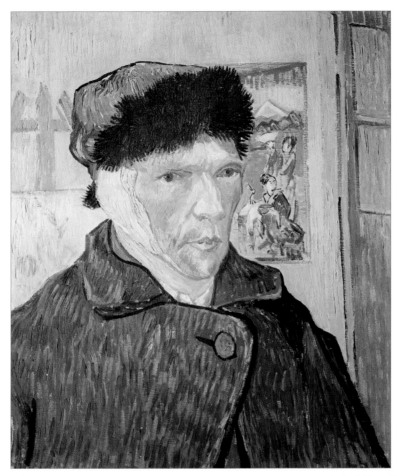

Self Portrait with Bandaged Ear, 1889, Vincent Van Gogh (1853-90)
Courtauld Institute Gallery, Somerset House, London/Bridgeman Art Library

The work of Vincent Van Gogh can, I feel, teach us much about our shifting attitude towards color harmony.

As you will know, he had the greatest difficulty arousing interest in his work, yet nowadays he is greatly admired. As much for his wonderful color work as for anything else.

In his day, it was commonly thought that the dull browns and grays of many an earlier painting showed true beauty. Never mind the bright, sometimes garish colors of Van Gogh.

His life and work should also encourage those who feel that they can only be considered an artist if others wish to purchase their work. Many have expressed this feeling to me.

Notice how the three basic hues are used not only for the main subject but are repeated elsewhere in the painting. A valuable lesson.

This really is a nonsense. I firmly believe that if you think like an artist, you are one.

In fact, painting can sometimes get in the way of this. Now there's one to ponder on. Does a true artist actually need to paint?

Violet-blue, blue-green and yellow-green

Add yellow-orange to reduce the strength of the violet-blue, orange-red for the blue-green and a touch of violet-red with the yellow-green.

1
9/7C
10/10E 9/2D

2
11/7C
10/10C 10/3D

3
11/8C
10/10C 10/4C

4
11/8C
48/3D 9/3B

5
9/9B
12/10C 12/4C

6
10/8C
10/10C 10/3C

7
13/8B
45/9B 13/3B

8
10/8B
45/9A 9/3B

9
13/9B
22/10B 12/4A

Many find that combinations from this area of the color wheel aid introspective activities such as reading and writing.

Although this applies more to interior decorating, a painting or areas of a painting based on certain of these combinations can provide an introspective element. Easily harmonised, these hues find many applications in fine art.

One of the most important factors in determining the colors we perceive is the effect of the visual sensation known as the *after-image.*

There are three types of after-image, successive, positive and negative. *Successive* and *positive* after-images are concerned with the effects of light on the eye, whereas *negative* after-images are concerned with colored surfaces. >

It is the latter that we are interested in. From now on I will refer to negative after-images simply as *after-images.*

The after-image is an optical effect that we must explore fully if we are ever to obtain the most from color, whether seeking color harmony or color contrast.

It is *absolutely vital* that the colorist understands the potential of this phenomenon.

I would like you to stare fixedly at the dot in the centre of the red shape above for about 20 seconds.

Then look at the black dot to the right of the diagram. Do you see anything? If you do, note its shape and color.

It will be the same size and shape as the red area above, but the color will, or should, have changed to a type of green.

Maybe you did not see this effect, or saw it only fleetingly. If so, do not worry, many people have difficulty in seeing after-images at first. Try looking at the red strip a little longer, maybe up to half a minute.

Before looking away, see if there is a bluish green edge appearing around the red. If so,

A pale blue-green 'edge' might appear at one side or the other.

gradually move your line of sight to the right and the entire image should follow.

If you still cannot see it, try making your eyes go slightly out of focus.

Although it may be difficult at first, you will almost certainly be able to 'pick up' the after-image with practice and patience.

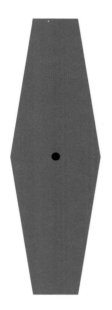

The after-image from the red shape to the left should look something like the above, (given the limitations of conventional color printing).

Why should a pale bluish-green shape appear after the eye has been stimulated by a red area? In general terms, what happened is that the receptors in your eyes which receive and transmit 'red' signals to the brain became fatigued, dulled from exposure to the red.

The 'green' receptors meanwhile had little to do and were fully rested.

When both the 'red' and 'green' systems focused on the white area, the rested 'green' receptors took over, the 'reds' took a break and an image was formed.

I have greatly simplified the reasons for our perception of after-images.

For our purposes, *how* it happens is not as important as the fact that it *does*.

Go back to the red strip on the previous page, concentrate on it and then make a mental note of the properties of the resultant after-image.

Do not concern yourself with the 'type' of green, whether it is bluish or otherwise, that will come later. How else would you describe the sensation?

Do you find that the after-image is 'luminous', 'bright', 'clear', 'glowing'? Almost as if a weak colored light had been shone onto the paper?

Although not as saturated as the stimulating color, being much paler, the after-image is invariably described as being more like a *light* than an area of paint.

It is, in fact, brighter and far more luminous than any paint in use today.

1. Now cover the green shape above with a piece of paper or similar and concentrate on the red for about 20 seconds.

2. Then uncover the green and look from the red to the green.

3. Where the after-image overlaps, about the centre, the green should appear to be far brighter than the rest of the strip.

To understand the reason for this extra intensity of color, think back to the first part of this exercise. The green after-image that we transposed to the right of the page now rests on green ink instead of on a black dot.

In effect you are looking at the green ink *through* a layer of green 'light'. It is not literally light of course, but has a very similar effect.

The result can be compared with painting a wall with a second coat, only here we are over-painting with green 'light'.

The after-image will gradually wear away as the 'red receptors' in the eye overcome their 'fatigue' and start to 'work' again. The green will slowly return to its former strength.

172

The after-image from the green should brighten the centre of the red once visually transferred.

1. Try the experiment the other way around, looking first at the green for a while and then at white paper. What do you see? There should be an after-image of red as the effect is reversed. *It will be a very pale red, more of a pink.* After-images are always very pale versions of the color that they represent.

2. This after-image will brighten the red at around its centre when you look at it. Whenever a red is concentrated upon, a green after-image will result, and vice-versa.

Red and green therefore are a pair of colors with a certain relationship to each other. That relationship is described as being a *complementary* one.

Whenever two colors are paired which give each others after-image they are known as complementary colors.

There are other types of complementary color pairs, those that mix additively (lights) to make white, dots of color that mix additively to make gray (pointillism) and colors that can be mixed subtractively (paints, inks etc.) to give a dark.

For now we will only concern ourselves with after-image pairings which might better be described as *visual complementaries.*

Blue and orange are visual complementaries and can be made to enhance each other. Blue will make orange

Yellow and blue-violet are also visual complementaries and can similarly be made to enhance each other.

The effect of altering a color by first looking at another, as you have just been doing, is known as *successive color contrast.* Successive contrast takes place whenever the eye moves quickly from one color to another.

The effect is not confined to red and green alone. We will now look at the after-images associated with a few other colors. After working through these exercises you will add blue and orange, yellow and blue-violet to red and green as further complementary pairs.

As already established, look first at the color on the left and take the after-image over to the color on the right. The result should be similar to 1a and 2a. Then carry out the exercise in reverse, looking first at the color to the right and taking the after-image to the color on the left.

Please bear in mind that the restrictions of conventional color printing will not allow for accurate illustrations. They are for guidance only. The actual after-images, of course, will appear before you as they are generated via the eye and brain.

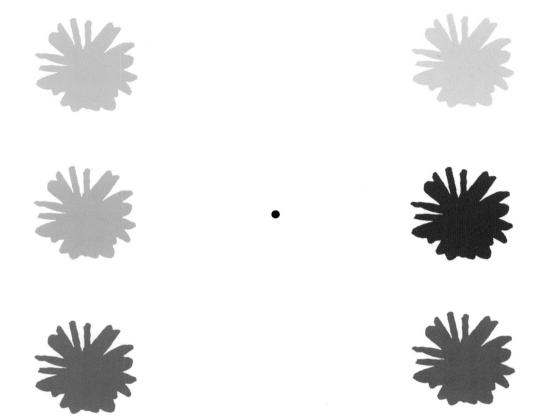

By covering the other 'flowers' and taking the after-image from each to the black dot in the centre, you will see that *all* colors have their own after-image.

We could also say that every time you discover an after-image you are in fact looking at the complementary of the first color.

As you will discover, the after image from this 'flower' is a pale red-orange. This suggests that the rather nondescript colored gray is in fact a dulled (or neutralised) green-blue. The after-image of a green-blue being a red-orange.

This can be a useful way to discover the make up of an otherwise difficult to discern colored gray.

Let's go back to the previous example, the discovery that the colored gray was a darkened green-blue because its after-image was a pale red-orange. Why did the red-orange tell us that the original color was based on a green-blue?

The easiest way to decide on the description of a color's after-image is to write the 'color name' in a different way:

green-blue becomes:

 green
 blue

As the complementary of green is red and that of blue is orange, we can 'fill in the gaps':

 green > red
 blue > orange

So the complementary of a green-blue is red-orange (again, reading downwards).

If it was impossible to decide on the make up of the dark 'colored gray' flower its after-image would tell us all that we needed to know.

As the after-image is a red-orange, it can be written as:

 red
 orange

When the 'gaps' are filled with the complementaries we have:

 red > green
 orange > blue

As the complementary partner of the red-orange after-image is green-blue it tells us that the nondescript base color of the flower is green-blue.

You might need to read this several times until it becomes clear. I had to.

This same approach will tell us that a yellow-green, for example, is the complementary partner of red-violet. As follows:

yellow-green becomes:

 yellow
 green

Which, when completed gives:

 yellow > violet
 green > red

So the complementary of yellow-green is violet-red. You can do this with any color. Just remember the basic pairings:

red/green - blue/orange - yellow/violet

Complementary pairs are found opposite each other on a comprehensive and accurate color wheel and on our mixing palette. With some reservations!

Any color wheel has to be regarded as a fairly rough and ready guide to color arrangements.

For the sake of convenience and the design of the palette, violet is placed opposite yellow, and those two colors are usually described as being complementary. The complementary of yellow, however, is more accurately described as being a *blue*-violet. When working with pigments the yellow/violet approach is more practical and helps to avoid greens when mixing this complementary pair.

1.

2.

3.

We are not confined to working with the after-image of a single color. As you will see in exercise 1 above, a pair of colors will provide a pair of after-images.

As you will notice, being complementaries the after image from the yellow (upper) and violet (lower) become violet (upper) and yellow (lower). It will help if you cover the exercises not 'in use'.

In exercise 2, a group of colors will give a group of after-images. You will probably find that only two or three after-images will appear at first, with the rest following a few moments later.

Number 3 is a little more complicated. With a little practice you will be able to take the entire picture to one side and see it in after-image form, even if it is a little blurry.

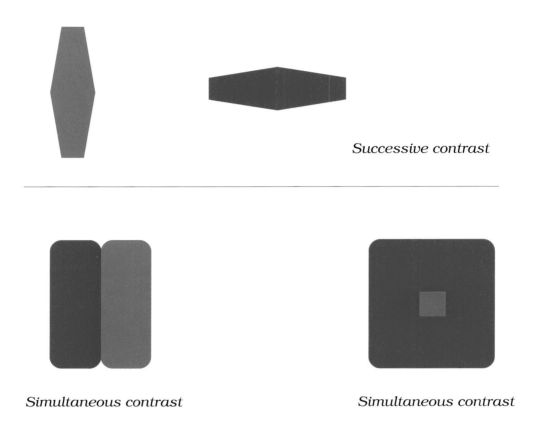

Successive contrast

Simultaneous contrast *Simultaneous contrast*

Altering a color visually by first looking at another (as we have been doing), is known as *successive contrast*.

Whenever colors are presented *side by side*, one colored area close against the other, or a color surrounded by another, the optical effect that they will have on each other is known as *simultaneous contrast*.

Do not let these terms be a concern. I mention this as creative people usually want the practical information, not the technical.

For practical purposes we can consider *successive* and *simultaneous contrast* to be one and the same. In fact, it is more than enough to simply be aware of the after-image and its effect.

Terminology

Although *successive* and *simultaneous* contrast are invariably described as being quite separate phenomenon, they have, in fact, much in common, relying as they do on the effects of after-image and eye movement.

When hues are involved, rather than the full range of colors (which would include black and white) the contrasts are often

described as being *'chromatic simultaneous contrast'*.

The term *'achromatic simultaneous contrast'* refers to the contrast of black-white and gray.

I make mention of these terms as you may well come across reference to them elsewhere. But you can use color successfully without having a clue about them.

The constant flickering of the eye tends to take the after-image from one color to the next. This can set up a strong contrast where one color butts up against another.

In addition to the constant flickering of the eye our focal point tends to wander around the general area, taking after-images with it to influence other colors.

If the eye dwells on the same image for more than a few seconds the receptors become fatigued and the 'picture' fades.

To overcome the tendency towards fading that occurs with a fixed stare, the eye is constantly on the move. New receptors become stimulated by a varying scene, giving a brief rest to those previously at work. This movement is quite rapid, the eye oscillating up to 70 times a second.

These constant movements of the eye are necessary for normal vision. In addition to this activity the eye will tend to wander, 'taking in the scene'.

Even when concentrating on a fixed point there is a tendency to stray away from it.

Successive contrast you will remember occurs when the eye goes from one color to another, even though they might be some distance apart.

In effect the same thing happens with *simultaneous contrast*.

Even though the colors might be butted one against the other, they are contrasted by a combination of after-image and eye movement, the eye flickering across the border taking the after-images from one color to another.

179

1.

2.

Going back to the greenish after-image that resulted from exposure of the eye to red, (page 170), you will recall that when the green after-image was 'taken over' to the green strip, the result was a brighter, almost luminous green.

Brighter in fact than any paint ever can be. Even the brightest paint of the future will surely be enhanced by a layer of colored 'light'.

The painted area in the middle of the strip overlapped by the after-image appeared as a much brighter green. The yellow similarly enhanced the blue violet on page 174.

Now we will see what effect the after-image resulting from the red will have on a color other than green, and the yellow on a hue other than violet.

In exercise 1, impose the after-image from the red (which will be green) onto the yellow.

As you would expect, where the after-image is superimposed upon the yellow, a *yellow-green* results. Green mixed with yellow.

In the reverse sequence the blue-violet after-image from the yellow will affect the red, making it lean towards violet.

After the eye has been stimulated we can either enhance another color, (as earlier with the complementary pairs) or we can alter its character, often to its detriment.

If, as examples, you wished to place a touch of bright yellow in a vital part of a painting, or add a small stroke of bright red, the partners shown above, (if placed close by or surrounding), would change them immediately to new and perhaps unwanted hues. The change would be permanent whilst the influence remained.

The after-image from any color can influence others similarly. It will be worth a few experiments with other combinations.

180

Notice how the red appears to change in the above diagrams:

1. A combination of after-image from the violet-blue (yellow-orange), and eye movement will cause the red to take on an orange-bias.

2. The effect of surrounding the red with orange is probably the most dramatic, as the blue after-image makes the red appear quite dark and out of character.

3. The red will be *enhanced* due to the green.

4. The blue-violet after-image from the yellow will cause the red to move towards red-violet.

5. The after-image from a green-blue is a red-orange. This will have its own influence on the red in the centre.

6. As you look at diagram 6, the yellow after-image will flood over the area of red. Exactly as it would if this were part of a painting.

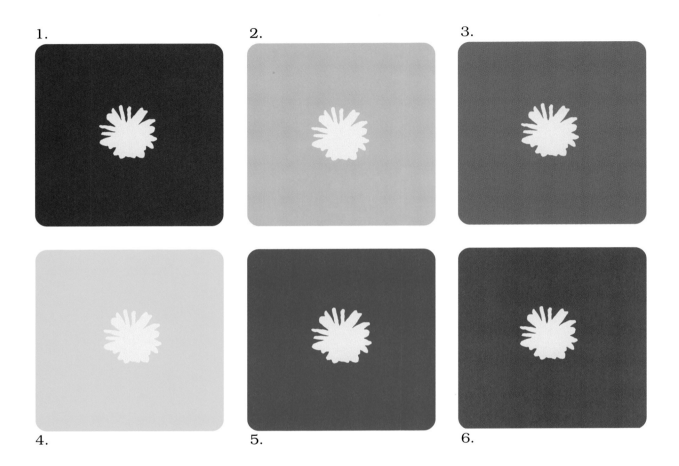

The pale gray centre will appear slightly orange when surrounded by the violet-blue in diagram 1. I think I will leave you to decide the influence of the other surrounding colors.

Any color surrounded by another will move towards the complementary of the outer color. Such movement can be almost unnoticeable, powerful, enhancing or damaging.

It is, I believe, vital for the colorist with an eye to contrast or harmony to have an appreciation of the effect of after-image. Not an in-depth knowledge necessarily, but certainly an awareness.

Very few who use color have this understanding. Those with it, such as yourself, are far ahead of not only most other artists but virtually all professional painters. Many of the latter that I have met feel above all of this.

1.

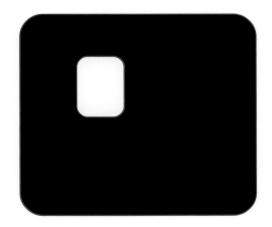

•

2.

Any shape will give an after-image which will be exactly the same size as the influencing color.

•

All colors have their complementary partner, including white and black, (or light and dark).

If you take the after-image from diagram 1 above, to the dot on the right you will, (unless you are experiencing difficulty identifying after-images), see the black and white shapes in reverse. As they give each others after-image, we can identify them as a complementary pair.

The black will appear as a bright white and the white as a dark gray.

The after-image from the white will not be a black because, as with all after-images, it is a paler version of the partner. The uses to which this very important complementary pair can be put are covered in detail from page 349, The Contrast of Light and Dark.

Exercise 2 will also be worth trying.

So far we have only discussed the after image of basic colors. Of further interest and importance is the fact that if a hue is made either lighter or darker, the after-image will be affected.

1. Fully saturated red

2. Red + black (dark)

3. Red + white (light)

Take all three after images to the right of the page to see three different after-images.

1.

In the diagram at the top of the page, the after image from the fully saturated orange-red, will be a blue-green.

2.

When the color is darkened the after-image becomes brighter. This is because the red content gives a blue-green after-image and the black (or dark) content gives a white (or light) after-image. The blue-green mingles with the white to give the bright blue-green.

3.

Intermixing of after-images also takes place when the red is made lighter. The white (or light) content will give a dark after-image which mixes with the blue-green from the red content.

It might take a little practice to see all three after-images together, but when you do so you will notice quite definite differences between the three color-types.

Rather than use the descriptions black or white, it will be more helpful to describe them as dark and light. There are, of course, other ways to darken a color than by the use of black. Colors also become lighter for various reasons, the effect of distance for example.

The light yellow might be surrounded by large areas of the grayed violet or intermingled with it.

Red can look particularly vibrant when surrounded by a dark. A light hue such as yellow will not have this effect.

One of the advantages of this aspect of the after-image is that very dark colors can play a more important role than is generally realised.

Dark colored grays, deep blues and browns etc. can be used over larger areas than saturated colors in most types of work. This makes them very versatile.

If, for example, a small 'touch' of pale yellow was to play an important role in a painting and the intention was to make it as bright as possible, its ideal neighbour would be a *dark violet.*

Violet and yellow, of course, are complementaries. The yellow would be made brighter by surrounding it or placing it alongside violet.

But a bright violet might be very difficult to handle and be unsuitable for the subject. Let's say that it was a beach scene and you wanted to show a light yellow patch of sand.

Bright violet might be impossible to introduce. But if the violet was darkened, even taken to a very dark colored gray, the following benefits would be available:

1. Being desaturated it could be used over a relatively large area. Rocks in shade perhaps?

2. Its after-image would be a bright, light yellow which would enhance the light yellow

paint. In fact, it would make it brighter than the paint would appear if simply applied to a white surface.

3. Rather than use any type of dark, (Paynes Gray for example), the dark colored gray, being based on violet, would lend itself towards color harmony as its partner, the yellow, was also involved.

One way to decide on the make up of an otherwise unidentifiable dark is to look for its complementary.

In this case, the dark colored gray would give a *light yellow* after-image. This would immediately identify it as a *dark violet.*

Dark being the complementary of light and violet-being the complementary of yellow:

Dark - light
Violet - yellow

Surrounding a hue with a dark can bring a great deal of brightness to it. Red can look particularly vibrant when so treated. Please see page 304, 'White, Gray and Black' for further information.

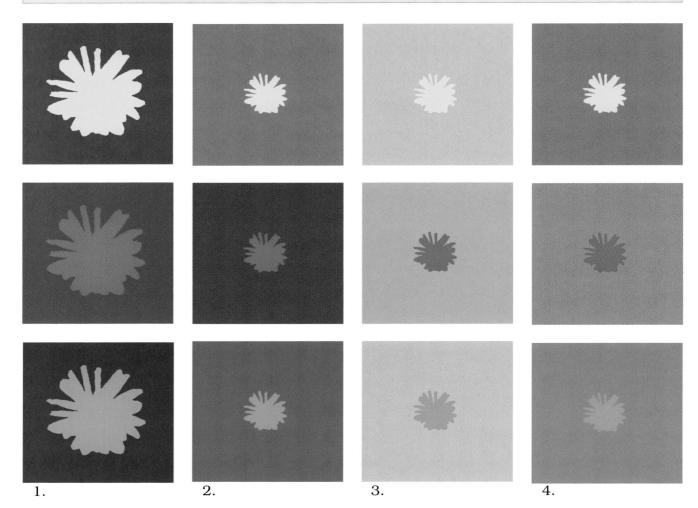

1. 2. 3. 4.

Of direct interest to the painter is the fact that a color can be made to appear brighter or changed in some other way by a neighbouring color or group of colors.

As you will know, a combination of after-image and eye movement can lead to one color greatly influencing another. If complementaries are employed they can be coaxed into enhancing each other.

There are many ways in which the range of after-image complementaries can be employed. They can be made to harmonise, to clash or to add a sense of movement and excitement.

Col. 1. Complementary pairs, applied fully saturated and covering about equal areas can appear harsh and inharmonious to many, but will contrast vividly.

Although difficult to handle and suitable only for certain types of work, complementaries used in this way can certainly add interest.

Subtle contrasts can be obtained by desaturating one of the pair and leaving the other fully saturated:

Col. 2. One of the hues can be desaturated (neutralised) by a small addition of the other. By now you will be very familiar with this process. Such desaturated color can be used in larger areas and will concentrate attention onto smaller, more saturated touches of color.

Col. 3. Alternatively, desaturating with white will allow that color to be used over a greater area and will move the main interest onto the saturated color. The latter is probably best applied in small patches or strokes.

Col. 4. Another approach is to mix both hues into a mid colored gray and use this in conjunction with the color that is left fully saturated.

186

Color Mixing Swatch No 44, page 418.

A complementary pair can be placed together in an almost endless variety of ways:

Both might be fully saturated. One saturated and the other desaturated with white, with its partner or with its partner plus white. Both might be desaturated by any of these methods. Both might be tints, tones (a colored gray plus white) or neutralised hues (a color reduced by its mixing complementary).

The examples shown here are barely a start to the vast range of approaches that have been taken by artists over the centuries. And these are just examples of two separate areas of color. In a painting one might be added to the other in small specks, strokes or close inter-mingling.

Again these examples are limited in that only two basic hues have been used in each. In practice the orange, for example, might vary from light to dark in a particular area, or from red-orange to yellow-orange.

One might be added to the other to create various colored grays, which themselves might be intermingled with one or other of the complementary pair. This, of course is where the individual skill of the artist comes into play. All that I can provide are the basic ingredients.

Do not be overwhelmed by the possibilities. You only need to keep a few things in mind and the rest is experiment and practice.

187

188

The complementaries have been used in a wide variety of ways ever since painting began because many find that they simply look good together.

William Turner was possibly the first artist to understand the effect of the after-image and also to exploit in a thorough way.

Other painters followed his lead but it was left to the Impressionists to really concentrate on the subtle contrasts and harmonies that are available. By juggling patches, strokes and dabs of various complementary pairings, by placing their color partners side by side, loosely intermingled or blended one into the other, in fact, by an almost endless variety of means, they produced work which has, it would appear, caught the imagination of more people than any other form of painting.

Their color work can still take the breath away. They produced such work not because they had an 'instinct' for color but because they studied the work of the color theorists of the day and painted with a close understanding of the effect of the after-image.

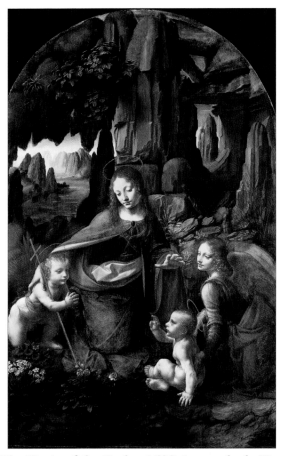

The Virgin of the Rocks, 1508, Leonardo da Vinci
© National Gallery, London

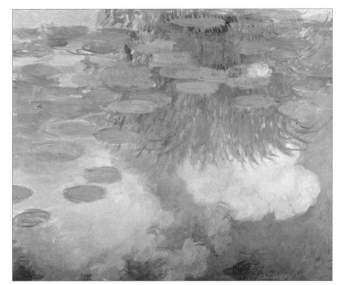

Waterlilies, 1914-17 (oil on canvas) by Claude Monet
(1840-1926) Musee Marmottan, Paris, France
Bridgeman Art Library

Art and Science had moved together during the Renaissance...

...and again during the Impressionist era.

As had happened during the Renaissance, the Impressionist era saw a brief coming together of art and science.

They have, sadly, moved far apart since and are now almost strangers. I feel that this shows in the work of many a contemporary painter and is often reflected in the approach of formal art teaching, even at the higher levels. However, you could certainly bring them back together in your own work and strive for similar results. It does not take a great deal of effort to come to terms with the basics of the after-image.

Many painters shy away from any mention of science or understanding of the craft of painting, feeling that it would inhibit their work. Fortunately neither the Renaissance artists or the Impressionists shared this feeling.

Introduction

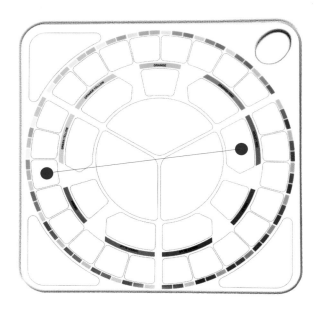

*Complementary pairings have played a vital
role in all forms of fine art and illustration.*

The visual complementaries are placed oppo-site each other on our color mixing palette. It is indeed fortunate that, with very slight vari-ations, the visual pairings are also mixing pairings.

This allows us to mix one into another know-ing that they give each others after-image, a very important consideration in color use.

As has already been mentioned, for practical purposes violet is placed opposite yellow and yellow and violet are described as complemen-taries. The complementary of yellow, however, is more accurately described as being a *blue-violet*. For the artist, the yellow/violet (as opposed to yellow/blue-violet) approach is much more practical.

Norham Castle, Sunrise, 1845, J.M.W. Turner
© Tate, London 2002

William Turner was one of the earliest paint-ers to fully understand the effect and power of the after-image. Before he gained this knowl-edge his paintings were usually rather drab, produced in the grays and browns common to his time.

In this simple arrangement the central area of violet-blue is sandwiched between orange-yellow, top and bottom. The blue is quite saturated and draws the eye

The yellow of the sky, reduced with white and just a touch of the blue, is surrounded with the same blue also desaturated with white and with, it would appear, a slight influence from the yellow.

The lower part of the painting is 'held in' at the sides by mixtures of the violet-blue and the yellow-orange; the pale, colored gray areas.

These grays are then further reduced with white and brought into play between 'strips' of pale yellow and blue, all taking the eye to the central image.

Although other colors take part in a minor way, this is principally an interplay of the two hues at various degrees of saturation, brought about through inter-mixing.

Blue-violet and orange-yellow

Being a complementary pair, blue-violet and orange-yellow will desaturate each other in mixes.

As they are also visual complementaries they can be encouraged to enhance each other.

1 41/2D 23/8D	2 41/3C 22/6D	3 41/1C 22/7C
4 41/2B 22/7B	5 41/1B 24/7A	6 41/3B 23/7B
7 41/3 24/7	8 41/1A 22/8A	9 41/2A 23/7

Blue-violet generally finds more use in painting than either red-violet or violet. This added versatility, together with the fact that orange-yellow is more acceptable to many than green-yellow, make these a very useful pair for many practical applications.

Orange-yellow, a bright, 'cheerful', hue, is well balanced with the much 'cooler' blue-violet. If both colors are desaturated, even very slightly, a modified contrast of temperature such as this can be of great benefit when seeking color harmony.

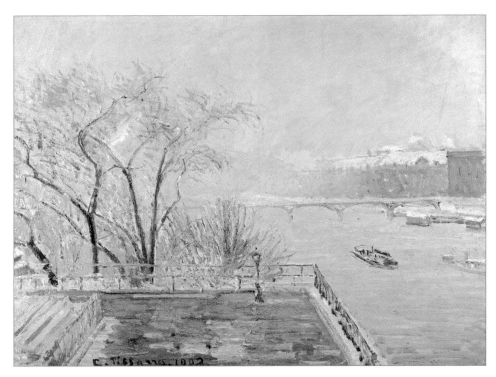

The Louvre under Snow, 1902, Camille Pissaro
© National Gallery, London

I have chosen the painting above to illustrate the fact that complementary hues need not be particularly obvious to be effective.

The blue-violet of the foliage and buildings has, it would appear, been desaturated with both the orange-yellow and white. The orange-yellow has also been desaturated to a considerable extent. Colored grays which result when both are mixed in equal intensity make up much of the painting, either at close to full strength or further reduced with white.

A very subtle use of a complementary pair.

194

Orange-yellow and blue-violet

To be acceptable to most an object's color should either be a good deal lighter or darker than its background. To this end, swatches 1 & 2 would not be as effective as the others. However, such arrangements as these can add visual interests to many areas of a painting. They can depict the subtleties of an evening sky for example.

1
23/8D
41/2D

2
22/7D
41/3C

3
22/7C
41/1C

4
22/7B
41/2B

5
24/8A
41/1B

6
23/7B
41/3B

7
22/8A
41/1A

8
23/7
41/2A

9
24/7
41/3

Complementaries act on each other optically, constantly enhancing each other. This fact gives any well matched pair great versatility.

By varying intensities and area a pairing such as these can give soft, quiet harmonies, when they are further reduced with white; bright, strongly contrasting arrangements when at or near full strength and calmer combinations when darkened. A very valuable pair in any palette.

The sequence has been reversed when compared to the previous page. Here the violet-blue is set against an orange-yellow background.

Such simple changes can make a great difference in the way that we perceive colors.

Along the Nile at Gyzeh, c.1850's (oil on canvas) by
Charles Theodore Frere (Bey) (1814-88)
Dahesh Museum of Art, New York,
USA/Bridgeman Art Library

Cadmium Yellow Light and a mixed violet

As you will see from the color mixing swatch reproduced above, it would appear that the entire painting has been produced from an orange-yellow and a mid violet.

Note the range of colored grays in the trees, where they lean slightly towards yellow, and in the foreground, where the yellow and violet have all but absorbed each other.

This example perhaps demonstrates the intention that the swatches on the following page are only starting points. They cannot show more than the two basic hues; the tints, neutrals and colored grays, as well as their arrangement, must come from the artist.

Likewise the *color mixing* swatch to the left. It can also only show a few of the possible blends from the mixing pair. Many more could be produced from further intermixing.

Orange-yellow and violet

As with all of the swatches on this page, the orange-yellow can be desaturated with white, with the complementary *violet*, or with white *and* the complementary. The violet can be desaturated with the same orange-yellow, with or without white. With all references to the use of white in this context, please accept that I mean with the addition of white paint or with the influence of a white background to thinly applied paint.

1 41/9D 41/1D	**2** 41/7D 41/3C	**3** 41/10C 41/1C
4 41/8A 41/2B	**5** 41/7B 41/3B	**6** 41/9B 41/2A
7 41/9 41/2	**8** 41/10A 41/1A	**9** 41/7A 41/4A

Small touches of violet, from bright to darkened, set against a pale orange-yellow background found favour with many earlier artists. The results can be very pleasing if the two colors are well handled.

As with all color combinations, it will pay dividends if small color arrangements are tried out, perhaps to one side of the painting, before committing to application. A little experimenting can go a long way.

Chatterton, 1856, Henry Wallis
© Tate, London 2002

When violet is added to orange-yellow a range of dull grayed yellows will result.

When mixed in near equal intensity the two hues will absorb much of each others light, giving a series of dark colored grays.

The top row of mixes in the color mixing swatches shown in this book have been applied fairly lightly, in order for the color bias to show.

If such mixes as that shown circled (left) are applied heavily they can provide the type of darks that were used in this painting.

Cadmium Yellow Light, which is opaque, was used to provide the mixes to the left. If a *transparent* yellow had been used, the darks would have been even deeper.

198

Violet and orange-yellow

You might look at swatch No 2 or even No 1 and think 'Where would I ever use such insipid color arrangements'? To my mind, visual complementaries can be of particular value when very light and intermingled in this way. Where it is a little difficult, when standing back, to decide where one color starts and another finishes. The Impressionists, in particular, were able to produce some very beautiful passages this way. As shown here, (with almost every swatch), violet and orange-yellow will desaturate each other in mixes.

1

41/1D
41/9D

2

41/3C
41/7D

3

41/1C
41/10C

4

41/2B
41/8A

5

41/3B
41/7B

6

41/2A
41/9B

7

41/2
41/9

8

41/1A
41/10A

9

41/4A
41/7A

This can be rather difficult pair to work with. However, by varying the strength and proportion of each color and balancing one against the other with care, some very interesting and harmonious arrangements are possible. Strong contrasts are possible with this duo.

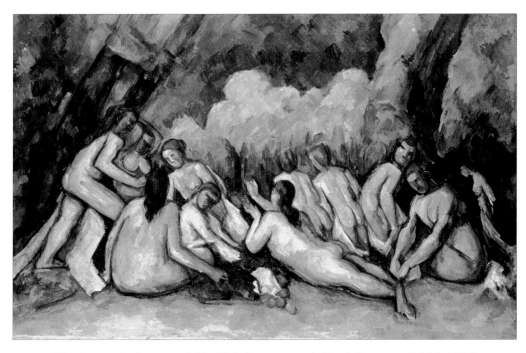

The Large Bathers, c.1900-05 (oil on canvas), Paul Cezanne (1839-1906)
National Gallery, London, UK/Bridgeman Art Library

I have used the above painting to illustrate not only the use of this color combination but also to show the difference between the two types of tint.

When hues are lightened by allowing the background white of the painting surface to play a part, they can be quite different to tints produced by actually adding white paint.

The mixes shown in the swatch above were applied thinly over a white background.

This combination is common in nature.

As you will see, the tints, especially of the yellow-orange, are quite different in character to those shown in the painting. Especially those applied to the central figure.

When white is added to any color it will dull and 'cool' it, altering its character as it does so. This is indeed fortunate as it extends the range of colors that we have to work with.

Yellow-orange and violet-blue

When using this pair to desaturate each other, if the mixes move too far towards green, try adding a little red to the orange to reduce the green. It might be that the yellow-orange was a little too yellow.

1
48/1D
28/3E

2
48/2E
28/3D

3
48/4D
28/2D

4
48/2C
28/3D

5
48/1C
28/2C

6
48/3D
28/3B

7
48/4C
28/2B

8
48/3C
28/3A

9
48/4B
28/3

As you look over these pages it will become obvious to you where the pairings work well together as far as you are concerned.

Most combinations can be further altered in area to encourage them to work together.

Brighter hues are best applied over small areas, just touches of color. When made lighter, all colors can be used over greater areas without upsetting balance.

Colors are constantly changing *visually* depending on their background. I emphasise the word visually because they do not change physically. The same wavelengths are reflected regardless of surrounding colors. They would be recorded as such by a camera.

It is only when the eye and the brain become involved that the effects of after-image come into play.

Bridge over the Dobra River, 1907, Matija Jama
National Gallery, Ljubljana, Slovenia

A little mixed yellow-orange plus some violet-blue on the palette and you have the beginnings of a vast range of colors which can be harmonised with relative ease.

The basic hues and their mixes can be reduced with white, as above, or via a white background.

Ultramarine Blue is the only bright violet blue at our disposal. The yellow-orange can be mixed in various ways. That shown on the right has been produced from Cadmium Yellow Light and Cadmium Red Light.

Mixed orange-yellow plus Ultramarine Blue. The mixes have been applied lightly, with the background white providing the tints.

Violet-blue and yellow-orange

Being mixing, as well as visual partners, these two will reduce each other's intensity in mixes.

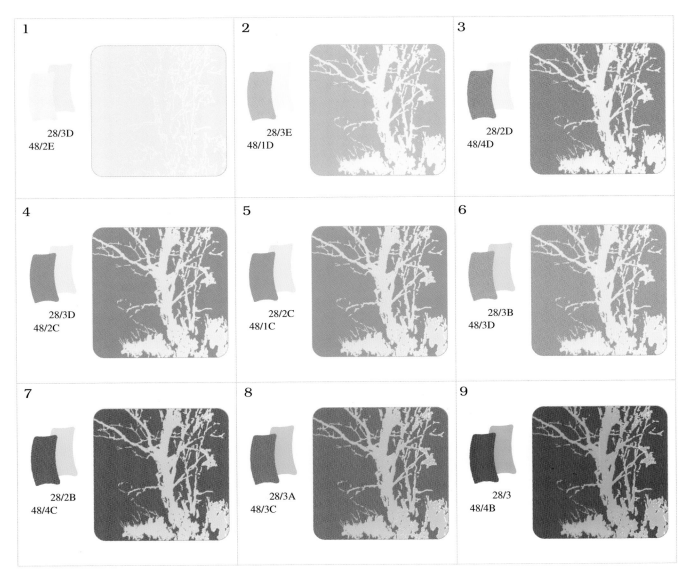

1

28/3D
48/2E

2

28/3E
48/1D

3

28/2D
48/4D

4

28/3D
48/2C

5

28/2C
48/1C

6

28/3B
48/3D

7

28/2B
48/4C

8

28/3A
48/3C

9

28/3
48/4B

Large areas of violet-blue, softened with white and with small touches of the yellow-orange can look particularly effective. More so if the latter color is also reduced somewhat.

Extremely versatile and with many applications, this particular complementary pair has been a long time favourite with painters world wide.

The Boulevard de Clichy under Snow, 1876, Norbert Gouneutte
© Tate, London 2002

Although I cannot be certain which colorants were actually used for the above painting, the most probable were Burnt Sienna and Ultramarine Blue.

These two would certainly give the range shown.

The pale oranges in the buildings to the left can be mixed from Burnt Sienna reduced with a 'touch' of the blue. White paint has then been added. The tint varies from the orange tints in the mixing swatch because I allowed the white of the background to give the tints rather than add white. If you neutralise Burnt Sienna slightly with Ultramarine Blue and then add white paint, you will see what I mean.

I feel that the pale oranges are based on Burnt Sienna because this appears to be the main colorant used in the other parts of the building and the trees.

It will also give the near blacks when mixed with Ultramarine blue. Notice the use of the colored grays further reduced with white.

Violet-blue and orange

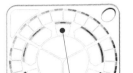

As you will see, these colors have all been produced from the mixes to be found on swatch 45. The orange has been used to desaturate the violet-blue and vice-versa.

When using this complementary pair for mutual desaturation, if you find your mixes start to become rather greenish it might be that the orange that you have mixed is a little too yellow. Add a touch of red to the orange to remove the greenness. Red and green being mixing complementaries, the extra red will absorb the unwanted green.

1

45/2C
45/8D

2

45/1D
45/9D

3

45/1C
45/10C

4

45/3B
45/9B

5

45/1B
45/10B

6

45/3A
45/9A

7

45/1A
45/10A

8

45/2
45/9

9

45/3
45/8

Violet-blue and orange were used again and again by the Impressionists painters. The blue had many applications, clothing, buildings, skies, interiors etc.

The orange was the ideal compliment, particularly when desaturated for flesh colors and hair. It had many other uses.

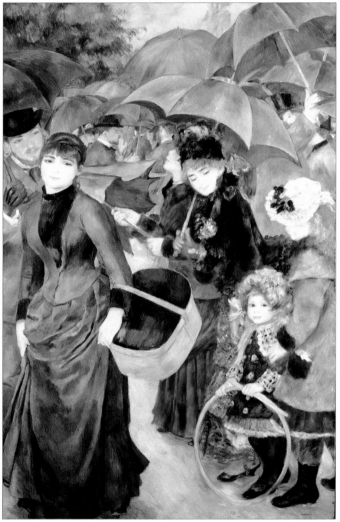

The Umbrellas, 1881-6, Pierre-Auguste Renoir
© National Gallery, London

Mixed orange and Ultramarine Blue

This painting does, I feel, show the interplay of a complementary pair at an advanced level. As you look around it you will see rich saturated color, a wide range of desaturated hues and close intermingling of the base colors.

Ultramarine Blue and Burnt Sienna

It appears that the most of the hues came from a mix of orange and Ultramarine Blue with the deeper blues coming from Burnt Sienna and Ultramarine Blue. Apart from the touches of green, all from just three colors.

Orange and violet-blue

One of the beauties of working with a complementary pair is that one can be used to desaturate the other. This means that only two colors need be in use on the palette (one, such as the orange here, might need to be pre-mixed). Although 'near' complementaries can be used (a red-orange instead of orange, for example) with little difference, if 'outside' colors are introduced for this purpose they can lead away from color harmony.

1
45/8D
45/2C

2
45/9D
45/1D

3
45/10C
45/1C

4
45/9B
45/3B

5
45/10B
45/1B

6
45/9A
45/3A

7
45/10A
45/1A

8
45/9
45/2

9
45/8
45/3

Violet-blue and orange can be harmonised at almost any strength by simply altering the area of color, balancing one against the next Particularly versatile, this pair has applica-tions in almost every area of color use. These swatches show orange against a violet-blue background, the reversal of the approach taken on page 205.

To Pastures New - The Goose Girl, 1883, James Guthrie
Aberdeen Art Gallery and Museums

Note the use of the colored grays, varying from mid-gray to blue-gray and on to orange-gray.

In the color mixing swatch to the right, orange (mixed from Cadmium Yellow Light and Cadmium Red Light) has been combined with Cerulean Blue.

Other green blues can be used in this approach as well as other mixed oranges.

Notice the use of the colored grays in the painting above. They range from the mid-gray of the central goose to blue-grays and orange-grays. A very simple approach which can lead towards outstanding color harmonies.

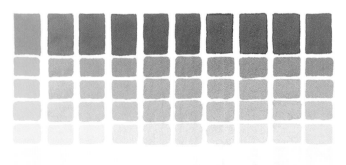

Mixed orange plus Cerulean Blue.

Green-blue and orange

As Color Mixing Swatch No 44 (page 418) will demonstrate, this complementary pair will desaturate each other very efficiently in mixes. They not only neutralise each other very well but give rise to some very useful colored grays.

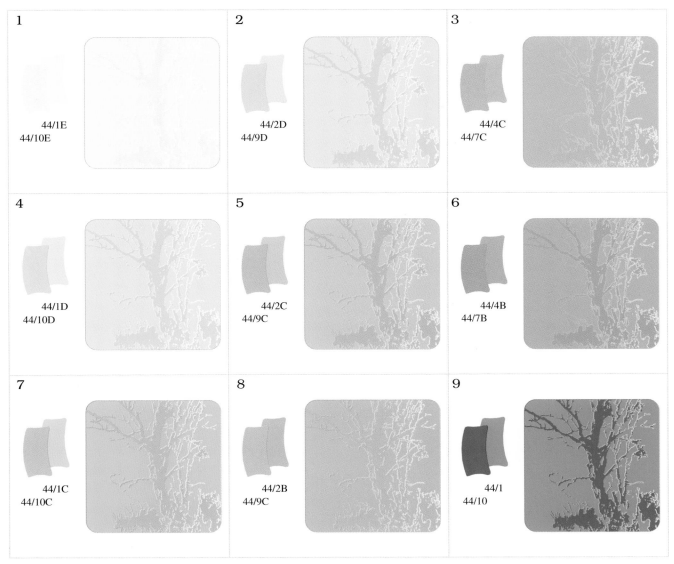

1

44/1E
44/10E

2

44/2D
44/9D

3

44/4C
44/7C

4

44/1D
44/10D

5

44/2C
44/9C

6

44/4B
44/7B

7

44/1C
44/10C

8

44/2B
44/9C

9

44/1
44/10

A favourite combination with artists over the centuries, the various blues and oranges have almost certainly been used more than any other color pairing.

When both are considerably desaturated with white, as in swatch No 1 above, and intermingled, they can bring an unusual 'light' to a painting.

Venice: San Giorgio from the Dogana, Sunrise by Joseph Mallord
William Turner (1775-1851)
British Museum, London UK/Bridgeman Art Library

When painting with a complementary pair, the *full* range of saturations can be worked together, or just a selection of them.

The approach taken in this painting would suggest that the colored grays played an im-

portant part, with the neutralised green-blues and oranges in support.

Can you see how easy it is to produce an entire painting from a single complementary pair plus a means of creating tints?

Please bear in mind that I am not suggesting that the mixing swatches shown on these pages are the exact colors that have been used in the paintings. They are meant to be an indication of the way that one color will act on another. In this example the orange used appears to have been slightly redder. To cover every possible nuance in a limited number of mixing swatches would obviously be impossible.

Orange and green-blue

The orange can be desaturated with white, with the general complementary green-blue and vice versa. Browns, which are really darkened reds, oranges and yellows, can be produced with ease when the appropriate complementaries are mixed.

1 — 44/10E, 44/1E	2 — 44/9D, 44/2D	3 — 44/7C, 44/4C
4 — 44/10D, 44/1D	5 — 44/9C, 44/2C	6 — 44/7C, 44/4C
7 — 44/10C, 44/1C	8 — 44/9C, 44/2B	9 — 44/10, 44/1

A particularly versatile pair, orange and green blue have been employed by artists and craft workers over the centuries.

They have been employed together from early oriental porcelain to the ceilings of mosques and have found a place in all forms of painting and artwork.

Before the after-image was fully explored they were used simply because they looked good together.

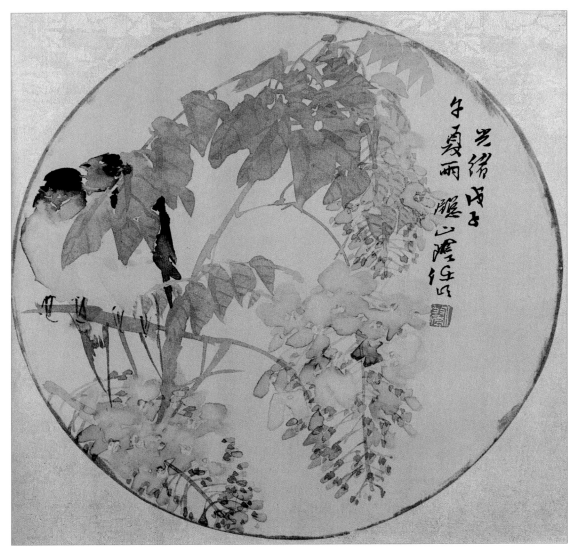

Swallows on a Wisteria, Jen Po-nien

This painting does, I feel, indicate the simplicity of many color arrangements which can be described as harmonious. The two basic hues are cleverly intermingled (left), are repeated throughout the piece and have been used to desaturate each other.

Many a painter would perhaps use green for the leaves, maybe paint the bird breasts brown, use a nondescript gray for the branches and introduce further colors for the border and background.

If you are seeking color harmony, I suggest that you feel free to ignore the colors which might be before you, avoid unnecessary 'outside' colors and keep everything as simple as possible.

212

Red-orange and green-blue

The red-orange can be desaturated with white, with the complementary *green-blue*, or with white *and* the complementary. Desaturate the green-blue with the same orange-red with or without white. Having said that I would like to emphasise that color mixing need not be so exacting. With these swatches I have added a *mid*-orange rather than a *red*-orange to the green-blue. It desaturates it in a way which is virtually indistinguishable from the use of the 'correct' red-orange.

1	2	3
44/10D 29/7D	44/9D 26/8D	44/8C 27/9D
4	5	6
44/9C 30/8C	44/9B 26/8B	44/8B 30/7B
7	8	9
44/9A 26/8B	44/9A 29/7	44/10 30/9A

Strong, vibrant hues when at or near full saturation, this complementary pair need to be considerably modified if they are to harmonise.

There are so many applications for color that a particular pairing might look stunning in a fashion design but unbearable when used to decorate a room. The areas over which colors are applied can often decide harmony. This applies equally well to painting.

La Place du Tertre, 1910, Maurice Utrillo
© Tate, London 2002
© ADAGP, Paris and DACS, London 2002

A wide range of the two base hues might be used in a painting.

The color swatches on the opposite page can be no more than starting points as they are necessarily limited to two base hues.

The one painting will very often contain a range of red-oranges and green-blues.

Various mixes for the red-oranges and perhaps several types of green blue; Cerulean Blue, Phthalocyanine Blue etc. White can be added for further reduction.

Green-blue and red-orange can contrast so strongly when at full strength and applied side by side that they set up a flicker in the eye.

This is particularly noticeable in smooth, heavy applications of oil or acrylic paint films, where saturation is enhanced.

These are strong, vibrant hues at or near full strength and need to be handled carefully if harmony is sought.

Green-blue and red-orange

The orange-red can be desaturated with white, with the complementary blue-green and vice versa.

1	2	3
26/8D 44/9D	29/7D 44/10D	27/9D 44/8C
4	5	6
30/8C 44/9C	26/8B 44/9B	30/7B 44/8B
7	8	9
26/8B 44/9A	29/7 44/9A	30/9A 44/10

As colors become closer in value, that is, they appear to move towards being equally light or dark, they can be harmonised readily. More so than when one is definitely light and the other dark.

This is because the contrast of light and dark is reduced.

Having said that, a certain light/dark difference is necessary in order to give clear definition where objects are concerned.

Shades of Evening, 1904, Mildred Anne Butler
National Gallery of Ireland

The Artists's Wife, Matevz Langus
National Gallery, Ljubljana, Slovenia

A Letter, 1878, Janez Subic
National Gallery, Ljubljana, Slovenia

A very versatile pair with many applications. In 'Shades of Evening' above, the blue-green takes the major role, followed by the colored grays which result when the two are combined. The orange-red takes a back seat but still plays an important part.

In 'The Artist's Wife' The two neutralised hues are presented as large 'clean' areas with the colored grays confined to the background.

In 'A Letter' the two approaches are combined. As with all color work, once the arrangement has been decided upon, the rest is all down to juggling.

216

Orange-red and blue-green

If needed, desaturate the orange-red with the blue-green and vice versa. Swatches 8 & 9 will be worth studying in this respect. The same dulled blue-green features in both. It has been desaturated with the orange-red, its mixing partner. The orange-red, in turn was desaturated with the green-blue to give the background to swatch No 8. More green-blue was added to the orange-red for swatch No 9. As it was added it 'absorbed' more of the red, making it darker. The character of the orange-red has been altered slightly but this is the most effective way to darken a color.

1
38/1D
38/10D

2
38/2C
38/9D

3
38/2C
38/9C

4
38/2B
38/10C

5
38/3D
38/8C

6
38/4B
38/7A

7
38/1A
38/10A

8
38/1A
38/10

9
38/3
38/7

With such vibrant colors, which can contrast very strongly when saturated, it adds to the chances of harmony if they are desaturated one way or the other.

As colors are darkened, for example, they become easier to work with and can be used over larger areas than when brighter.

The background to No 9, for example, could be used to cover a larger area than that of No 8 without being distracting.

Unfortunately such darkened hues can become rather oppressive if used on a large scale.

As with all advanced color use, it is a case of thinking about and juggling with the possibilities.

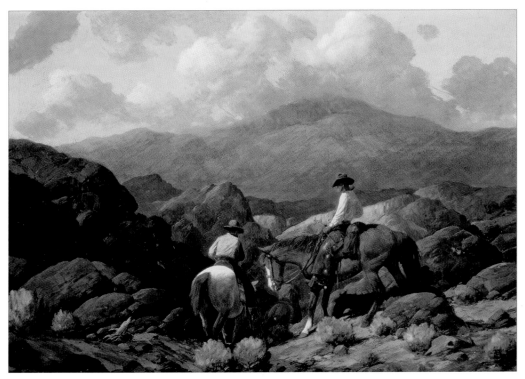

Into the Jackson Hole Country, 1937 (oil on canvas)
by Frank Tenney Johnson (1874-1939)
Private Collection/Bridgeman Art Library

Although other colors do appear, this is basi-
cally a study in blue-green and orange-red.

As you will notice, the darks and browns of
the painting can be produced from these two
hues, as one absorbs the other.

Such 'colored grays', mixed from the comple-
mentary pair, have a much better chance of
harmonising than would any 'outside' dark or
brown.

218

Blue-green and orange-red

Rather than introduce 'outside' colors, use the blue-green to desaturate the orange-red and vice versa. Being mixing partners they will darken each other very efficiently. The 'character' of the desaturated color will be altered slightly but less so than other means of darkening. A good example of this approach is to be found in swatches 1 and 2: In No. 1 the orange-red is unmixed. In No. 2 a little of the blue-green has been added to darken it.

1

38/10D
38/1D

2

38/8C
38/3D

3

38/9C
38/2C

4

38/9D
38/2C

5

38/10C
38/2B

6

38/10A
38/1A

7

38/7A
38/4B

8

38/9
38/3

9

38/7
38/3

Although the above swatches are necessarily set on the page, they will seldom be the ideal. Try varying the proportions, spread pale colors over larger areas and reduce the size of brighter colors to small accents, for example.

With complementary pairings it is important that they do not contrast too strongly if you are seeking color harmony.

As you will see in the above examples, it is not difficult to modify them.

Azaleas, 1868, Albert Moore
Hugh Lane Gallery, Dublin

When asked to picture violet-red and yellow-green together in a painting, many artists would imagine a rather garish arrangement. However, when they are very much reduced in saturation, as is the case here, they can be used together very successfully.

I feel that this illustrates the fact that *any* two, or more, colors can be encouraged to harmonise. There is no such thing as an impossible starting point despite what you might have read about these two or those three colors never being used together.

These particular hues together could possibly be described as a 'mood' arrangement. So far I have only ever found them used to this extent in two situations:

Either in very peaceful paintings such as this or in wild, violent, and dramatic religious works. From one extreme to the other but with little in between. Its a strange world.

220

Violet-red and yellow-green

Mixing, as well as a visual complementaries, they will reduce the intensity of each other when combined. One color 'absorbing' the other.

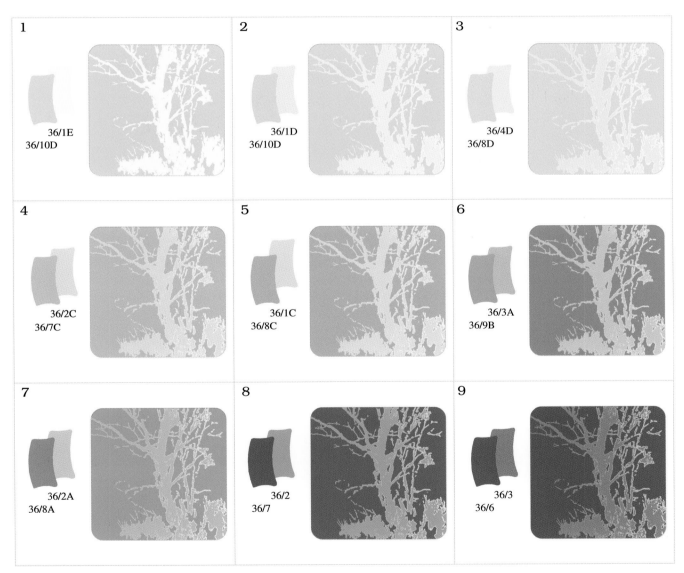

1	2	3
36/1E 36/10D	36/1D 36/10D	36/4D 36/8D
4	5	6
36/2C 36/7C	36/1C 36/8C	36/3A 36/9B
7	8	9
36/2A 36/8A	36/2 36/7	36/3 36/6

Yellow-green can look rather acidic at or near full strength.

If anything, the violet-red, its complementary partner, emphasises this characteristic.

These two tend to sit together better when reduced somewhat. Either with each other or with white. If either, or both, become relatively bright, they can become rather awkward,

Spring Sun, Matej Sternen
The National Gallery, Ljubljana, Slovenia

1. 2. 3.

I have shown this particular painting to illustrate the fact that a color combination need not necessarily be used over the entire work. In this instance the yellow-green and violet-red form almost a 'side show' to the right of the painting. (Please see detail 4. at right).

These same two basic hues have then been repeated in different places on the painting to lend balance to the other colors involved (1-3 above). Repeating a color, or colors, in this way can help to hold a painting together as well as assist when color harmony is sought.

4.

Yellow-green and violet-red

When using these two hues, the yellow-green will normally be mixed rather than obtained from a tube. Once prepared it should be treated as a single color. The blue or yellow from which is blended can be added as work proceeds but caution is advised as color control can be quickly lost if this is overdone.

1

36/10D
36/1E

2

36/10D
36/1D

3

36/8D
36/4D

4

36/7C
36/2C

5

36/8C
36/1C

6

36/8A
36/2A

7

36/9B
36/3A

8

36/7
36/2

9

36/6
36/3

As with any of the combinations shown, you might find that some of the above clash rather than harmonise.

Everything depends on personal taste and how the colors are to be combined in the finished piece. As previously mentioned, you might find these two difficult to work with if either or both are at or close to full saturation.

British Industries - Cotton c.1923/4 (LMS Poster)
by Frederick Cayley Robinson (1862-1927)
Private Collection / Bridgeman Art Library

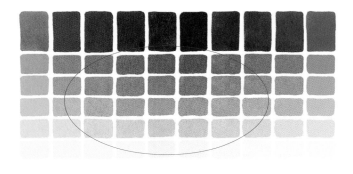

The range of colors used in this work are similar to those obtainable from the intermixing of Quinacridone Violet and Phthalocyanine Green, as above.

Both are transparent and will therefore lend themselves readily to the creation of darks.

At the time, the unreliable, but equally transparent Alizarin Crimson would have been the most likely violet-red.

Complementary pairings, particularly reds and greens, can look very harsh and inharmonious. But this is when they are at or near full strength and have been used in a clumsy fashion.

When one is employed to reduce the intensity of the other, and the range is carefully selected and played one hue against the next, it can be a quite different matter.

A softy, calm painting which does not reflect the hectic sweat shop depicted.

Violet-red and green

When working with a complementary pair, use one to desaturate the other. White will desaturate such mixes even further. Or white can be added directly to the base hues.

1

21/8D
21/3E

2

21/10D
21/2E

3

21/10C
21/4E

4

21/10C
21/3D

5

21/9C
21/1D

6

21/9B
21/2D

7

21/8B
21/1C

8

21/10B
21/2C

9

21/7C
21/3B

Common advice is that red and green are complementaries and can be used together for both contrast and harmony. This is too general as there are many versions of each basic hue and each will cause change of a different nature. In these swatches I have deliberately used only one type of green, Phthalocyanine, to show the vast range of red/green combinations possible.

Any other mid-green could be employed, premixed or otherwise. Which red with which green? This should always be the question.

If the green varies from a yellow-green to a blue-green the differences in contrast will be very noticeable.

But even within the mid-greens 'family', (following the above title), there will be certain variances.

Leda and the Swan, 1530, After Michelangelo
© National Gallery, London

The color swatches on the opposite page are set violet-red against green. They take on a different character to the page prior to this, where the green is set against a violet-red background.

The description 'green' of course is very general and encompasses an enormous range.

In the painting above, a dull green has been employed which varies from a very pale tint to a darker, dulled version. Darkened, it would seem, by the violet-red.

A difficult combination to use but worth pursuing if you are attracted to the potential calmness on offer.

Green and violet-red

Visual complementaries, being either very close or sometimes exact mixing complementaries, will desaturate each other very effectively. This approach allows us to 'darken' colors as closely as possible whilst retaining their characteristics.

1

21/3E
21/8D

2

21/2E
21/10D

3

21/4E
21/10C

4

21/3D
21/10C

5

21/1D
21/9C

6

21/2D
21/9B

7

21/1C
21/8B

8

21/2C
21/10B

9

21/3B
21/7C

Compare these arrangements with the orange-red/green swatches to be found on pages 229 and 231. The 'cooler', less vibrant violet-red will have a diminished contrast with the same green, allowing wider use when harmony is important. As the reds move into the violet region of the color wheel their use becomes rather restricted for many applications. For certain subjects however they can give unusual and vibrant combinations.

227

'Fuji in Clear Weather' from the series '36 views of Mt. Fuji' ('Fugaku sanjurokkei'), pub. by Nishimura Eijudo, 1831 (hand colored woodblock print) by Katsushika Hokusai (1760-1849) British Museum, London.
UK/Bridgeman Art Library

Self Portrait, 1826, Jozef Tominc
The National Gallery, Ljubljana, Slovenia

Strong contrasts can be set up when this pair are worked closely together at anywhere near full strength.

In the painting above, both the orange-red and the green have been applied in a reasonably saturated form. Strong enough to contrast to the point where they could be a little distracting.

In order to overcome this tendency the two have been mixed to produce the colored grays. These, leaning both towards the green and the orange-red have been applied as small dabs of color at the base of the mountain.

They do, I believe, act as a bridge between the brighter versions of the two colors. Being also mixed from these colors (rather than 'outside' colors), they are an aid color harmony. Please see row 2 page 91.

In 'Self Portrait', left, a slightly different approach has been taken. Although the two hues are not in danger of contrasting strongly, the colored grays still play an important role.

Green and orange-red

When working with a complementary pair, which are mixing as well as visual partners, use one to desaturate the other. To be exact, which can be inhibiting when working with color, we could say that a *blue*-green should be used to desaturate the orange-red, rather than a *mid*-green. In practice we are working with a red-green combination, that is all that really matters.

1
32/2D
32/9E

2
32/3E
32/8C

3
38/10C
21/10D

4
38/9B
21/8B

5
32/2C
32/8

6
38/8A
21/8A

7
38/10A
21/10A

8
38/10
21/10

9
38/9
21/9

An orange-red tint, pink, can have a calming effect and is sometimes used in prisons for this reason. If using pink to any extent, try the subtle contrast offered by a very pale green.

If used at strength, these can be a rather difficult pair to work with as one of their qualities is that they contrast strongly when used in a saturated form.

With some modification to strength and area, they can be encouraged to harmonise.

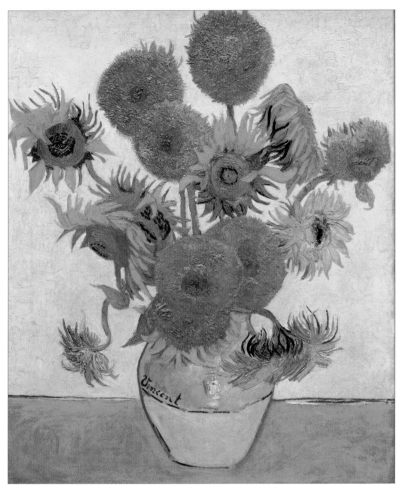

Sunflowers, 1888 by Vincent Van Gogh (1853-90)
National Gallery, London, UK/ Bridgeman Art Library

Orange-red and green.

Orange-red and yellow-green.

I feel that we can base the above painting on orange-red and mid-green, with the addition of a little yellow-green. As you will see from the color mixing swatches above, when orange-red is desaturated with either type of green, with or without white, a series of dulled or-

anges will result. When first painted, the flowers were a lot yellower. Van Gogh, who was passionate about color, was obliged to use Zinc Yellow due to its low cost. Zinc Yellow turns an orange to brown-orange on exposure to light. *Yet we still use such paints.*

Orange-red and green

As in swatch No.s 1, 2, 3, 5 and 7, you can use the orange-red to desaturate the green and vice-versa. In these exercises it will make only the slightest difference if a *blue*-green is used to darken the red instead of a mid-green, as in No.s 8 & 9.

1

32/9C
32/2D

2

32/8C
32/3E

3

32/9C
32/2B

4

21/9B
38/9A

5

32/8
32/2C

6

21/8A
38/8A

7

32/9
32/1A

8

21/10
38/10

9

21/9
38/9

When the roles are reversed and the orange-red becomes the background color, an entirely new range of effects is created. There are many facets to color harmony and contrast. For this reason alone it pays to experiment before applying color.

Color swatches such as these can only offer very general guidance.

As color mixing swatch 32 (page 414) will show, orange-red and a mixed bright green will give a wide series of neutral colors as well as the colored grays to be found around the middle of the swatch.

These, plus greens and reds to be found elsewhere, will give a wide range with which to work.

As with all of the color mixing swatches, the above hues can be harmonised with ease.

The Chinese have made, and still make, extensive use of this bright, energetic pair, often applied at full strength. When so used they have a powerful effect on each other and contrast strongly.

As a small child I helped my Grandmother to paint my bedroom a vivid green, with bright red patches (it was her idea). The effect remains with me to this day.

A color scheme not to be recommended for any but eccentric Grandmothers, as mine certainly was. But then so is my Mother, Brother and Sister.

I am the only one to have escaped.

14/2 23/1	14/4 23/1	14/5 23/1
14/7A 23/1	14/7 23/1	14/9 23/1
14/7A 23/1	14/7 23/1	14/9 23/1

Small touches of bright (fully saturated) orange-red set against a variety of greens can either sit together comfortably, or contrast so strongly that they have to be handled with extra care.

Decide for yourself which category each of the above falls into.

Your assessments will almost certainly be at odds with those of others, color being such a subjective issue.

Many artists have employed the technique of placing small touches of bright red against a green background. It can be very effective is care is taken.

Lao-tzu by Chi'en Ku, c.1500

The green-yellow has been treated in a very simple way, mainly applied in a thin layer to allow the background white to provide the tints.

The red-violet, on the other hand, has been used in a wider range of saturations: Desaturated with yellow (I suspect), and applied very thinly to give the tints of the robes.

The same mix but applied a little heavier for the slightly darker violet-reds.

Finally the colored grays which result from a combination of these hues to give the darks of the tree and background shrubs to the left.

When the possible mixes from a complementary pair are fully explored they can be used to great effect.

Green-yellow and red-violet

Mixing, as well as visual partners, they will desaturate each other very efficiently.

1
22/3D
42/1D

2
24/4B
42/1C

3
23/4C
42/3C

4
24/3B
42/3B

5
22/3B
42/2B

6
23/4A
42/1B

7
22/3A
42/2

8
24/3A
42/1A

9
22/3
42/2

Green-yellow can be very effective when much reduced with white (either in paint or background form).

This is particularly so if its partner is also a tint. Many find it a difficult hue to work with at or near full strength.

The red-violet can also be troublesome. If used in a saturated form it might be necessary to reduce its area.

Small dashes, lines or patches of the color rather than heavier applications can be advisable.

235

Portrait of the Journalist Sylvia Von Harden (1894-1963) 1926
(mixed media on panel) by Otto Dix (1891-1969)
Musee National d'Art Moderne, Paris, France/Bridgeman Art Library
© DACS 2002

A complementary pair can be successfully employed whatever the proportional relationship. In this painting the yellow appears in a very limited way; in the matchbox and in the hands, face, chair and drink. Yet it is enough to bring added visual interest.

Reversing the expected values

Many find discord in color pairings which have been reversed in value. As an example, where the normally light yellow is darkened and the comparatively dark red-violet is lightened, an unusual relationship is set up which many find disturbing.

There are two main responses to this situation. The first is to avoid such arrangements, the second is to say 'let the viewer be disturbed (without knowing why), that's what I intend.

42/2
22/2C

Many find discord in color pairings which have been reversed in value.

Red-violet and green-yellow

Either hue will desaturate the other. This is the most efficient way to darken a color. Although, strictly speaking the color is not truly darkened, as it will change in character, this is the most efficient means at our disposal.

1
42/1D
22/3D

2
42/1C
24/4B

3
42/3C
23/4C

4
42/3B
24/3B

5
42/2B
22/3B

6
42/1B
23/4A

7
42/2
22/3A

8
42/1A
24/3A

9
42/2
22/3

On this page the previous color arrangements are reversed, with the red-violet now becoming the background color.

By varying the approach in this way, as well as by varying the saturation and areas, different feelings can be evoked.

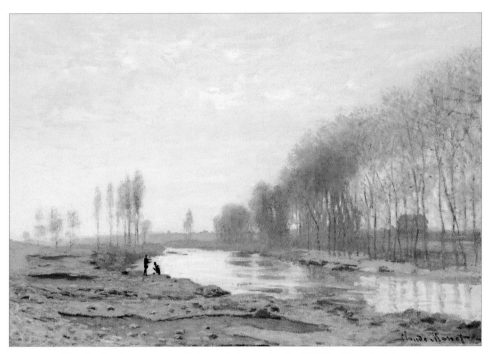

The Petit-Bras of the Seine at Argenteuil, 1872, Claude Monet
© National Gallery, London

When working with a complementary pair, it can be a mistake to stick too slavishly to the chosen colors. You should always feel free to introduce further hues, However, they should not dominate the work if you wish to retain the 'feel' of the original selection.

In the painting above, the artist appears to have worked more with the green-yellow end of the range together with the colored grays. The violet varies from blue to red violet.

Mid-violet, where it has been used, has been applied in a very desaturated form.

Violet and green-yellow

As mixing partners they will desaturate each other with ease and accuracy, keeping each close to its original character.

1
42/2D
42/7D

2
42/3E
42/9C

3
42/1D
42/7B

4
42/2C
42/7B

5
42/1C
42/8B

6
42/3C
42/9B

7
42/2B
42/9B

8
42/3A
42/7B

9
42/3
42/10

The violet/green-yellow combination can give very soft, subtle harmonies when well handled. Passages in a painting where these two have been used with skill can look very attractive (to my eye).

However, if used at or close to full strength, without care, they can look very harsh together. Such comments, it must be emphasised, reflect only my views. If you feel differently we will both be right.

The High Street, Oxford, 1837, J.M.W. Turner
© Tate, London 2002

A color study based on a simple but potentially effective combination. Note the intermixing of the yellow and violet to give the rather nondescript darks. They balance with the rest of the work as they are mixed from the same two base colors.

Green-yellow is not quite so adaptable as the violet and usually needs to be modified.

At or near full saturation it can appear at odds with almost any other color. When taken back with white or desaturated slightly with the violet it becomes more agreeable to many. Our eyes are very responsive to green and the slightest trace in a yellow is noticeable. We tend to describe as green a color which is very close to yellow.

240

Green-yellow and violet

Found opposite each other on the color coded mixing palette, these two hues will readily desaturate each other.

1	2	3
42/7D 42/2D	42/9C 42/3E	42/7B 42/1D
4	5	6
42/7B 42/2C	42/8B 42/1C	42/9B 42/3C
7	8	9
42/9B 42/2B	42/7B 42/3A	42/10 42/3

As wide a range as is practical is offered within these pages. As will be obvious, the range can be expanded in an almost unlimited way. The combinations offered are no more than suggestions. Cast your eye over them and decide for yourself which color arrangements harmonise, which contrast and which fall somewhere in between.

Introduction

Yellow-orange plus red-orange balanced against a dulled blue. Such combinations have been in use for centuries.

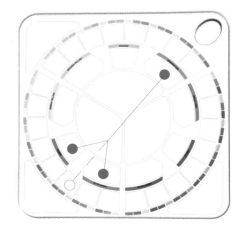

This combination of colors sounds more complicated than it actually is.

To select such an arrangement simply work around any complementary pair. In the color wheel to the left, the complementaries orange-red and blue-green have been selected.

The orange-red remains but the hues either side of its partner, (the blue-green), have been chosen. Possessing a far greater versatility than a straightforward complementary pair, such arrangements have many applications for all users of color.

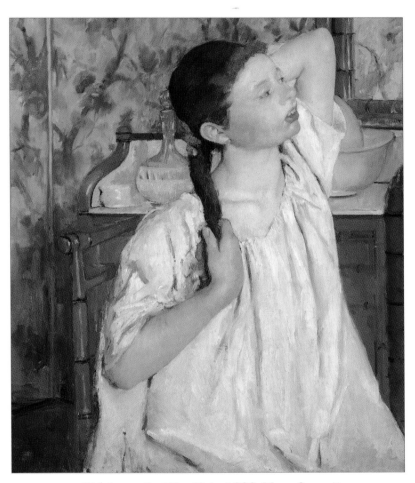

Girl Arranging Her Hair, 1886, Mary Cassatt
Chester Dale Collection, Photograph © 2002 Board of Trustees,
National Gallery of Art, Washington D.C.

Using the harmonising arrangements which can be readily obtained from the complementaries as a base, let us now study other combinations which are closely identified with this way of working.

The 'split opposites' arrangement calls for the initial selection of a complementary pair.

One of the pair is replaced by its neighbours and the three colors are worked together.

Mary Cassatt's painting above gives an example of a complementary and its split opposites.

Based on the relationship between the close complementaries, blue and mid-orange, the blue remains but the mid-orange has been replaced by an orange which leans towards red and a yellowish orange.

243

Shadow Play, Leni Mader

In 'Shadow Play' above, the artist has used a darkened orange-red in the shadows and offset this color with a green-blue (a type of blue) and a mid green. The general complimentary pair are orange-red and blue-green (a type of green).

By going to the colors either side of the green-blue an arrangement which both striking visually as well as being harmonious has been created.

Other colors, such as the yellow, do not interfere with the main theme.

Color harmony, color contrast and visual interest can be obtained via the use of a complementary and its split opposites. It is a perfectly sound approach.

Any three such key colors, with their wealth of possible saturations are able to provide a very extensive range within which to work. The use of this approach gives an additional base color whilst remaining within the complementary pairing description.

You should be wary, however, of placing too much reliance on systems which call for strict color selection.

By all means use one of these methods of color selection, (they are an excellent initial guide), but I suggest that you do not place an excessive reliance on them.

If, with progress, your work calls for additional colors you should not hesitate to introduce them. Always remain flexible, it is not vital that you stay with your initial color plan.

You might start with a *related* group, feel that a little more contrast is required, add a touch of the main complementary, then perhaps a touch of another complementary.

The final result might well be based on an arrangement quite different from your initial intention. What is important is that colors are selected, as you work, *for sound reasons.*

Perhaps a touch of a certain red as a complementary to a green which might itself have been introduced to extend a wider family group, and so on.

Although there is a lot to be said in favour of working to a carefully thought out plan, we should not feel duty bound to follow a particular system, either imposed by others or self imposed.

As with the jazz musician, work around a common theme but do not be afraid to improvise. As long as the improvisation is for sound reasons.

The Interior of the Buurkerk at Utrecht, 1644, Pieter Saenredam
© National Gallery, London

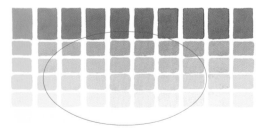

Orange and green-blue

Red orange and green-blue

Mixes from orange and green-blue (above), will provide most of the colors used in the painting. It would appear that a little orange-red was then introduced to lead towards the neutralised, orange-reds in the lower part of the picture. This combination has been used quite extensively over the ages.

Not only by artists but by builders, interior decorators and all manner of craft workers.

Used so widely not because of a knowledge of after-image but simply because the colors can look so well together. When they are carefully modified and balanced one against the other that is.

Orange, green-blue and orange-red

In normal practice the mixing partner for the orange would be either type of blue, violet-blue or green-blue. However, in order to use colors with a relationship to each other it will be more useful to use the same green-blue that appears in this arrangement. Desaturate the green-blue with the orange or orange-red. Use a blue-green to desaturate the orange-red.

1

25/7D
27/6D 25/3D

2

25/8D
26/6D 25/2D

3

44/9D
44/2D 25/2C

4

44/9B
44/2B 25/2B

5

25/10B
26/6B 25/1B

6

44/9A
44/2A 25/3A

7

25/7A
26/6A 25/2A

8

44/8A
44/2 25/2

9

25/10B
26/6A 25/1A

The green-blue can bring a freshness to the orange and orange-red: two hues which might otherwise be difficult to work with.

Harmony becomes increasingly difficult when these hues are used in strength.

This is particularly so because they are naturally bright with a distinct contrast in 'temperature'.

When reduced in intensity one way or the other they can be very versatile.

A Young Woman standing at a Virginal, 1670, Johannes Vermeer
© National Gallery, London

The color use in this painting bears similarities to the approach taken later by the Impressionist painters.

Each main hue is repeated here and there around the painting; with the violet-blue never very far from its general complementaries.

These colors are even repeated in the three paintings.

The dark 'colored grays' of the Virginal and large picture frame can be obtained from a mix of Ultramarine Blue (violet-blue) and a mixed orange.

248

Orange, violet-blue and orange-yellow

Ideally use the violet-blue to desaturate the orange, and vice versa. Blue-green could be used with the orange, and the results would not be too dissimilar, but it means bringing in an additional color. The orange-yellow will need a touch of violet (as used here), to reduce its intensity as the violet-blue will probably make it a little too green.

1
45/10D
45/1D 41/1D

2
45/9C
45/3C 41/2C

3
45/8C
45/2B 41/3B

4
45/9A
45/2B 41/2B

5
45/9B
45/1B 41/1B

6
45/9B
45/1A 41/2A

7
45/9A
45/2 41/2

8
45/8
45/3 41/3A

9
45/10
45/1 41/1

The orange and the orange-yellow have much in common and can be worked together with ease.

These particular colors can be harmonised quite readily as the violet-blue is matched with a pair which both have the hue 'orange' in common. Such closeness is a definite help Being general complementaries 'blue and orange', these three can give rise to strong contrasts as well as subtle harmonies.

Summer, 1914, E. Charlton Fortune
Fine Arts Museum of San Francisco, Museum
Purchase, Skae Fund Legacy

The orange-yellow has been used in a very subtle way, being intermingled with other hues in the bottom left of the painting, in the main grassed area and behind the fence.

Orange-yellow and violet, when well handled, can look very attractive. This, I believe, is illustrated in the study to the left, where the two hues are balanced with the yellow-green.

Orange-yellow, violet and yellow-green

The orange-yellow and the violet make a reasonably close mixing pair. Alternatively desaturate the orange-yellow with blue-violet. This will be a closer mixing pair but at the cost of introducing an additional color. The yellow-green will require a touch of violet-red to desaturate it. Add white to any of the above mixes or directly to the base hues.

1
41/8C
41/2E 36/2A

2
41/10D
41/1D 36/4C

3
41/10D
41/3C 36/1A

4
41/7C
41/2D 11/2D

5
41/10C
41/1D 36/2A

6
41/6C
41/2B 36/2C

7
22/6B
41/4C 36/2

8
41/7D
41/3B 36/3A

9
41/10A
41/3A 10/4B

Orange-yellow and yellow-green can make rather awkward partners unless reduced with white and or their mixing partners.

The violet can be used as an effective 'go between', allowing a modified contrast to add interest.

These three basic hues, together with their various saturations can produce some unusual color arrangements.

If you are looking for a color scheme which is out of the ordinary, this approach might well give it to you.

251

A Convent, Garden, Brittany, 1912, William Leech
National Gallery of Ireland

The contrasts of light and dark, of temperature, of saturation and complementary are all present in this painting. But they are not present by chance.

William Leech was, in my opinion, a great colorist and would have carefully planned this work before commencing.

I have yet to come across advanced color work by an artist who did not have a good understanding of color as a subject.

It cannot, I feel, be an instinctive process. I do not believe that it is a gift.

Without a doubt many a painter can use certain combinations to great effect without any knowledge of color. But those same arrangements tend to appear in all of his or her work.

Just as someone who can play a piano by ear will impress many, so the painter who relies on the same approach time and again will also impress. But the *trained* pianist can become the concert pianist in just the same way as the trained painter can become a great colorist. The position is open for *any* thinking artist.

Green-yellow, violet-red and green

A red-violet will desaturate the green-yellow, yellow-green will lower the intensity of the violet-red and either red will reduce the green. General complementaries, rather than the close complementaries described here will do a very similar job. There are, of course, other ways to produce or to modify a color.

1
29/10C
29/1E 15/6D

2
33/3D
42/2C 9/4C

3
36/9D
09/1D 9/5C

4
29/10C
29/1C 33/10B

5
36/9C
14/1D 14/6D

6
33/2B
42/2B 33/10B

7
36/9A
42/1C 9/5

8
29/10B
29/1B 14/6

9
33/2
29/1B 33/9

When colors are selected on the 'split opposite' basis some unusual combinations can come together. These three are no exception and will give some varied and interesting color schemes.

To achieve harmony it might be better to work on the violet first.

When reduced with white and or its complementary it can be used easily with its partners even when they are comparatively strong.

At strength, the violet can be rather overpowering, as in No. 9 and possibly No. 7. Whether it is or not depends entirely on the viewer. There are no definites when it comes to color.

253

Elena Carafa, 1875, Hilaire Germain Edgar Degas
© National Gallery, London

The complementary pair orange-red/blue-green can be modified into the three main hues used in the painting. As they are based on mixing complementaries (as well as visual), they will give a very wide range of hues; from the bright highlights shown to the neutralised (or dulled) hues and the darks and light grays.

Notice, in particular, the way the theme is extended into the colors of the face, a very nice touch and one that we can learn from.

The color theme is then taken to the door in the background. The same basic colors have been blended into a 'colored gray' which is then further modified by white.

A powerful combination which you can use with ease. Believe me, you can; after perhaps a little practice.

254

Green, orange-red and green-blue

As the color mixing swatches which commence on page 403 will show, either type of red can be used to desaturate the green. A blue-green will reduce orange-red and a red-orange will lower the saturation of green-blue.

1	2	3
38/8D 13/6D 46/1E	38/10D 09/4D 46/1D	38/10D 09/5C 46/1D
4	5	6
38/9D 14/7B 46/3C	38/7C 14/8B 46/2B	38/10C 13/5B 46/2C
7	8	9
38/7B 15/8B 46/4B	38/10A 33/10 46/2B	38/9A 21/9B 46/3

As combinations based on complementaries are taken from the opposite sides of the color wheel, there will always be a contrast of 'temperature'. This contrast will be extreme when these particular combinations are used at full strength (fully saturated).

Not only will the orange-red have a strong temperature contrast with its partners but complementaries also contrast visually in their own right. Temperature and complementary contrasts combined.

For these reasons it usually pays to lighten or darken these hues, or use in small 'touches' when at or near full strength.

The Watering Place at Marly-le-Roi, 1875 (oil on canvas) by Alfred Sisley (1839-99)
National Gallery, London, UK/Bridgeman Art Library

If a complementary pair is taken and inter-mingled both on the palette and within the painting, a wide range of desaturated colors will emerge. In the case of the painting above, these vary from soft dulled oranges through a series of colored grays at differing strength through to muted blues.

Notice the variation in the blues, both green and violet-blue have been employed, neither being very far from a touch of the complementary orange.

As both original colors are desaturated, they can be used over large areas.

Note the interesting touch of orange sand-wiched between the neutralised blues at the far end of the road. Through after-image the orange will be visually enhanced.

As you will see in the detail above, an inter-play between the two colors when both neu-tralised, and also made into colored grays, can add great visual interest.

Violet-blue, orange and green-blue

To reduce the intensity of blue-violet add orange-yellow, for orange use either type of blue and to desaturate green-blue add red-orange. Close complementaries as described here do not have to be used as there are other ways to modify a color.

1
44/1D
49/9D 44/10E

2
44/3D
23/8D 44/8D

3
44/2D
22/8D 44/10D

4
44/2C
49/9D 44/10E

5
44/1D
49/9C 44/9D

6
44/3B
23/9B 44/8B

7
44/3C
22/8B 44/9C

8
44/1B
23/8A 44/8B

9
44/2A
23/10B 44/9A

Used with some modification, violet-blue and green-blue make a versatile couple. If the orange, their basic complementary, is also either lightened or darkened you have a wide range of possible combinations to work with.

With regard to orange; it seems to be one of the most widely disliked hues when applied at or near full strength (fully saturated). As with certain pinks, many either love it or loath it. With this in mind it often pays to take orange towards a tint by either adding white or using a white background. Alternatively it can work well when neutralised (made darker). Particularly dark versions are often described as browns, a color group enjoying wide acceptance. If color groups enjoy things, that is.

The Reader, 1910, Frank W. Benson

Most of us have our own favourite color or color combination. If pressed into making a choice I would say that these three would be my first. What possibly adds to the attraction for me is that I rarely find them used together in a well balanced way. When they are, as in this painting, I find them to be quite beautiful. You might very well feel otherwise, and why not? Color preferences are entirely personal. We might also not both enjoy grapes.

Violet, orange-yellow and violet-blue

The close complementary of the orange-yellow is actually a blue-violet. Remember however, that we are going to either side of the complementary of the orange-yellow, as shown in the palette diagram to the left. Either use the close complementary blue-violet to desaturate or the general complementary, violet.

1
41/3E
41/10E 45/9D

2
41/2C
41/9C 45/9C

3
41/1C
41/10D 45/10C

4
41/1B
41/10B 45/10C

5
41/2B
41/9B 45/10B

6
41/1B
41/9B 45/9A

7
41/2B
41/9 45/9B

8
41/3A
41/8 45/8

9
41/1
41/10 45/10

The violet and the violet-blue make a well balanced pair as they have much in common, both reflecting violet in varying degrees. Color combinations based on the split opposite approach point the way not only to color harmony but also to arrangements which can contrast strongly. For an extensive range, vary the relative strength of the colors and juggle with the areas that they cover. A little experimenting will soon show the way.

Matej Sternen, The Red Parasol, 1904,
The National Gallery, Ljubljana, Slovenia

The two types of red balanced against green are a common theme in nature. They can be worked together very well.

Although there is a slight contrast of temperature between the two reds, it is at its strongest between the reds and the green.

Notice how the strong reds of the parasol have been picked up and repeated in various parts of the painting; from the face, to the leaves in the background and even into the trunk of the sapling. By repeating a color in this way a painting can not only be held together very successfully but color harmony becomes more possible. This is particularly the case when the color is employed at different saturations. You will often see this in nature.

Orange-red, green and violet-red

As green and red are complementaries, either type of red will desaturate whichever green you are using. However, the results will vary considerably depending on the green and red in actual use. It might help to check the color mixing swatches commencing on page 403 before deciding on the color arrangement to use.

1
33/10D
38/10D 33/1D

2
33/8C
38/7D 33/4C

3
33/10B
38/8D 33/2C

4
33/9C
38/10C 33/3C

5
33/9C
38/8C 33/3E

6
33/10C
38/7C 33/1B

7
33/10A
38/7A 33/2B

8
33/9
38/9A 33/1A

9
33/10
38/10 33/1B

Red and green are a versatile pair which can give results ranging from soft harmonies to very strong contrasts.

This is a combination which occurs very frequently in nature. As is mentioned elsewhere, the red and green coloring matter in plants often blend to give the browns and dull red-violets of the stems and leaf stems.

We can certainly learn from this. If, in a painting where red and green are in close proximity you wished to use various 'browns' and dull red violets, it will pay to mix them from the same red and green.

Why introduce 'outside' colors which could cause an imbalance and make color harmony that much more difficult to obtain?

The Window, 1925, Pierre Bonnard
© Tate, London 2002
©ADAGP, Paris and DACS, London, 2002

A particular arrangement of colors, chosen for their potential to harmonise, do not necessarily have to be used over an entire painting.

As in the study to the left, they can be concentrated in one area, with other combinations, such as the blues and violets of the background, used in another.

Moving away from the study, you will notice that each of the principal hues has been repeated elsewhere in the painting:

Violet-red occurs in the rooftops and the side of the balcony. Violet is repeated in the hills and the window frame. With green-yellow appearing in the buildings and also on the window frame. A well balanced arrangement.

Violet-red, green-yellow and violet

The violet and green-yellow can be used to desaturate each other and violet-red is best reduced with a green.

1

42/3D
33/5D 42/6D

2

42/2D
33/3D 42/8E

3

42/1D
33/1D 42/10D

4

42/3C
33/3C 42/8C

5

42/4C
33/4B 42/6C

6

42/1B
33/1B 42/10B

7

42/2
33/3A 42/8A

8

42/2B
33/1 42/10A

9

42/3A
33/2A 42/7

Colored grays have a vital part to play. They occur around the middle of the range and are the result of a complementary pair absorbing much of each others light.

If the colored grays are further reduced with white the results can be very subtle. This is a vital area of color use which is much neglected.

Introduction

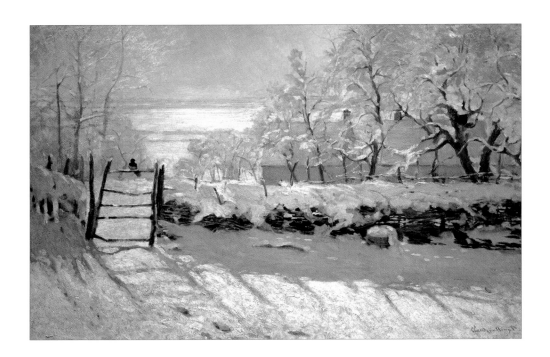

The title is a bit of a mouth full but is really quite harmless. This approach is based on selecting a color and matching it with its complementary.

The colors which lie to either side of one of these are also selected.

It all comes down to a related group (see page 93) paired with its general complementary. Some beautiful, in the (eyes of many), color combinations are possible using this guide to harmony. It offers both variety and subtle contrast.

Personally I find it to be the most versatile of the approaches that we have so far discussed.

264

A complementary pair.

A complementary and its split opposites.

Related hues and the general complementary.

As we move from one approach to another we are simply adding to the basic complementary pairing, bringing together a wider range of hues each time. It is worth bearing in mind that the basic pairings are selected because they are visual complementaries, each giving the others after-image. That they are also mixing partners is an added bonus.

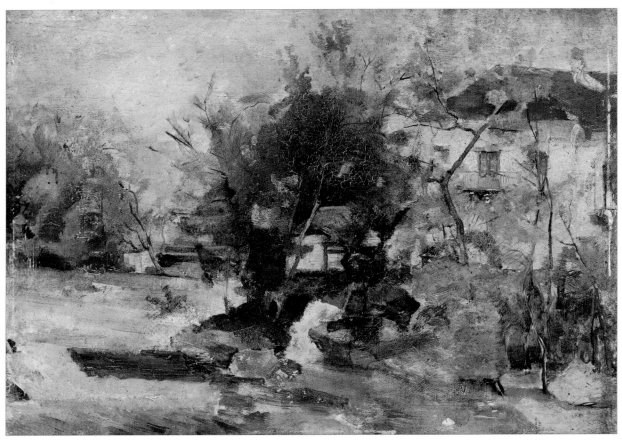

House by the Water, 1888-1889, Jozef Petkovsek
The National Gallery, Ljubljana, Slovenia

It would appear that the violet-red has been desaturated with the yellow-green rather than either of the other two hues. (Please see color mixing swatch to the right).

Notice the range of saturations involved, from very pale dull oranges to deep colored-grays.

Yellow-green and violet-red.

266

Blue-green, green, yellow-green and *violet-red*

The blue-green can be desaturated with white, with the complementary orange-red, or with white and the complementary. Either type of red can be used with the green and yellow-green can be desaturated with violet-red. However, in order to keep the number of colors down as much as possible, the violet-red can be used with all three opposites.

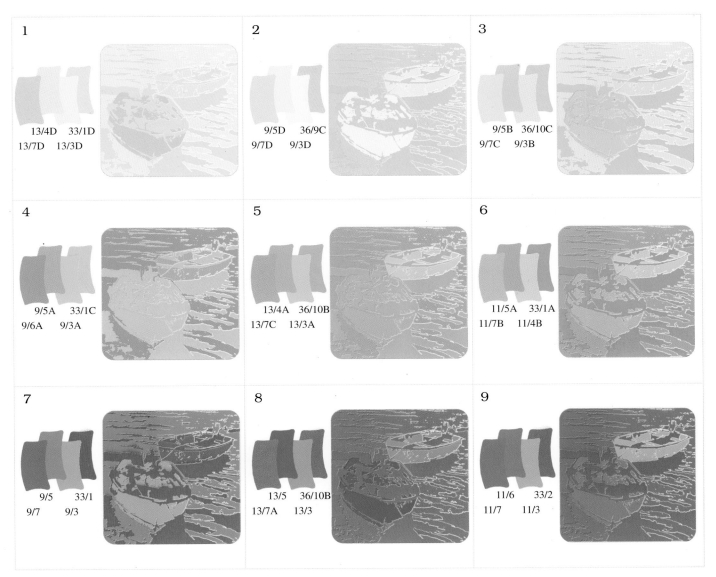

1
13/4D 33/1D
13/7D 13/3D

2
9/5D 36/9C
9/7D 9/3D

3
9/5B 36/10C
9/7C 9/3B

4
9/5A 33/1C
9/6A 9/3A

5
13/4A 36/10B
13/7C 13/3A

6
11/5A 33/1A
11/7B 11/4B

7
9/5 33/1
9/7 9/3

8
13/5 36/10B
13/7A 13/3

9
11/6 33/2
11/7 11/3

The violet-red tends to be easier to work with when applied as a pale tint. As it becomes more saturated it can upset the balance unless the other colors involved are also fairly strong. When all are darkened this combination of hues can take on a rather sombre appearance, as in No 8 perhaps. However, if one or two of the colors are made a little brighter, as in No 9, this effect can be lifted somewhat.

Not an easy arrangement to work with, its main application is probably in floral painting or botanical illustration.

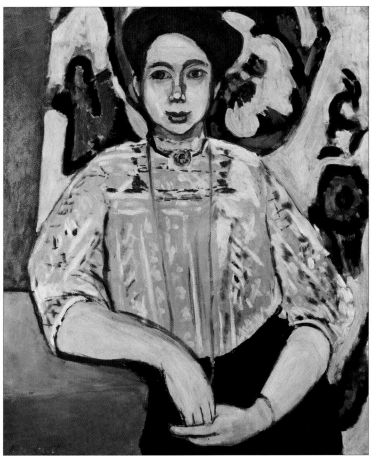

Portrait of Greta Moll, 1908, Matisse
© Tate, London 2002
© Succession H Matisse/DACS 2002

A simple and, I would suggest, very effective use of color. When you are working to a plan that has been carefully thought through, such results (color wise) are easy to obtain.

Many painters go wrong, I believe, because they start with a wide range of colors on the palette and concentrate on line, form, composition and perspective etc. The actual color combinations are sorted out during the painting, not before hand.

These often tend to rely on chance and whatever color happens to be on the brush at the time, particularly at the end of the session!

What also hinders color expression is the belief, held by many, that the actual colors before the painter should be slavishly copied.

Greta, above, might well have been wearing a white top and leaning against a blue whatever it is. She might also have been blonde.

However, Matisse would have been more interested in producing a well balanced piece of color work that in our Greta's wardrobe.

If you have always thought that colors should be copied from life it might be worth trying to use color for its own sake in your next painting. A large gin might help. (I'm kidding).

Green-blue, blue-green, green and *orange-red*

The mixing partner of the orange-red is a blue-green. The green-blue can be desaturated with a red-orange, or the same orange-red as employed here. To desaturate the green use either type of red but ideally the same orange red as employed in this arrangement.

1
38/1D 38/10E
46/2D 21/10C

2
38/2C 38/8E
46/3C 21/8D

3
38/3C 38/7D
46/1D 21/10C

4
09/7C 38/9C
44/8C 09/5C

5
11/7B 38/10B
11/10C 11/5B

6
38/1B 38/9A
46/1C 21/8B

7
38/3B 38/7A
46/2B 21/9C

8
13/7C 38/10A
13/10C 13/5C

9
09/7 38/10A
09/10B 09/5

The three 'cool' hues can be balanced very well against the 'warm' orange-red. Although it takes a little practice and care to harmonise (rather than contrast) these three, the end result can be very pleasing.

With all the possible tints (lightened color), neutrals (darkened color) and tones (a colored gray mixed with white), these four basic hues offer tremendous potential to the imaginative painter.

Obviously, only a tiny fraction of the possible combinations can be shown above. It will be worth a little experimentation if you find this general arrangement to be of interest.

View of the Siene at Carrieres-sur-Siene, 1906
by Maurice de Vlaminck (1876-1958)
Galerie Daniel Malingue, Paris, France/Bridgeman Art Library
© ADAGP, Paris and DACS, London 2002

Blue-green and orange-red

Blue-green and violet-red

As you will see from the mixing swatches above, not only can many of the various reds and blue-greens be mixed with ease, but the darks of the central tree trunk and building can also be produced this way. The darks are available because the basic complementary pair is red and green.

As they are mixed they absorb each others light, leading to the dark 'colored grays'.

Red-orange has also been used, giving the wider range of colors shown in the work.

A difficult foursome to work with but the artist has, I feel, offered a well balanced arrangement despite the strong contrasts.

270

Red-orange, orange-red, violet-red and *blue-green*

Desaturate with white, with the complementary or with white *and* the complementary. For red-orange add green-blue, for the blue-green add orange-red (and vice versa) and for the violet-red add a touch of yellow-green.

Alternatively use the same blue-green with the other three in order to keep the number of hues limited.

1
38/10D 38/1B
26/8E 39/9D

2
38/9C 38/1E
26/9D 39/10D

3
38/8D 39/1C
26/7C 39/8C

4
38/8C 38/1D
26/8C 39/10C

5
26/10C 39/2D
26/7D 39/9C

6
26/10B 39/1B
26/8C 39/9B

7
38/8A 38/1A
26/8B 39/8B

8
26/10C 39/2A
26/7B 54/2B

9
38/9B 38/2
26/9A 39/9A

The two reds, orange-red and violet-red can be rather difficult to work with in the same piece. Much in the same way that the two types of yellow can give problems. To help overcome this tendency it pays to vary the intensity of one to another.

Nocturne: Blue and Silver - Chelsea, 1871, J.A.M Whistler
© Tate, London 2002

I have shown these two paintings together to illustrate the fact that once the basic color combination has been chosen, the possibilities are almost endless.

In the work above, the orange-yellow plays a very minor role against the other three hues. In the painting to the right it plays the major part.

'Formulas' which suggest that colors have to be applied over certain areas in relationship to each other and at certain intensities are a nonsense and should be ignored: it is only the skill of the artist that is important.

In the painting to the right you will notice that in some areas the orange-yellow has been mixed with one or other of its partners. You should not hesitate to do this as you work although care must be taken if you are to maintain color harmony.

Krizanke in Autumn, 1909, Rihard Jakopic
The National Gallery, Ljubljana, Slovenia

Violet, blue-violet, violet-blue and *orange-yellow*

Desaturate with white, with the complementary or with white *and* the complementary. The orange-yellow and the blue-violet are mixing complementaries and will desaturate each other very efficiently. Use either type of yellow with the violet and yellow-orange with the violet-blue. Alternatively use the same orange-yellow with all three opposites.

1
41/1D 41/3C
22/6D 22/10D

2
23/7C 41/2C
24/6B 23/10C

3
23/9D 41/3C
23/8C 23/10B

4
22/7B 41/2D
22/5C 22/10B

5
22/7C 12/01C
22/5B 22/10B

6
22/08C 41/01B
41/10B 22/10B

7
22/8A 41/2B
22/6C 22/10D

8
22/7C 41/3B
22/5C 22/10A

9
22/8B 41/1A
22/6A 22/10C

Orange-yellow can be rather difficult to work with when at or near full saturation, as it can appear a little brash.

However, when modified and well balanced with the other hues the results can be very attractive (to my eyes, that is, you might well have other ideas, in which case we will both be right). Although seldom handled well, in my opinion, this combination can give outstanding harmonies in all forms of work.

The Magpie, 1869 (oil on canvas) by Claude Monet (1840-1926)
Musee d'Orsay, Paris, France/Bridgeman Art Library

The painting above will, I believe, show what can be done when colors are pre-planned and applied with skill and sensitivity.

The two types of blue, played one against the other, work very well with the blue-greens. These 'cooler' colors are set off with the slightly 'warmer' neutralised red-oranges of the buildings.

Very small touches of red-violet and orange-yellow add to what is (to my eyes), a beautiful color arrangement. A calm, peaceful scene which fully conveys the influence of the snow laden sky. And all achieved through the careful and *knowledgeable* use of color.

One hue, with its range of saturations will give a vast range of individual colors to work with.

Two, particularly if they are complementaries will give enormous scope.

Four basic hues will give an almost unlimited range of individual colors and color combinations.

The few suggestions shown on the opposite page are necessarily very limited, they are to give possible starting points only.

I strongly suggest that you will gain far more by experimenting with the possibilities than confining yourself to any of my suggestions.

Violet-blue, green-blue, blue-green and *red-orange*

In order to keep the number of colors in use to a minimum the red-orange can be used to desaturate all three of its partners in this arrangement. Alternatively, use the more direct mixing partners. For violet-blue add yellow-orange, the red-orange and green-blue are mixing partners and will desaturate each other. Add orange-red to reduce the intensity of the blue-green.

1
20/9D 27/9E
45/8C 20/5C

2
46/1D 26/8E
45/10D 13/9C

3
20/10C 27/7D
45/9D 20/6D

4
46/2C 26/9C
45/9C 13/8D

5
46/2D 26/7C
45/8B 13/8C

6
20/10B 27/8C
45/10B 20/7C

7
46/2B 26/8A
45/9B 13/8B

8
46/3B 26/9A
45/7B 13/9B

9
20/10A 27/8B
45/10 20/5B

The two types of blue, violet-blue and green-blue, set up an interesting but subdued contrast which is often found in early Chinese and Persian work. When well balanced they can be very effective.

The complementary red-orange, when used with skill, can add a contrast varying from the subtle to the extreme. The blue-green is somewhat of an outsider and should be treated with a little care. When reduced in intensity it can have an important role to play in this versatile arrangement.

Portrait of Hermine Gallia, 1904, Gustav Klimt
© National Gallery, London

Apart from touches of green-blue and green in the background, the rest of this painting reflects the colors under discussion.

However, these hues are applied in a very delicate form and are sometimes difficult to distinguish. The green-yellow, for example, has been applied very faintly around the neck and appears in the lower front of the dress.

Colored grays, which appear to have been mixed from green-yellow and violet appear throughout the dress, particularly at the lower back, where they are applied a little heavier than elsewhere.

Touches of very faintly applied violet-red, red-violet and violet appear in the rest of the figure, mingled with the colored grays.

They also recur behind the subject, linking figure and background.

As has been mentioned, a particular color scheme need not be used over the entire area of a painting. A small, or in this case, larger section can be treated as a separate color study. This approach can be very effective when colors from the main study appear elsewhere, as with the pale red-violets of the background for example.

Violet-red, red-violet, violet and *green-yellow*

Either use the same green-yellow to desaturate the other three or use their actual mixing partners: violet-red/yellow-green; green-yellow/red-violet; red-violet/yellow-green and violet with either type of yellow, orange-yellow or green-yellow. Here I have used simple mixes for the related hues and subdued the green-yellow with violet. It is just one of the approaches that can be taken.

1
22/3D 42/1E
22/1D 22/6D

2
24/4C 42/2D
24/1C 24/6B

3
22/3C 42/1C
22/1C 22/5C

4
24/4A 42/1C
24/1B 24/6A

5
24/3B 42/1B
24/1B 24/6B

6
24/2C 42/2B
33/2A 24/6A

7
22/3A 42/1A
22/1A 22/5B

8
22/3 42/1B
22/1 22/5A

9
24/3 42/2B
24/1A 24/6

To many, these four hues tend to harmonise only when they are all reduced with white, or with white and the complementary.

The green-yellow, in particular, can add unwanted contrast at strength and needs to be used with some care. Unless you are seeking such contrasts that is. Swatch No. 7 is an example of the type of contrast that I am referring to.

As with any close to or fully saturated color it can always be used over smaller areas in a piece of work.

The Hayfield, Adolphe Monticelli 1824-1886
Hugh Lane Gallery, Dublin

Yellow-greens *Green-yellows* *Orange-yellows* *Red-violets*

Monticelli's work has been described as 'dripping with light and saturated with warmth'.

Although we might not find it exceptional, such bold use of color was unusual for his time and influenced many of the Impressionist and Post Impressionist painters who were to come later.

The speckles of white used liberally in this painting suggest another possible way to encourage a painting to harmonise.

White, being a neutral color, can be scattered about a painting almost with impunity and it can certainly help to hold the work together.

Yellow-green, green-yellow, orange-yellow and *red-violet*

For ease, and to keep the range limited, the red-violet can be used to desaturate the other three hues. Alternatively, use the closer mixing partners: yellow-green/violet-red; red-violet/green-yellow; green-yellow/red-violet and orange-yellow/blue-violet or a mid-violet. There are many ways in which a color can be taken in another direction.

1	2	3
13/1D 22/3C 13/4D 41/3C	9/01C 22/2C 09/4C 41/3C	10/1C 24/3C 10/5C 41/2B
4	5	6
09/1B 22/2B 09/3A 41/3B	10/1B 22/3B 10/4B 41/3B	10/1A 24/4A 10/4 41/2A
7	8	9
13/1A 22/2 13/3 41/2A	09/1 22/3 09/3 41/2	09/1B 24/3 09/3 41/2

The use of the two types of yellow in the one piece, green-yellow and orange-yellow, can introduce slight discord as they do not always sit well together.

It might pay to lighten or darken one or both to reduce intensity. Alternatively use them over relatively small areas or keep them separated.

Still life with Oranges and Walnuts, 1772, Luis Melendez
© National Gallery, London

The Market Place, Whitby by Charles Martin

Two paintings showing two quite different approaches.
The proportions and range of available mixes offer almost endless variety.

Orange-yellow, yellow-orange, orange and *violet-blue*

A variety of approaches have been taken to alter the intensity of the colors in these swatches. If using our mixing palette, the complementaries, either close or general will be found opposite each other.

1

26/3D 45/8D
41/3C 45/3C

2

26/4C 45/10D
26/1D 45/2D

3

26/3A 45/10C
26/1D 26/6C

4

26/3B 45/9D
41/2C 45/1B

5

26/2C 45/9C
41/2B 45/2B

6

26/3C 45/7B
26/1B 45/2B

7

26/2C 45/10B
26/1A 45/1C

8

26/3B 45/8A
26/1A 45/3A

9

26/2B 45/10A
41/4A 45/2C

The combinations shown on these pages are only suggestions. Drop a color and use just three or 'borrow' a hue from another swatch.

With the almost unlimited range of possible combinations neither this, or any guide that I can imagine, could ever be definitive.

Danae, 1907-8 by Gustav Klimt (1862-1918)
Private Collection/Bridgeman Art Library

The work of an artist who clearly understood color, in particular the effect of the after-image.

Many artists of this era shared the knowledge handed down by the earlier Impressionist painters. There then followed a brief period where this information was used in a wide range of painting styles.

Then, with only a handful of knowledgeable artists as the exception, we drifted into an understanding of color which found its equivalent in Medieval times.

I feel that this is where we still are today, with many an art teacher (fortunately not all), simply walking away when asked a question on color, materials or technique. This is common, even at university level.

'Express yourself, be free' students are told. How? Through ignorance?; And then what?

It is as if any matter which could be described as being even slightly academic (particularly if scientific), has to be avoided at all costs.

An art student requires a lot more than a strange wardrobe and the ability to describe the latest study in twenty invented phrases.

A three year degree course, for example, could well accommodate a year of study before a brush is even picked up.

Orange, red-orange, orange-red and *green-blue*

Reduce intensity with white, with the complementary or with the complementary and white. Mixing complementaries will be found opposite each other on the color coded palette shown to the left. A variety of approaches have been taken to produce these swatches. No. 2, for example, shows an orange and a green-blue which have been reduced with each other. The red-orange is a simple mix and the orange-red has been reduced with a blue-green.

1
30/8D 44/8D
44/1D 38/7C

2
30/7D 44/9E
44/2C 38/8B

3
30/9D 44/10E
44/1C 30/10C

4
30/7C 44/8C
44/3A 30/10D

5
30/8C 44/9C
44/1B 30/10B

6
30/9B 44/10B
44/3C 30/10C

7
30/8B 44/8A
44/2C 30/10D

8
30/7D 44/10
44/4B 30/10E

9
30/9C 44/9
44/2A 38/8D

As with all color combinations it can never be the case that these two, three or four colors harmonise. It depends entirely on how they are used, at what saturation and over what area etc. Ultimately of course, it depends on the viewer.

Introduction

A

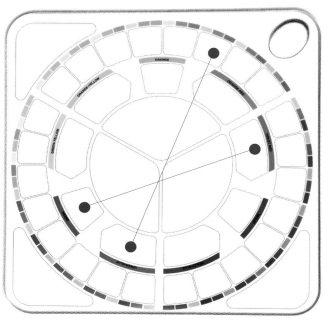

B

A wide range of harmonies and contrasts are available from a complementary pair.

The selective addition of a second pair can increase the range of available colors without detriment to color harmony. However, to select two pairs of complementaries and make them work well together does call for some care.

Such arrangements are usually described by titles such as 'double split complementaries',

As these tend to sound more like ice creams, I will describe any such arrangement simply as 'two pairs of complementaries'.

I feel that we should be relaxed when selecting two such pairs.

We are often informed that 'this pair' together with that 'exact pair' should be used. In diag. A above I have indicated the use of two *close* complementary pairs, Yellow-green/violet-red and green-blue/red-orange.

Close complementaries are to be found oppo-

site each other on the mixing palette.

In B, above, I have selected the same close pair green-blue/red-orange but matched it with a *looser* or *general* complementary pair, green and violet-red. (Green and violet-red rather than a specific green and violet-red).

Mid green (rather than a yellow-green) and violet-red are not exact complementaries and they are not to be found directly opposite each other on the palette. But, and this is an important 'but', they can be worked together very successfully.

Understand all that you can about color and then relax, be flexible and bend every 'rule' that you come across. But the understanding *has* to come first if you wish to extract the most from color. Any two sets of complementaries can be worked together successfully, whether they are close or general.

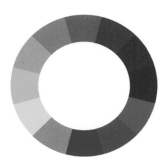

The 12 hues of most traditional color wheels do not allow for the fact that pure red, yellow and blue do not exist.

Two types of each primary are required for full mixing and color use guidance. I believe that a practical, working color wheel requires a minimum of 24 basic hues.

In the case of our mixing palette, where an outer wheel color ● is linked to ○ it indicates that the same color applies to both positions.

Green-blue for example can be placed into either the arrow shaped well or into the well behind it, as indicated.

The violet, green and orange positions (left blank above) are simply mixing aids and represent either color immediately behind. Or, to be exact, a mix of them..

The color wheel that I have based my mixing palette on has 24 separate hues allocated to the outer mixing wells, Conventional color wheels usually show around 12.

One of the reasons for the difference is due to the fact that color wheels traditionally show a red, a yellow and a blue as if they were pure and separate colors. In fact, these colors do not exist in a pure form, as readers of my book 'Blue and Yellow Don't Make Green' will be aware. Every red is either a violet-red or an orange-red.

Each blue either leans towards green (a green-blue) or towards violet, (a violet-blue). Similarly every yellow you will ever come across will

either be an orange-yellow or a green-yellow. I have incorporated these additional colors into the mixing palette 'wheel' as they are vital for accurate color mixing and use. My approach therefore is based on the colors that we actually have to work with.

Whereas the traditional wheel would show, for example, red and green as opposites, this is not the case with our way of working. Two types of red lie opposite green, not one.

Let's go back to basics for a minute. In general terms we can say that the following pairs are both visual and mixing complementaries:

Red and green, blue and orange and yellow and violet.

285

1.

2.

3.

4.

1. A mid-orange can be paired with either type of blue.

2. Likewise violet with either type of yellow and

3. green with either type of red.

Closer complementary pairings are easily identified (4&5), but we should be careful not to become too concerned with such detail when working with color.

The complementary of orange is given as blue on the standard color wheel. But which blue? As mentioned, we do not have a pure blue to work with. Therefore orange has to be matched either with a green-blue or a violet-blue.

As with orange, there is not an easily identified complementary to red as pure red does not exist. A mid-green therefore can be paired with either a violet-red or an orange-red.

Mid-green is actually rather difficult to define as a hue because it usually leans slightly towards yellow or towards blue. For this reason I have included both yellow-green and blue-green into my 'wheel' and have placed their rather more precise complementary partners opposite.

If you are working with a definite yellow-green you will find that its partner is a *violet*-red.

If the green leans towards blue, a blue-green, its partner will be an *orange*-red.

Violet is another hue without a precise complementary. Yellow is usually given as its partner on the conventional wheel. Again, the question has to be asked, which yellow?

Even a yellow which appears to be 'pure' will lean either towards green or orange.

(In scientific terms yellow and *blue*-violet are complementaries, but we are working in *pigments* and have to take into account the colors that are actually available to us).

Having identified the choices; green with either type of red as *general* complementaries, yellow-green and violet-red as an example of *close* complementaries, I have to say that there can be a danger in trying to be too precise about the exact pairing of complementaries.

Color pairings which are reasonably close will give similar results. In fact, it often pays to experiment with color pairings which are not close complementaries but which are suitable for the work in hand.

I do not want to give a double message here. Exact complementaries will give more predictable results and should be fully understood, but in practice we should remain flexible.

A close understanding of color will enable you to develop your sensitivity to it. But the understanding has to come first.

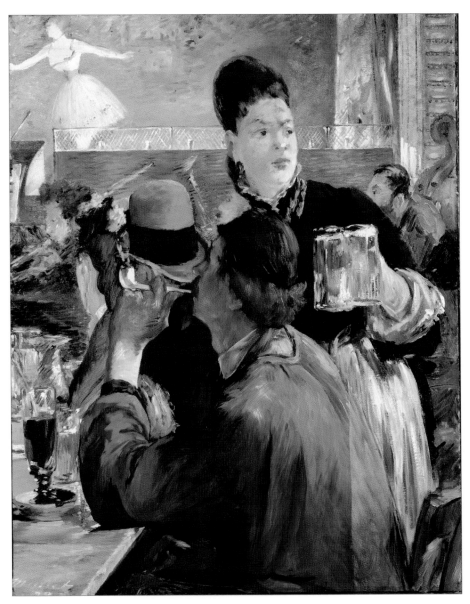

Corner of a Café-Concert 1878, Manet
© National Gallery, London

In this work Manet used the complementary pairs blue/orange and yellow/violet.

Let us consider the thinking that might have gone into the *planning* of the painting; this was not 'make it up as you go' time.

For a start, the lighting in this type of establishment would almost certainly have been 'warm' in color and have allowed for the liberal use of orange, which could be exaggerated if need be without loss of credibility. Orange in this scene was an ideal base color. It was used in the faces and hands, in the drinks and, with some desaturation, to give a range of browns and 'colored grays'.

With so much 'naturally occurring' orange, it was almost inevitable that blue (its after-image), would be chosen for the shirt worn by the central figure.

Wherever you look on this painting you will find examples of the complementaries being worked closely together in a wide range of saturations.

To build on both the harmony and the contrasts available from blue and orange, touches of one have been introduced into the other.

Blue is mingled with the orange of the waitress' apron and on the bar top. The small dab of clear blue introduced between the orange of the beer glasses she is holding is a very nice touch.

Other examples of this color pair, either placed together or used to desaturate each other are also to be found.

Manet gave variety to the blues of the shirt by desaturating them with orange to produce darker blues, with white to give tints and with both orange and white to provide colored grays and their tints.

A *related* group, blues and blue greens are used in the backdrop to the dancer.

Since the background is mainly blue-green, the orange-red used in the figure is almost a predictable choice.

Note the range of orange-reds and the way in which they have been used; desaturated with white for the flesh and with white and blue for the clothing.

These desaturated orange-reds have been cleverly and subtly intermingled with touches of blue.

The red-orange of the dancers hair is relatively saturated. Judging by the large number of redheads to be found in the paintings of the Impressionists, France must have been swarming with them at the time.

I feel certain that their prevalence was due to the versatility of blue; it can be used to depict clothing, buildings, water and sky etc.

The frequent use of this hue often led to the introduction of its complementary. A reddish orange was therefore the natural choice for the dancer's hair. It would not have mattered to Manet if she had been a blond or a brunette.

Like the other Impressionists, he was very aware of the effect of the after-image.

Nowadays, many artists would feel that they had to paint what they saw, blond or otherwise. Are we missing something?

Color was introduced into the background in other interesting ways. For example, touches of orange and white to give the *contrast of saturation*. Other contrasts such as those of *light and dark* and *temperature* also occur within the painting.

Note also the variety of blues, saturated and also employed as tints, which have been used in the dancer's top.

An interplay of yellows and violets. Art and science (after-images etc.) came together briefly, as they had during the Renaissance. It was not to last.

In the top right of the painting Manet introduced the second complementary pair, violet and yellow. The yellow has been variously desaturated with white, with its complementary violet and with white *and* violet.

As balance, the violet appears to have been desaturated with yellow (as in the figure of the musician). Touches of violet also appear in other parts of the painting. Notably on the left side of the painting, as shown above.

Yellow has been introduced elsewhere, particularly into the orange patches.

In my opinion, this painting demonstrates a very skilful use of color. Every touch of every hue has a definite place and a specific purpose. This was not a painting that 'put itself together' as work progressed. It was planned.

The work involves two pairs of complementaries which have been employed in a wide variety of saturations.

The only thing stopping most painters working to this level is a lack of information about color in general, the after-image in particular and color mixing. All are overcome-able.

Two Children Playing on the Sand Dunes, 1877, Eva Gonzales
National Gallery of Ireland

As four basic hues, together with all possible variations are involved, the color swatches shown opposite can only be a tiny selection of possibilities from countless millions.

One or the other might be useful as a starting point perhaps, but they can give no more than very general guidance.

It is a case of deciding upon a particular approach, placing the basic hues on the palette and carefully constructing the balance as you work.

Although I believe that color planning is very important, it should not be at the expense of flexibility or the pursuit of happy accident.

290

Blue-violet/orange-yellow & green-blue/red-orange

Use the color pairs to desaturate each other. This they will do very efficiently as they are mixing as well as visual complementaries. Alternatively use general complementaries.

1

41/1D 27/8D
22/7D 44/9D

2

41/2D 26/9D
22/8D 44/10D

3

41/3D 26/8C
24/7C 44/9D

4

41/1B 26/8B
22/7B 44/10B

5

41/2B 27/7B
23/7C 44/9C

6

41/3B 27/8
22/7B 44/8C

7

41/2 27/8
22/7A 44/9A

8

41/2A 26/8A
22/8A 44/10

9

41/1A 26/8
22/9 44/9

Subtle and unusual harmonies are available from these hues if the potentially strong contrast of complementary as well as 'temperature' is modified.

If you wish to introduce contrast this arrangement is a very useful and versatile way to draw attention to your work. Strongly contrasting colors can be very attractive.

These paintings are based on the same two complementary pairings. Similar arrangements are to be found in other works by the artist.

A combination which is found to be successful, as far as the painter is concerned, lends itself to countless interpretations.

An elderly lady artist of my acquaintance used the same four colors over a long and creative career. She produced very attractive paintings by the hundred. Not one was the same as another.

Apart from anything else, this illustrates the necessarily limited nature of the suggestions on the opposite page.

Poplars on the Banks of the Epte, Autumn 1891
(oil on canvas) by Claude Monet
(1840-1926)
Private Collection/Bridgeman Art Library

Claude Monet, Stacks of Wheat (End of Summer) 1890/91, (oil on canvas) The Art Institute of Chicago.

Green-blue/red-orange & green/violet-red

The green-blue and the red-orange will desaturate each other as will the green and violet-red. White will reduce intensity even further. There are many ways to alter a color and the approach should not be too rigid. For example, red-orange is the close complementary of green-blue. But in these swatches I have chosen to use the dulled orange, Burnt Sienna to reduce the green-blue. Once you understand color mixing the 'rules' can be bent as you see fit.

1

26/9D 21/1E
46/1C 21/10D

2

26/8D 21/3D
46/2C 21/10D

3

26/9C 21/2D
46/1D 21/9C

4

26/8C 21/1C
46/2D 21/10B

5

26/8A 21/1C
46/3B 21/9B

6

26/9B 21/1B
46/1A 21/8B

7

26/8B 21/2B
46/3 21/8A

8

26/8B 21/2
46/2 21/10A

9

26/9A 21/2A
46/2A 21/7B

The violet-red can add a touch of subtle sophistication when used with caution. Lighten, darken or use over small areas.

In my experience, these combinations are a lot easier to employ when all four are further reduced with white. You might find otherwise.

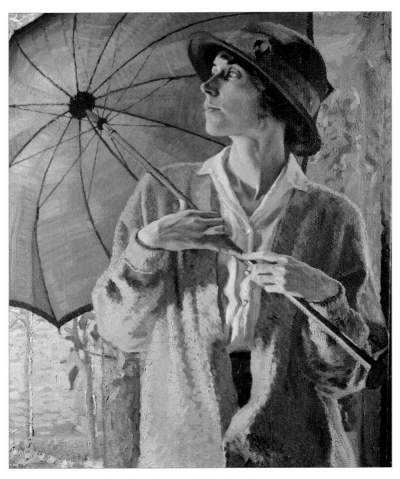

The Sunshade, 1912, William Leech
National Gallery of Ireland

With four basic hues and their vast range of possible mixes, the combination shown above is only one of countless millions: as are the swatches to the right.

Just as it took only a handful of notes to produce some of the greatest musical master-

pieces, so it only takes a few basic hues to produce a color masterpiece.

It is open to anybody with a knowledge of color mixing and color use to produce such work. You could be the next great colorist even if you cannot draw.

294

Orange-red/blue-green & red-violet/green-yellow

To reduce intensity add white and/or the mixing partner. Whenever you come across reference to the addition of white on these pages, take it to mean white paint or the effect of a white background on thinly applied paint.

1
38/1D 42/1D
38/10D 22/3C

2
38/3D 42/2C
38/9D 22/2C

3
38/1B 42/2B
38/10B 22/2B

4
38/3C 42/2C
38/8B 22/3C

5
38/1C 42/1C
38/10C 22/3B

6
38/3 42/2
38/9 22/3

7
38/2B 42/1B
38/10A 22/3A

8
38/1 42/1
38/10 22/3

9
38/2 42/1A
38/10 22/2

At or close to full strength (fully saturated), these foursome can take on a 'carnival' atmosphere. When considerably reduced with white they can be harmonised quite readily. This is also the case if they are darkened, but the results can then look rather sombre. This is not to suggest that they cannot be harmonised at strength, but caution is advised.

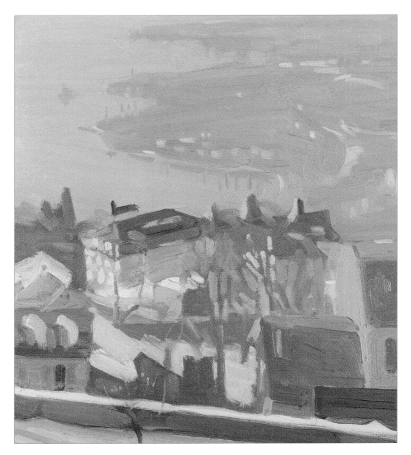

Glion, William Leech. 1912, Private Collection

Red-violet/green-yellow.

Blue-violet/orange-yellow.

Apart from the small touches of green and red-orange, the rest of the painting features only the two complementary pairs under study.

Each has been so reduced in saturation, by one method or another, that the individual colors may not be immediately obvious.

Very subtle contrasts and harmonies can be produced this way, but first of all, color mixing has to be mastered.

I believe that it is because of our general lack of skill in this area that many attempts to produce harmonious work fails.

296

Red-violet/green-yellow & blue-violet/orange-yellow

The above mixing complementaries are also optical complementaries. Therefore they will not only desaturate each other in mixes very effectively but will enhance each other visually when applied with care.

1

42/1D 41/3D
22/4D 22/8C

2

42/2B 41/1C
22/2D 22/7D

3

42/3B 41/1C
22/3C 22/7C

4

42/3A 41/1B
22/4B 22/7C

5

42/2B 41/1C
22/2B 22/8C

6

42/1C 41/1B
22/3C 22/8B

7

42/1 41/2
22/3 22/7

8

42/2 41/1A
22/3A 22/7A

9

42/1B 41/2A
22/2A 22/8A

This is basically a violet/yellow combination, with variety added by the use of two versions of each color. As such it lends itself readily to providing well balanced and versatile harmonies to be used over areas of a painting or indeed to provide for the entire painting.

Strong contrasts are easily set up when these hues are used at anywhere near full saturation.

Desaturating with a 'touch' of the mixing partner plus white can be a useful approach to take.

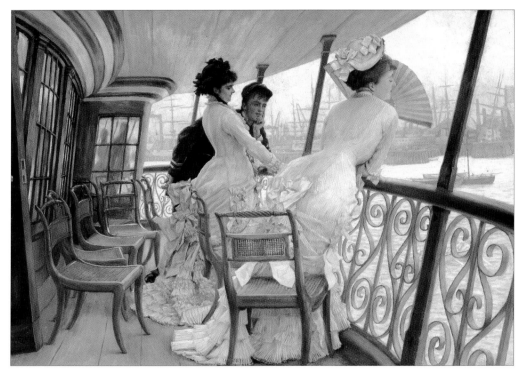

The Gallery of HMS Calcutta, 1876, Tissot
© Tate, London 2002

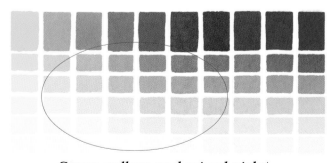

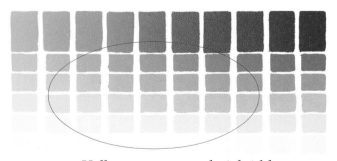

Green-yellow and mixed violet

Yellow-orange and violet-blue

If you look around the two mixing swatches above you will be able to pick out many of the color types in the painting. It appears that a touch of red has been added to give the dulled orange of the chairs. Further refinements will be available through additional mixing.

To produce such exquisite (to my eyes), color work as the above all you need are four base colors and a knowledge of color mixing.

Oh, and a touch of genius, but I am sure you can manage that.

Violet/green-yellow & violet-blue/yellow-orange

The violet and the green-yellow will desaturate each other in mixes as will the violet-blue and the yellow-orange. This does not mean that you should restrict yourself to this approach as both close and general complementaries will do much the same job.

1

42/1D 28/2C
42/7D 45/8D

2

42/1B 26/2B
42/8C 22/10D

3

42/1A 28/3C
42/9C 45/9C

4

42/2B 27/3C
42/8B 23/10C

5

42/2C 26/3B
42/9D 23/10C

6

42/3A 27/2B
42/10A 22/10B

7

42/1B 26/3B
42/10B 23/10C

8

42/3B 27/3B
42/9A 22/10C

9

42/2B 27/3C
42/8B 45/10A

If any of these four hues are used at or near full strength they can quickly dominate and cause discord. This is particularly the case with green-yellow I feel.

When reduced in intensity by one means or the other they can give rise to some very attractive color arrangements. An arrangement many will find worth exploring.

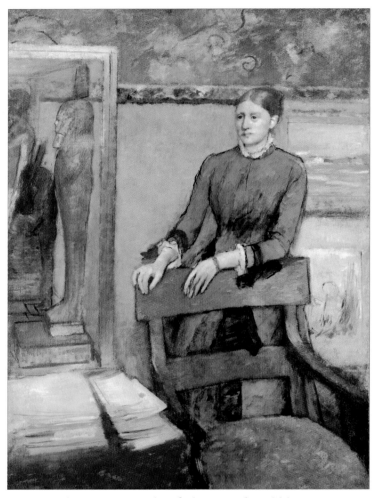

Helene Rouart in her fathers study, 1886, Degas
© National Gallery, London

Violet-blue/yellow-orange

Blue-green/orange-red

The two color mixing swatches above will barely indicate the potential ranges that are available. Through further mixing this resource becomes vast.

Notice how the *very pale* blue-green of the papers (bottom left), has been contrasted with the *very dark* orange red: Contrasts of complementary, light and dark and 'warm' and 'cool'.

Violet-blue/yellow-orange & blue-green/orange-red

Either reduce the base colors with white, with the mixing partner or with white *and* the mixing partner. Violet-blue and yellow-orange are mixing partners as are blue-green and orange-red.

Alternatively use general complementaries rather than the close partners listed here.

1
28/3D 32/1E
45/8C 13/9D

2
26/3D 38/10D
45/8D 20/6C

3
28/2C 32/2D
45/9D 13/8D

4
28/3C 32/2C
45/10B 13/9B

5
26/2B 32/1B
45/10C 20/6A

6
26/3B 38/8A
45/8B 13/9A

7
26/2A 38/7B
45/10B 20/5C

8
26/2B 32/1B
45/8B 20/6A

9
26/2B 38/9
45/10A 13/8A

At or anywhere near full strength these hues will set up strong contrasts at the expense of color harmony. Used in a desaturated form they can provide some very unusual and versatile combinations. Worth exploring in any form of color work.

Peace - Burial at Sea, 1842, J.M.W. Turner
© Tate, London 2002

Orange-yellow and violet.

Turner, that great colorist, was a master of the 'colored gray'. In the painting above the dark colored grays (as well as many of the very pale grays), appear to have come from a blend of the orange-yellow of the centre and violet. The latter appearing in a very faint form behind the central ship.

The spot of bright violet-red amongst the smoke is a very nice touch. (Please see detail above). Elsewhere, the violet appears to have moved a little towards blue and, together with an extremely subdued yellow-green, gives the color of the sky and possibly some of the colored grays in the water.

302

Violet red/yellow-green & violet/orange-yellow

Violet-red and yellow-green will reduce each other in mixes as will the violet and the orange-yellow. There are, of course, other approaches that can be taken.

You will discover some of the alternatives if you compare these swatches with the color mixing swatches which commence on page 403.

1
36/1D 41/3C
36/9D 41/10D

2
36/3D 41/3C
36/8D 41/9D

3
36/2D 41/3B
36/10D 41/8D

4
36/3C 41/2C
36/7C 41/8C

5
36/3B 41/1C
36/8C 41/9C

6
36/2C 41/2C
36/9C 41/10C

7
36/4A 41/2A
36/9B 41/8B

8
36/1C 41/2B
36/10B 41/9B

9
36/2B 41/2
36/9A 41/8A

These pairings can give unusual harmonies but the orange-yellow tends to dominate unless checked.

As with all complementary pairs they can be encouraged to enhance each other and contribute towards color harmony.

Introduction

The addition of white, gray or black to an arrangement of hues will add a further dimension and help to create additional harmonies.

Indeed, colors which might otherwise be difficult to harmonise can often be made workable this way.

As you will see, your knowledge of the effects of after-image will be a great help in forecasting the results of incorporating white, gray or 'black' into your work. I write 'black' this way as we will be examining our approach to this color in the coming pages.

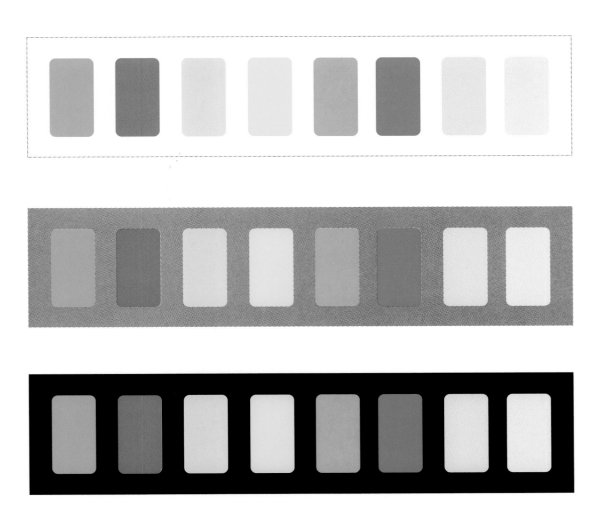

Surrounding a color with white tends to darken it and reduce its brilliancy. As you will be aware, the reason for this is that the after-image from white (light) is black (dark).

The dark after-image will, through eye movement, flood over the various hues, altering them as it does so. This is particularly noticeable with light, bright hues such as yellow.

Gray has a calming and neutralising effect, particularly when surrounding the brighter hues.

Black, (or preferably a mixed dark in painting), surrounding a hue causes it to appear richer, almost glowing. This is particularly the case with red. They have often been placed together by painters for this very reason.

Stella in a Flowered Hat, 1907, Kees Van Dongen
The National Gallery of Ireland

This painting does, I feel, illustrate the effect of white on a variety of colors. When white *paint* is used rather than a white background being allowed to show through, the overall effect can be rather 'chalky'. When lightened this way, colors become duller, 'cooler' and otherwise transparent paints become more opaque.

This should not be a deterrent to the use of white as such colors cannot be produced in any other way. They have unique properties of their own.

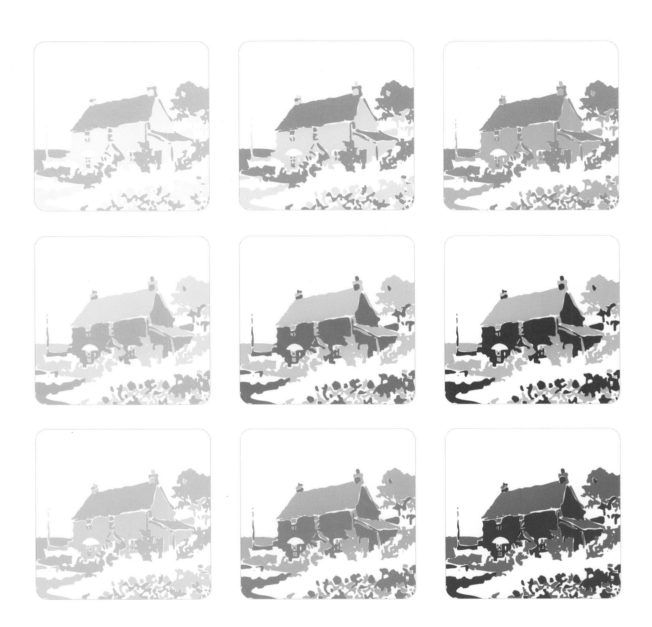

White, of course, can come either from white paint or from the influence of a white background. The type of white employed will bring its own range of influences.

In paint form, for the watercolorist, Chinese and Titanium White are both 'cool' and fresh. Likewise Titanium White for the acrylic painter.

In oil paints the choice is wider. Flake or Lead White is a 'warm', creamy white. Titanium White is 'cold' and bright. Zinc White is fresh but forms a hard brittle film on drying and is best avoided for this reason. The type of white priming on canvas or painting board will have an influence as will the whiteness of paper.

Although very bright white paper will add freshness, this is often temporary as artificial whitening agents tend to darken on exposure to light.

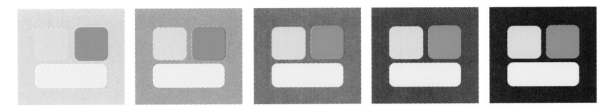

The same hues have been repeated in the above exercises. Notice how the colors intensify (due to after-image), as the gray background becomes darker.

Gray has a soft, calming effect on all colors, whether used as a surround or as a separator. The effect will vary considerably depending on the value of the gray.

Very pale grays will bring a dark after-image to the scene (light and dark being complementaries). Whilst a dark gray will throw a light after-image over other colors.

Much, of course, will depend on the area of gray involved.

The after-image from small 'touches' of gray will hardly influence neighbouring colors as after-images are the same size as the originating color.

Surrounding a color with a much larger area of gray will have a greater effect.

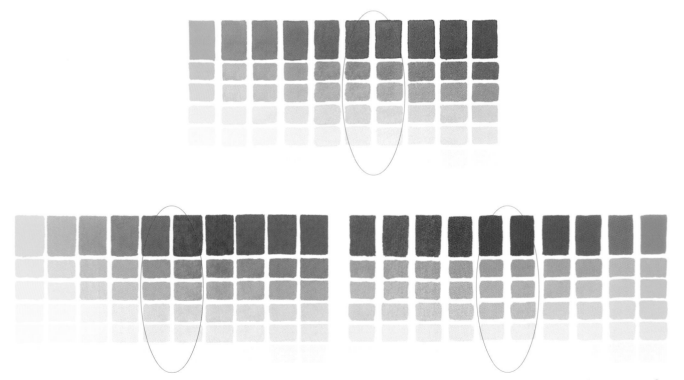

A vast range of colored grays can be mixed from the basic complementary pairings, blue/orange, yellow/violet and red/green.

This factor opens up enormous possibilities when working with the complementaries and at the same time seeking color harmony.

If you are working with blue and orange, for example, the ideal gray to use will come from a mix of those same two colors.

With the addition or otherwise of white, such colored grays will give a very wide range of values.

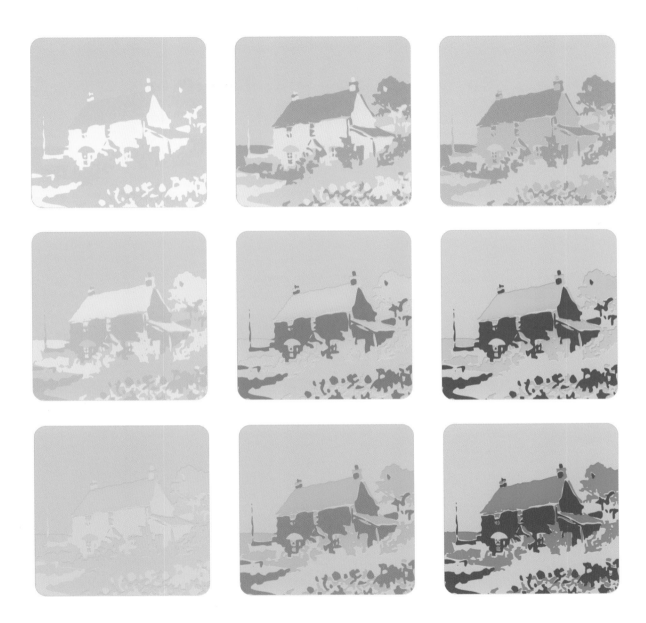

The neutralising effect of gray is particularly noticeable on the brighter, stronger colors.

By reducing contrast, otherwise discordant hues can be brought into line and persuaded to harmonise.

Used with skill, colored grays (from the complementaries), can have a vital role to play in most forms of work.

Used fully saturated or lightened with white (one way or the other), to form tones, colored grays can considerably enhance the complementary colors from which they are mixed.

Only those without color mixing or color usage skills will continue to refer to grays as 'mud'. An apt description only when they turn up unexpectedly and have nowhere to go.

Once you have control of the brighter hues through an understanding of color mixing, the neutrals and grays can become possessions to be treated with loving care.

They can certainly enhance your work dramatically. The relationship between colored grays and the two colors from which they emerge is vital where color harmony is sought.

Swatch 48 - Ultramarine Blue and Burnt Sienna

Swatch 21 - Quinacridone Violet and Phthalocyanine Green

You might find other blacks or near blacks amongst the color mixing swatches which might be more suitable for your work.

The actual black to be used in a painting is an important consideration.

I do not feel that black paint or ink has any part to play in color mixing. It muddies other colors and removes any possibility of controlled color mixing.

Black paint, used fully saturated, can often suggest damage to a painting and can look very stark. There is nothing, of course, wrong with this if it is the intention.

I would suggest that you mix your blacks from Burnt Sienna and Ultramarine Blue. The resulting darks are soft, transparent when applied thinly and very forgiving. Alternatively, mix Quinacridone Violet and Phthalocyanine Green, particularly if you are working with those colors.

There is a case for using black for outline work, particularly if the lines are kept thin and unobtrusive.

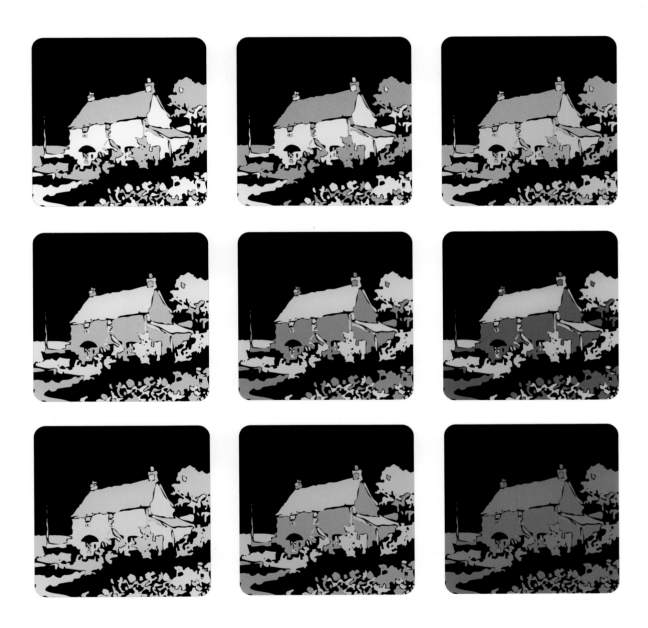

Contrast can be heightened by the use of black. This will often detract from color harmony. Whereas white and gray tend to blend into a painting with ease, black becomes a very definite additional color in its own right and must be treated accordingly,

A black surround (and to a lesser extent a black edge or outline) will tend to enrich red, make yellow appear 'cooler' and blue almost luminous. Black will make these and all other hues seem particularly brilliant.

The area of black involved will have a direct influence on the result. Up to an extent, the more that a hue is surrounded in area the greater the effect of after-image thrown by the black. Black outlines will have less of an effect.

311

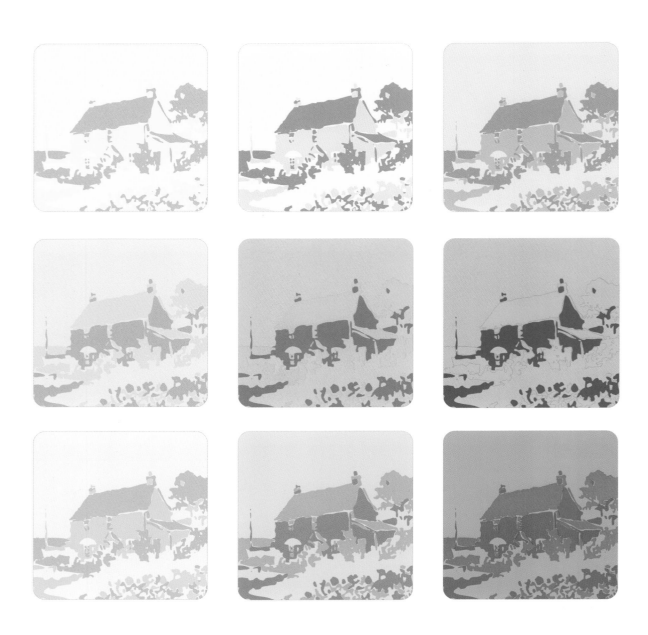

As an alternative to the use of black, white or gray, the tint of one of the colors can be used in the background.

When used in this fashion, the tints act almost as 'go betweens', reducing color contrast and very often aiding color harmony.

It is also another example of the fact that when colors in an arrangement have something in common, they are on the way to color harmony for many people.

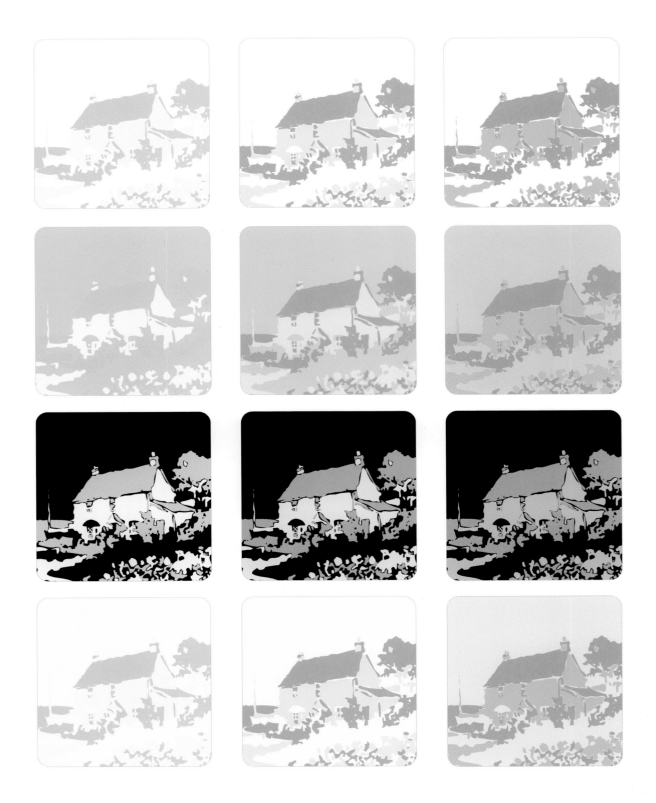

A comparison of the varying backgrounds that we have been discussing will be of value.

The foreground colors are the same in each column. The differences can be very definite.

Towards a definitive statement on the coming trends in mens wear and accessories (a)
Together let us explore the stars, 1962, Richard Hamilton

The use of either white, black, gray or tint in the background is fairly common. To find all four elements at work in one piece is unusual.

In the above painting they all appear at once, the tint being the small area of pink in the top right corner.

Although I have only discussed this area of color work (the background),very briefly, you might find it of interest to explore further.

Perhaps use a fully saturated hue as a background. Maybe a bright yellow or red.

If doing so it will be worth bearing in mind that saturated colors appear to advance when placed alongside the less saturated.

This factor will make it more difficult to convey a feeling of depth. This might, of course, not be your intention but it often is in the case in realistic painting.

Introduction

1.

2. 3.

4. 5.

The way that the paint is applied at the edges of an area influences our perception of color and therefore has a bearing on whether colors harmonise or perhaps contrast.

In illustration 1, above, the paint was applied thinly and brushed out well at the edges. This technique can give a glowing, almost atmospheric effect, particularly when complementaries are involved.

When a complementary pair such as orange-red and blue-green (3) are juxtaposed in this fashion, they react at the 'join' in much the same way as light behaves on velvet.

An intense visual reaction is set up as the after-image from one color is transferred to the other. The effect takes place over a much longer joint outline than it would had the outlines been straight. In much the same way that a zig zag line becomes a lot longer when stretched out. Like velvet, such edges can appear very rich in color.

Please note: the mechanics of color printing will have a certain influence on the effects described here. They will be worth trying out in paint form for greater accuracy.

In stark contrast to the approach illustrated on the previous page, here the colors are flatly applied and touch at sharply formed edges.

This format highlights the interaction between colors, each affecting the perception of its neighbour. This is particularly noticeable where a dark color butts against a lighter color, causing the edge of the lighter color to appear paler. The artist/colorist needs to be aware of these effects. Please see 'The After Image' page 170.

316

Yet another approach has been taken in the above illustration. The same flat, evenly applied colors are separated by thin white lines.

Each color is independent of and barely affected by its neighbour.

Although the areas of color do not influence each other directly through after-image, the use of white can enhance contrast between colors. The way that one color can affect another at its edge has a vital part to play.

When compared one to another, the differences become more apparent. The varying effects might not be of concern to you if you always work with one approach or the other. However, there might be an occasion when you wish to extract that little bit more from color.

The committed artist/colorist needs as full a repertoire as possible at his or her fingertips. A knowledge of the 'effect of the edge' is vital.

Contrast can be heightened by separating hues with white.

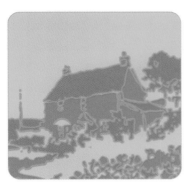

Gray will reduce contrast, often aiding harmony.

Colors have less opportunity to influence each other when they are outlined in black.

Using a tint of one of the main hues can often be an to aid color harmony.

Separating colors by a line can lead to varying effects.

Through after-image, white tends to darken and reduce the brilliancy of colors when used as a *background*.

However, contrast can be heightened by separating hues with white in the form of *lines* or narrow surrounding bands. White applied in these forms will not flood an area of another color with its dark after-image.

After-images remain the same size as the original stimulating color. Therefore the after-image from a white line can be no more than a dark line of the same width, not an area of after-image flooding over other colors.

White of course can come either from white paint or from the influence of a white background.

Whereas white heightens contrast when used to separate colors, gray will reduce contrast, often aiding harmony.

Black, (or preferably a mixed dark in painting), *surrounding* a hue as its background causes it to appear richer, almost glowing.

When black is used to *separate* colors they have less opportunity to influence each other, depending, of course, on the width of the separation. This effect can be seen on leaded windows as well as on paintings with areas outlined in black ink or paint.

Using a tint of one of the main hues can often aid color harmony.

319

When white is used to separate colors, visual interest is added in the form of contrast. This contrast increases as the colors being surrounded become either darker or more saturated.

Many color arrangements which might otherwise be rather bland can be brought to life, and freshness added, when thin strips of white are introduced to separate other colors.

Border contrast, which can lead to a flicker at the edge between fully saturated complementaries is all but eliminated, unless the white border is very narrow.

Freshness and 'sparkle' are probably the two main benefits to be gained by the use of white and many a dull piece of work can be brought to life by the careful use of this color.

The two areas that I have concentrated on as far as white is concerned are 'white in the background' and 'white in the outline'.

There are, of course, many other ways in which it can be used, including the introduction of irregular patches of white to add 'sparkle'. This approach is a favourite with the watercolorist but perhaps should be explored a little more in other media.

Gray has a soft, calming effect on all colors, whether used as a surround or as a separator.

The neutralising effect of gray is particularly noticeable on the brighter, stronger colors. By *reducing* contrast, otherwise discordant hues can be brought into harmony.

I have gone into some detail concerning the use of gray in the background, and here as a surrounding line but I am sure that you will have realised by now the importance of gray in general color work.

Applied in an almost endless variety of ways,

mixed, colored grays are vital to a full color repertoire.

I say mixed *colored grays* because the conventional idea of gray, a black and white mix, has little application in advanced color work. Many, including myself, find it dull and lifeless unless part of pure black and white work.

To aid harmony it pays to mix your grays from hues already in use. If a complementary pair such as blue and orange are involved in the painting, they will produce colored grays which will be a definite aid to harmony.

Black, or a very dark mixed colored gray, used either as a background or surrounding line will tend to visually enrich red, make yellow appear 'cool' and cause blue to appear almost luminous.

When used as an outline it tends to separate other colors. By being somewhat isolated they have less opportunity to directly influence each other. This isolation seems to accentuate their particular characteristics.

The lead strips in a stained glass window, for example seems to have this effect on the individual colors of the glass.

The painter can also employ this approach by the use of black or very dark outlines.

I have been describing black lines *around and separating* other colors. Where black lines are used as part of the general design, not outlining other colors as such, they simply become another color in the arrangement.

322

The lead strips in a stained glass window, seem to isolate individual areas of color, removing them from much of the influence of neighbouring hues and perhaps making each more interesting in its own right.

They're Biting, 1920, Paul Klee
© Tate, London 2002. © DACS 2002

1.

2.

3.

4.

Black lines can be employed to either closely outline individual areas of color or to loosely outline them.

In details 1 and 2 above, the individual areas of color have been loosely surrounded.

This will draw attention to the colors but not to the same extent as in details 3 and 4, I would suggest.

Tighter work, where solid color is taken to either side of the black line will isolate the individual areas of color to an even greater extent, as in the stained glass window. As with all forms of color work, there is plenty of room to move around in once you have the basics together. Otherwise you can be cramped whilst surrounded with the same amount of space.

As an alternative to the use of white, gray or black, the tint of one of the colors can be used to separate the others.

When used in this fashion, the tint acts almost as a go-between, reducing color contrast and aiding color harmony.

In one sense this situation can be considered similar to many found in nature, with a single color cropping up here and there in different parts of the scene.

Although the tints from several, or even all of the colors used elsewhere in the painting can be employed, the situation would quickly revert to general color work rather than outline work.

Seldom seen, the use of a tint to outline other colors is a simple approach with many applications. It is certainly worth exploring on a rainy day if you are seeking subtle and harmonious color arrangements.

The use of the complementary to the main color arrangement for the outline can bring a great deal of 'zing' to a painting or other type of work.

The effect of after-image (from the principle colors), on the line will enhance it quite dramatically. This approach can be used in a small section of a piece of work, or overall.

I cannot say that I have ever seen this tech-nique used fully, but it has great potential for many types of work. It is certainly not easy to ignore and would need to be used with skill and care if it is to add harmony rather than only give a strong contrast.

If the lines are similar in value to the color they are surrounding, as in the top left illus-tration, they can bring an unusual 'light' to a painting.

325

Introduction

Of direct interest to the painter is the fact that a color can appear brighter or be changed in some other way by a neighbouring color or group of colors.

A combination of after-image and eye movement can lead to one color greatly influencing another.

There are many ways in which the range of after-image complementaries can be employed. They can be encouraged to harmonise, to contrast, to clash or to add a sense of movement and excitement.

Complementary pairs, applied fully saturated and covering about equal and relatively large areas can appear harsh and inharmonious to many, but will contrast vividly.

Although difficult to handle and suitable only for certain types of work, complementaries used in this way can certainly bring interest to a painting.

Subtle contrasts can be obtained by desaturating one of the pair and leaving the other at full strength.

Desaturating the color with white will allow that color to be used over a greater area and will move the main interest onto the saturated color. The latter is probably best applied in small patches or strokes.

Alternatively one of the pair can be 'darkened' by the addition of the other. By now you will be very familiar with this process. Again such a desaturated color can be used over larger areas and will concentrate attention onto smaller, more saturated touches of color.

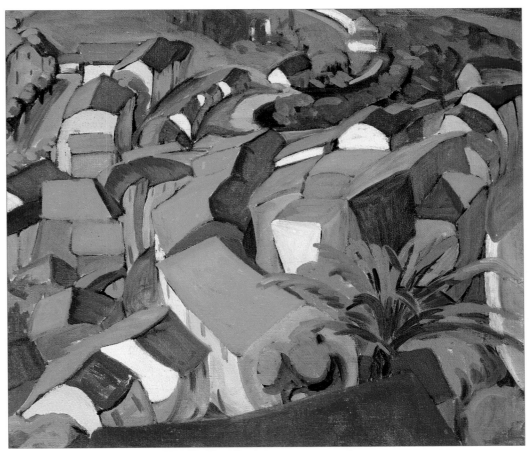

Patterns of Rooftops, 1920-22, Mary Swanzy
National Gallery of Ireland

Orange-reds and blue-greens balanced against violet-reds and yellow-greens.
Additional vibrancy is provided by the light/dark contrast.

As discussed, the effect of the after-image can be very dramatic and lead to powerful contrasts. Where a complementary pair are involved, at or near full saturation, the contrasts can be very powerful indeed. You can certainly make your work eye-catching with this approach.

For most purposes the painter does not need to be particularly concerned with the *exact* matching of complementaries.

If red and green are being used, for example, it is not vital that the precise complementary green or red be used.

A particular orange might have Cerulean Blue as its complementary, (decided by the afterimage given by the orange) but a different blue, say Ultramarine, might be more suitable for the work in hand. Alternatively, differing oranges can be used with the one blue.

Some painters will look at a patch of color, decide on its after-image and try to match that exactly with a paint.

This approach can be useful in extracting the maximum contrast and will keep both colors closer to their true character, but it can lead to stilted work.

Stilted because the painter is perhaps looking too hard for a 'formula'.

To quote Eugene Delacroix 'Cold exactitude is not art; ingenious artifice, when it pleases or when it expresses, is art itself'.

*Use our mixing palette or any other color
wheel as general guidance only*

Our color mixing palette has been designed to indicate the *mixing* complementaries. These are to be found opposite each other. With certain slight variations these are also the *visual* complementaries.

For practical purposes, visual and mixing complementaries can be considered to be one and the same.

The painter should not, I feel, try to match up the complementaries exactly. Color use by the artist should be more about expression than exact measurement.

As with all information on color, the artist should feel free to work around it, to adapt and to be flexible.

Within the limitations of color printing, the colors sealed into the palette will identify the mixing/visual partners; they are directly opposite each other. If the color to the left or right of either hue is more appropriate for the work it should be selected.

It is important to realise that every color, and we can recognise several million, has a visual complementary. No color wheel can show more than a small percentage of such pairings. Treat the indicator colors on our palette, for example, as a general guide only.

For any color wheel to be truly accurate and cover the full range of color pairings it would have to be several miles across and a different method of printing to the conventional would have to be used.

As such, it is better to rely on your knowledge of the situation and use such devices as general guidance. It is for this reason that I went into such detail concerning the after-image.

A word of caution: paint tube labels provide little help in our search for complementary pairs.

For example, in some manufacturers' ranges, Cobalt Blue and Cadmium Orange are complementary, while in others this is not the case.

A violet-red might be very closely paired with Viridian in a particular manufacturer's water colors but not with their oils.

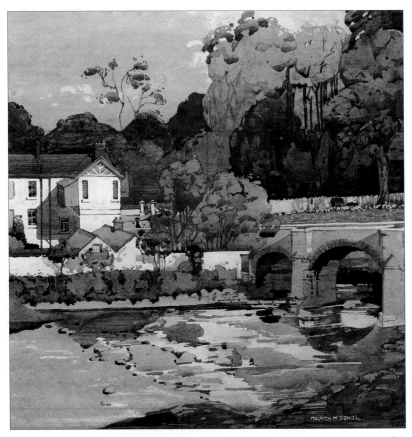

The Dropping Well Public House, 1922-23, Maurice MacGonigal
National Gallery of Ireland

As in the painting above, a complementary pair can be used close to, or at, full saturation and still be coaxed into harmony; rather than simply contrast.

By setting fully saturated colors against desaturated areas a balance has been maintained. Light against dark and warm against cool combine with the contrast of saturation and of complementary.

The dark areas in such a painting should be produced by mixing the blue and orange without the addition of white. Such darks harmonise readily with the complementary pair as they are produced from them. The common practice of introducing 'outside' darks such as Payne's Gray can only upset the balance.

The mixed darks can, of course, be reduced with white to add to the range.

Saturated colors, neutralised hues, colored grays, tones (a colored gray with added white), played one against the other can produce amazing and very attractive results.

And all from just two hues, white and a little knowledge of color mixing.

The Pope accords Recognition to the Franciscan Order, 1437-44,
Stephano di Giovanni called Sassetta
© National Gallery, London

Although the Impressionists, preceded by that great colorist William Turner, made full use of the complementaries, they had also played an important part in earlier work.

Not, I would suggest, in such a refined way, but certainly as far as providing contrast was concerned. In the painting above, the pairings red and green and blue and orange have been combined to give a strongly contrasting arrangement.

As with many later paintings, saturated hues have been set alongside neutralised colors, colored grays and tones (lightened colored grays).

The contrast of light and dark, saturation and warm and cool are also present.

Similar arrangements are to be found in many earlier paintings, particularly those produced by Chinese artists, where such contrasts were often employed.

May in a Red Dress, 1926, William Leech

I have chosen to show this painting because I feel that it echoes the color work of that shown on the previous page.

An almost identical green is set against a very similar red. Desaturated versions of both hues are present. Blue and orange are also in evidence, as is the contrast of light and dark, although to a lesser extent. Various colored grays are also present.

I can have no idea whether or not William Leech had studied or even seen the earlier work. If I could say for certain that he had, it would be very encouraging.

If a gifted and knowledgeable colorist such as Leech felt free to draw inspiration from earlier work, so should we all.

Artists have always learnt from earlier artists. But very little, if anything, can be gleaned simply by looking at paintings or quality reproductions of work that we might find attractive.

Learning is *only* possible once we know what is going on, when we can 'read' the color arrangements, when we can analyse them.

If, by the end of this book, you are unable to do this, I will have failed in my objective. I have your future understanding in mind more than any other factor. It is why I embarked on this project.

When you can look at, say, a Monet and understand his work, you can not only learn from him directly but you will be in for a real buzz. It can be heady stuff.

Andre Derain, 1905, Henri Matisse
© Tate, London 2002
© Succession H Matisse/DACS 2002

After the Impressionist era, certain artists rebelled against the earlier approach and used color in a quite different way.

What should be realised however, is that they had a good understanding of the effects of the after-image. Much of it learnt directly from the work of the Impressionists.

They took this understanding and produced some very striking work.

As you look around this painting you will see examples of complementary pairings and various contrasts.

I will leave you to decide on the actual arrangements that have been used.

Introduction

*As white is added progressively, from top to bottom, the color
gradually becomes less saturated.*

Desaturating with white

Before looking at this contrast in practice, we will explore ways in which the saturation of a color can be varied.

Adding white will desaturate a color, quickly moving it away from its fully saturated state.

As you will know, the painter can add white in two ways; by actually mixing white paint into a particular color or by allowing the white of the support to show through.

By applying color in a thin or transparent layer, the whiteness of the support will create a tint which is brighter and usually more transparent than that made by adding white paint.

Oil or acrylic painters usually add white paint and work with more opaque color arrangements. Whenever white paint is added to a color it dulls it, makes it 'cooler' and causes transparent colors to become more opaque.

Watercolorists are commonly advised never to use white paint in their work.

However, by discarding the use of white paint in mixtures the watercolorist removes half of the possible tints which would otherwise be available.

It is important to realise that the tint produced by adding white cannot be made any other way. The result of adding white to say, Ultramarine Blue is quite different to that obtained by applying the same blue as a wash.

Used with care, white paint can increase the range of colors which are available, without detriment to the finished work.

There is no need to plaster the mixed paint on thickly. A tint produced with the use of white paint can be applied as thinly and as delicately as any other color.

The fact that it can increase opacity should not be a problem as many other watercolor paints are also opaque. Cerulean Blue for example.

By the same token it should not be overlooked by the oil and acrylic painter that very clear tints can be achieved by allowing the white priming of the support to show through the final paint layer/s.

This approach would allow for brighter, often slightly 'warmer' and perhaps more transparent tints to be used than is traditionally the case.

Head of a Young Man, Pablo Picasso

A complete painting can be built up by contrasting the range of saturations obtainable by adding white, one way or the other, to a single base color.

Limitations are imposed using this technique since the darkest color will always be the fully saturated base color. The contrast of light and dark can therefore be somewhat limited if you start off with a relatively light color.

For example, if the above was based on a type of yellow the contrast would be minimal, by working on a relatively dark color, as was the case, the artist had a reasonable range of values to work with. This is a simple way of working which can give interesting results.

334

The Adoration of the Name of Jesus, 1578, El Greco
© National Gallery, London

White tends to 'cool' a color quickly. If used as the sole or the main method of desaturation the finished work can look somewhat 'cold'.

This factor is illustrated, I believe, in the painting *The Adoration of the Name of Jesus* by El Greco.

A great 'mixer in of white', his highlights often look rather 'cool' and chalky due to his enthusiasm in this area.

This is not to detract from his wonderful skills as an artist, as every approach to color use is equally valid.

335

Desaturating with the complementary

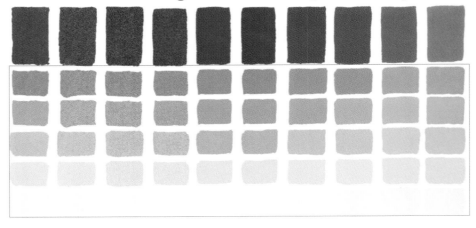

As this contrast calls for colors which are only desaturated with their complementary, or mixing partner, it follows that the tints (boxed) cannot be used.

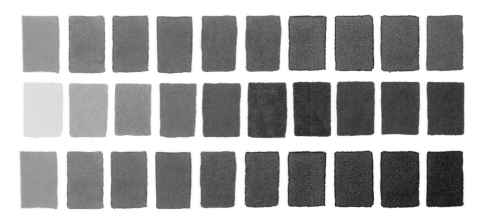

No colors are available which are lighter than the most fully saturated. This can be rather limiting.

The saturation of a color can also be reduced by adding its complementary.

Although some particularly useful neutralised colors can be achieved, the application of this contrast over an entire painting is rather limited.

If it is to be the only method of desaturation it follows that no colors are available which are lighter than the most fully saturated.

For this reason the contrast of saturation using only the complementaries is usually employed in small areas of a painting.

Adding black will also desaturate a color. Black is kinder to some colors than to others. Yellow quickly loses its character but blue, for example, changes in nature more slowly.

Although many interesting and unusual colors can be created this way, control of color mixing is quickly lost and many mixes can appear somewhat unattractive.

Just as a color can be desaturated with the addition of its complementary and white so it can be mixed with black and white. However, both will quickly kill brilliance.

Desaturating with the complementary and white

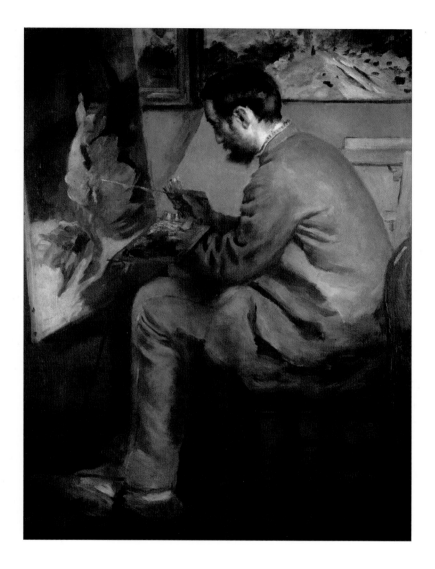

A complete painting can be built up by contrasting the range of saturations we can obtain by mixing a complementary pair and *further extending the range with white.*

This approach generates a very wide range of colors and values and is without a doubt the most versatile.

As you look around the painting you will see the basic blue move through a wide range of values from the palest grayed blue to the deepest dark.

The darks will emerge as the blue and orange are mixed in equal intensity. These deep colored grays have probably been applied directly from the palette to give the shadow areas. White was added to the same mix to create the lighter grays. These in turn had either the blue or the orange added to give the wide range of desaturated colors.

This is a very simple but extremely effective method of introducing subtle contrast to a painting.

To Pastures New - The Goose Girl, 1883, James Guthrie
Aberdeen Art Gallery and Museums

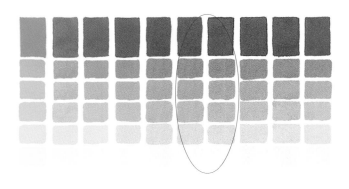

The range shown in color mixing swatch No. 44 will, if certain mixes are applied a little more heavily, provide sufficient colors for such a painting. Two hues, (one of them pre-mixed) and you have an easily opened doorway to color harmony. Can you see how easy it can be once the course has been charted?

As already mentioned, the term 'colored grays' refers to a mix of a complementary pair at equal intensity.

This does not mean equal *amounts* of paint as strengths vary between pigments, but refers to a situation whereby one color all but cancels out the other and vice versa, as circled left.

In the painting 'To Pastures New', the artist has made very skilful use of the range of neutrals and colored grays obtainable from the complementaries green-blue and orange. Please see page 208 for further information on this pairing.

Apart from being a wonderful (to my eyes) example of the contrast of saturation and the use of a complementary pair, the painting highlights the value of the colored gray.

The shadows and leggings of the girl have almost certainly been mixed from the same blue and orange that have been used to produce the rest of the painting. Where colored grays really come into their own, I feel, are when they are reduced with white. The girl's dress, back of the shawl and boots are painted in such 'let down' colored grays. These are often described as 'tones'.

The Bridge at Grez, 1901, Sir John Lavery

Colored grays from yellow and violet?... *...from blue-green and orange-red? ...* *...from blue-green and violet-red?...* *...and from green - blue and orange?*

In the painting 'The Bridge at Grez' the artist appears to have used a variety of colored grays. Although I cannot be certain, they seem to be based on the complementary pairs described under the details above.

The contributing colors are close to the colored grays. The blue-green and violet-red for example, appear as a mixed colored gray alongside touches of the two colors in a more obvious form.

At first glance this might seem to be a very complicated way to work. Rather than 'complicated' I would suggest that it is a sophisticated approach which can be emulated with practice. But it takes time to build not only the skill but the confidence required. I would suggest that for most painters the simpler but equally effective approach taken on the previous page would be the way to start. And then possibly add to the repertoire gradually.

Introduction

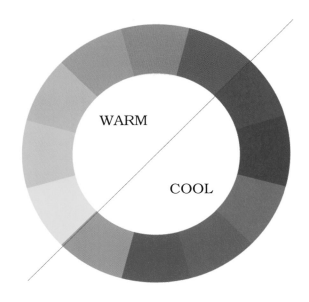

As a general guide the conventional color wheel is divided into two parts, warm and cool.

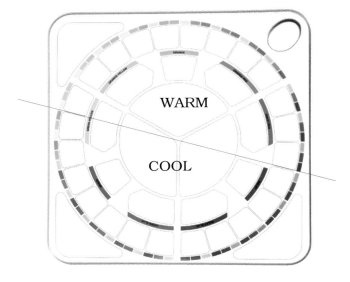

The more extensive color wheel that we are using can be similarly divided.

Colors are frequently described as being of a certain temperature, whether hot, warm, cool or cold.

Colors associated with fire and heat; reds, oranges and yellows, are often described as being warm or hot while the blues and greens of ice and water are thought of as being cool. (Actually the hottest part of a flame is blue so we have a bit of a contradiction).

I believe that we can become too concerned with this particular contrast. I was recently drawn into a tussle (which became global) as to whether Ultramarine Blue was 'warm' or 'cool'. It surely does not matter what exact description we use, it's how the color itself is employed that is important.

As a general guide the conventional color wheel is divided into two parts, warm and cool.

This can only be a rough guide as the final 'temperature' of a color is largely decided by the way in which it contrasts with others.

Cerulean Blue will appear decidedly 'chilly' when set against a Cadmium Red Light but takes on a relatively 'warm' appearance when it is compared to Phthalocyanine Blue, particularly if the latter has a little white added.

Ultramarine, a blue leaning towards violet, seems 'warm' against Phthalocyanine Green but 'cool' when contrasted with Cadmium Yellow. So it can be both.

Describing colors by temperature is a fairly recent practice.

The Harvest, 1929, Raoul Dufy
© Tate, London 2002, © ADAGP, Paris and DACS, London 2002

As in the painting above, the maximum contrast can be obtained when hues are applied close to, or fully saturated and in close proximity to each other, warm against cool.

The 'cool' blues of the sky contrast with the mainly 'warm' colors of the horizon and several of the clouds. In turn, the colors of the lower three quarters contrast amongst themselves. Several individual contrasts are at play; the horses, 'cool', 'warm', 'cool' for example. By intermingling temperatures, some rather powerful contrasts have been set up.

1.

2.

3.

4.

A fairly straightforward approach to use, it can either be drawn on as the principal contrast or become an element of the work almost by default. Whenever a complementary pair is used, for example, a certain contrast of temperature is inevitable.

Although this contrast can contribute significantly to the final effect of a painting, it has no place whatsoever in the teaching of color *mixing.* I am constantly asked by those being taught this way, 'Is this blue, (or red or whatever), warm or cool?

All that this approach does is add confusion.

The 'temperature' of various colors can be contrasted in a rather strident way, as in 1. above, or more gently as in 2 and 3.

We are surrounded by this contrast in our everyday lives, as picture No 4. will possibly illustrate.

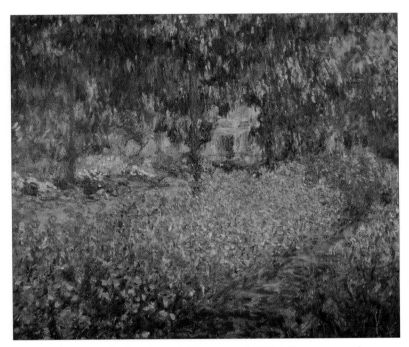

The Artist's Garden at Giverney, 1900 (oil on canvas)
by Claude Monet (1840-1926)
Musee d'Orsay, Paris, France/Bridgeman Art Library

Visual interest can be added to a painting through the skilful manipulation of the contrast of temperature.

A painting that is entirely 'warm' or entirely 'cool' can be rather bland. By contrasting 'cool' and 'warm' the work can be brought to life and have much greater impact.

Areas of a *single* hue can also be made more interesting through this contrast. Constable was particularly skilful in this technique. His trees, fields or hedgerows were never of a uniform temperature.

Small patches of 'warm' and 'cool' greens were placed side by side to break up what could have otherwise been a rather monotonous arrangement.

Claude Monet was also a great master of this technique. As you will see in the painting above, not only are areas of 'warm' and 'cool' colors placed side by side, reds against greens for example, but within each area of single hue a further series of contrasts have been established.

Please bear in mind that none of this is hard to do. Producing a painting to match the above might be more than a little difficult. But learning from it and putting what you have learnt into practice in your own work, is not.

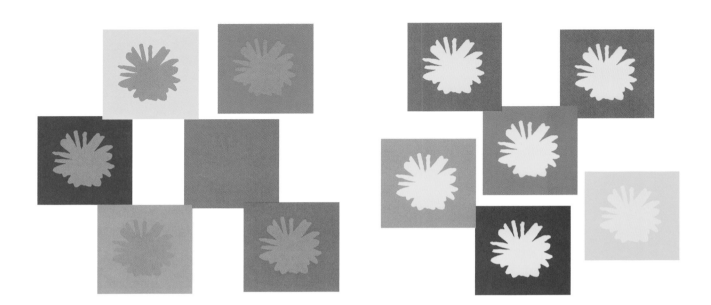

The red-violet can be shifted from 'warm' to 'cool' through the choice of background color.

I have placed the above in a random fashion so that you can decide for yourself how the central color is being moved.

Likewise, a green-yellow such as Hansa Yellow can be moved from 'warm' to rather 'cool' when contrasted with certain background colors. Other influences such as the contrast of light and dark or of after-image will also become involved.

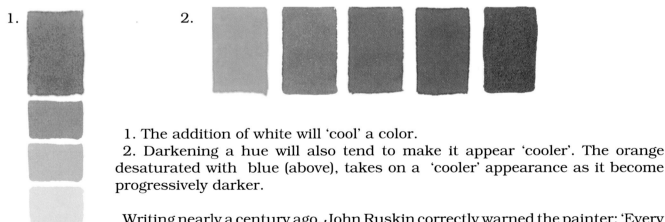

1. The addition of white will 'cool' a color.

2. Darkening a hue will also tend to make it appear 'cooler'. The orange desaturated with blue (above), takes on a 'cooler' appearance as it become progressively darker.

Writing nearly a century ago, John Ruskin correctly warned the painter; 'Every hue throughout your work is altered by every touch that you add in other places; so what was warm a minute ago, becomes cold when you have put a hotter color in another'.

Although we can divide the color wheel into two as a general guide to 'warm' and 'cool' colors, such guidance can only ever be of limited use as so much depends on the contrast of one color to another.

The Window, 1925, Pierre Bonnard
© Tate, London 2002
©ADAGP, Paris and DACS, London, 2002

The contrast of temperature can be of considerable help in giving the illusion of depth. And on a two dimensional surface such as paper or canvas we need all the help possible to give a three dimensional feel.

Colors take on a blue bias at distance due to the scattering of blue light in the atmosphere.

Blue, which is considered to be a 'cool' color, is synonymous with distance and will appear to recede due to our association of it with distant hills and mountains etc.

In addition to this factor, our eyes actually change focus slightly when we look at blue.

'Cool' colors such as blue recede visually and 'warm' colors appear to advance.

By using 'warmer' hues in the foreground and 'cooler' colors in the distance, a feeling of great depth can be created within a work.

In the painting above, the scene through the window is given depth by being composed of mainly 'cool' colors-blues and greens; objects closer to the viewer are painted in 'warmer', rather more saturated colors.

Depth is therefore established and further emphasised by graying the blues in the distance (top centre) and sharpening the foreground detail. (Another important aid to creating depth).

Notice the careful contrast of 'warm' and 'cool' colors on the table and the 'cool' blue-greens set against the 'warmer' yellow-greens of the garden.

To add even more interest there are touches of 'cool' blue and 'warm' orange-yellow. The overall color arrangement gives a feeling of depth as well as being visually stimulating (in my opinion).

Introduction

Pottery, 1969, Patrick Caulfield. © Tate, London, 2002

Visual interest can be heightened by surrounding individual hues with black or with white.

Rather powerful contrasts can be obtained when mainly or only saturated colors are employed.

The painters 'secondaries', green, orange and violet, have less impact if used alone and diminish the contrast if combined with the primaries.

The introduction of 'tertiary' hues such as blue-green will weaken the contrast even further.

Most painters tend to work with both saturated and desaturated colors; the former being commonly used in small touches, more as an accent, while the latter are used more extensively.

Powerful contrasts can be obtained when mainly or only saturated colors are employed.

The painter's 'primary' colors, red, yellow and blue, used at full saturation can be contrasted very effectively. By giving excitement and movement, this trio has a particular appeal to children and to the child in most people. As other hues are added, even though at full strength, the intensity of the contrast is reduced.

Visual interest can be heightened by surrounding individual hues with black or with white.

Pool of London, 1906, Andre Derain

The Impressionist era had seen color use taken to new heights. Artists had studied the color theories of the day and, in particular, understood the impact of the complementaries.

Many of the painters who followed had the same interest in color but decided to use their knowledge in a different way. A group who became known as 'Les Fauves' (Wild Beasts), used color in an almost violent way. To use such bright, strong color in a convincing manner takes a great deal of skill.

A critic described them as 'wild beasts in a cage'. Whether or not you agree with that description at least it was expressed with passion. Nowadays the art critic is usually content to describe the latest exhibition in a series of invented phrases and deliberately jumbled but very 'clever' words. These read just as well backwards, its worth a try.

As far as our subject is concerned, a painter who happens to be part of the 'in crowd' needs only to use bright color, with or without skill, to be described by the critic as a 'colorist'.

A simple but effective contrast that is possibly over employed by many contemporary painters.

The Contrast of Hue in its various forms is by far the easiest of all contrasts to use.

It requires little imagination or skill to produce work with a wide appeal. The ease with which this contrast can be usefully employed has led to its widespread adoption by many contemporary painters.

A glance around almost any gallery featuring 'modern art' will reveal the popularity of this most basic of contrasts.

In my opinion, splashes, patches, dots and streaks of bright red, yellow and blue etc. are used with such monotonous regularity as to make much of this type of work particularly boring.

With the countless possible combinations of color available to the imaginative painter, the continual use of this simple contrast is surely a regression in terms of color expression and understanding.

Amazingly, painters who rely *only* on the contrast of hue, either through lack of skill, imagination or training are often described as 'colorists' by the critics and the art press. This is rather like describing the loudest rock band as the most advanced musically.

A colorist would surely include the contrast of hue *amongst* his or her repertoire, not rely on it exclusively.

This is not to say that this particular contrast does not have merit, because it does. Some very attractive pieces (to my eyes) have been centred around this approach.

But vast areas of canvas and paper have also been covered by it in a rather thoughtless way, as a visit to many an art school will demonstrate. 'Its straightforward, slap it on and you have a painting, and it's a lot easier than us teaching you the real skills of the artist'.

I had better stop there.

Introduction

The Virgin of the Rocks, 1508, Leonardo da Vinci
© National Gallery, London

One of the main problems faced by the painter is the depiction of a three dimensional subject onto the two dimensional surface of paper, canvas or board. A particularly powerful means of creating the illusion of the missing third dimension, depth, is to be found in the contrast of light and dark.

Manipulating light and dark in order to convey a feeling of depth was developed during the Renaissance and was known as Chiaroscuro, (derived from the Latin for 'light' and 'dark').

Many of the compositions might appear to us as being rather contrived, with a strong light source concentrated on very specific areas. Contrived but still possible.

Dark and desaturated colors tend to recede visually, as will the 'cooler' colors.

Light, saturated and 'warm' colors on the other hand will tend to advance. We are mainly concerned here with the fact that darks recede and light colors advance.

Self Portrait at the Age of 63, 1669 (oil on canvas) by Rembrandt (1606-69)
National Gallery, London, UK / Bridgeman Art Library

Artists such as Da Vinci, Caravaggio and Rembrandt were particularly skilled when it came to manipulating the interplay of light and dark.

In their portrait paintings we can find examples of the feeling of depth that can be achieved by concentrating all or most of the available light onto the face and (often) the hands, which are then set against a very dark background.

This approach created the illusion of depth and concentrated the viewers attention onto the subjects face and possibly other selected areas.

The balancing of clearly defined areas of light and dark, relying on strong light from a specific direction was, if anything, the most important and widely used contrast of these earlier artists. I would not describe them as great colorists, the latter came from Turner onwards, but they could handle this particular contrast in an amazing way.

The rather extreme light/dark contrast of traditional Chiaroscuro has been replaced in the main by a softer, less dramatic approach. This is possibly due to the greater use of other types of contrast.

By deliberately playing light against dark, the skilful painter can add depth, realism and interest. The latter factor is particularly important.

If a piece of work is relatively even in value, i.e. if it is painted either entirely in light colors or entirely in darks, or alternatively in a variety of mid grays, much of the potential interest will have been lost. The possible visual excitement offered by the contrast will have been replaced by a rather bland arrangement of values.

(This is not always the case, but it takes a very skilful artist to avoid this situation).

It is not only the painter of course who is able to make use of this valuable contrast.

The infinitely variable contrast of light and dark are constantly explored by the etcher, the wood and lino block printer and the worker in pencil, pen and ink.

Chinese and Japanese artists working in black ink on white paper have long employed this contrast, possibly in its purest form.

1.

2.

After a few moments you should see a lighter ochre shifting around the dark blue and a darker version around the very pale blue. The after-image takes place within our brain.....

.....and cannot therefore be 'painted in' without appearing awkward and unnatural, as above. This approach is fine as long as the intention is not to *depict* the after-image.

The full range of hues can, of course, be involved in this contrast. Light blues, for example, can be contrasted against darker blues, and pinks against dark greens.

A word of caution, if a light color is placed alongside a dark one in order to change their apparent values, as you might when painting a brightly lit scene, it must be clearly realised that any changes to the values that take place are entirely subjective. *They cannot therefore be painted.*

To illustrate this, consider a situation where two objects, one low in value (dark) and the other high in value (light), are placed against an evenly colored mid-value background.

The effects of after-image and eye movement might well make the background color around the dark object appear to be lightened. At the same time the background surrounding the area of high value color might seem to be darker. These changes will take place automatically, as in diag. 1 above.

If the edges of these areas (where the main after-image occurs) *are actually painted lighter or darker* and also come under the influence of the after image, as they will, the result can be rather unnatural and awkward looking. Please see next page before trying to take all of this in.

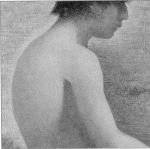

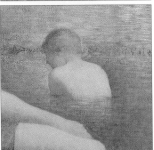

Bathers at Asnieres, 1884. Georges Seurat (1869-91)
© National Gallery, London

The Painting 'Bathers at Asnieres,' by Georges Seurat, does I believe, provide a particularly good example of the unnatural appearance which can result from attempting to actually *paint* such contrasts. Alongside the lighter part of the figures, the water is painted particularly dark and alongside the shaded areas it is painted very light. Personally I see the resulting bands of light and dark as rather clumsy and unnatural.

Without delving too deeply into the reasons for this exaggerated contrast, it must be said that confusion abounded in Seurat's time between subjective and objective color phenomena. *(And not just in his time!)*

Compare the way in which the light/dark contrast was handled by Seurat and how Rembrandt used this technique in his self portrait.

Although Rembrandt's arrangement might seem very contrived to us, with a strong light originating from an undisclosed source and with the light areas being offset against a particularly dark background, the scene is at least possible - very contrived, but possible.

Dark areas can make light areas appear even lighter and vice versa but the actual changes take place within the brain.

Rembrandt: Self Portrait aged 63
Bridgeman Art Library

Rather than be over concerned with value differences, as many painters are, simply imagine your work as a black and white photograph. If it would make an acceptable photograph you have it about right.*

If the light areas are made darker and the dark are made lighter, we would soon reach a point where it was very difficult to make out detail.

** I have chosen a less than perfect photograph to illustrate the fact that contrasts (including those in a painting), to not have to be perfectly balanced in order to convey a great deal of information.*

When working with light and dark we are, of course, contrasting their difference in value. The contrasts which exists between the varying values in a painting provide a tremendous amount of information on the subject/s depicted. More information, in fact, than we obtain from the actual color of an object.

As far as the artist is concerned, we could say that value will define an object and color will add beauty and interest.

Artists will often make preliminary sketches before painting in order to arrive at a balanced value relationship. Where the differences are relatively slight the painting can appear calm, where they are great the design can look cluttered and busy.

As discussed under the heading 'the background color' page 86, as contrast is removed, images become harder to discern.

A good example of this is to be found in the black and white photograph.

A well balanced range of values will enable us to discern detail in such a photograph with ease. But if the light areas are made darker and the darker made lighter we would soon reach a point where it was very difficult to make out detail.

If there was absolutely no contrast at all it would be impossible to see detail, as the entire image would be white, black or gray. This is obviously extreme but I use the example to illustrate the need for well balanced contrast in a painting. 'Balance' is the word; too little contrast and a painting can be difficult to follow, too much and it can look unnatural.

You might actually want the work to be difficult to discern or to look unnatural, but that is another matter.

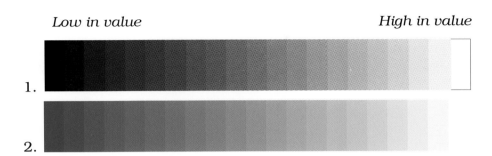

Low in value High in value

1.

2.

The gray scale (1): Notice how the edges appear to be fluted. This is due to the effect of after-image. The edge of each 'box' affecting its neighbour on either side. Light making dark and dark making light.

This effect will happen with any color, such as the violet blue above (2). The effect of after-image is permanent unless the influencing color is removed. But then, of course, it will be replaced by another, even if this is only the white of the paper, and the color will change again under its new influence.

3. ■ + □ = ■

■ + □ = ■

4. ■ + □ = ■

■ + □ = ■

Our perception of value is not even over the entire gray scale. We are able to make out very small differences between value at the low (dark) end of the scale but not at the higher value (light) end.

A tiny amount of white added to black will alter the color to a noticeable extent (3). But the *same* amount of white added to a very pale gray will usually go unnoticed (4). Much larger amounts of white will have to be added in order to make any obvious change. This factor applies to any color, more so to the darker ranges. You could not, for example, progressively add the same amount of white to Ultramarine Blue and expect to produce an even scale moving from the dark end to the lighter.

More and more white would have to be added at each stage in order to produce equal differences.

Not equal differences in the *reflected* light, that would be a *physical* difference, but differences that we can make out visually.

This is another example of the fact that we take in what is happening in the physical world and then manipulate the information within the brain to suit our needs. Its how we *see* a color, not what it might be physically.

Why am I going into such detail in a book for the artist? Well, if a passage in a painting is high in value, composed of say, yellows and tints of other colors, extra consideration will be required if they are to contrast in value, one pale color against the next.

The differences in value might be more obvious for a camera, but we have other things going on. Whereas darks require only slight modification, the high value colors will require a lot more.

A dense black will occur deep inside a burnt tree.

Light reflected from a waxy leaf is brighter than the whitest of white paint.

1

100

Were it possible to calibrate the range of brightness between the darkest and lightest paints and show it on a value scale of 1-100, it might look something like this.

Although extremely useful as a device for creating a feeling of depth within a painting, the contrast of light and dark (or value contrast as it is often called), has another, possibly more vital role to play.

Painters do not generally realise that the pigments which provide our coloring matter have a rather limited range of values. Between the whitest of white paints and the blackest of blacks there exists a brightness range which is easily outstripped by nature.

A well made Titanium White, for example, appears rather dull when compared with strong sunlight reflected from a waxy leaf, a white surface or a piece of shiny metal.

The problem is less extreme at the dark end of the scale, a dense black paint is fairly close in value to a dark object in the shade.

Black velvet in deep shadow is one of the darkest blacks since nearly all of the light is absorbed as it works deep into the pile. A dense black will also occur deep inside a burnt tree.

Were it possible* to calibrate the range of brightness between the darkest and lightest paints and show it on a value scale of 1-100, it would look something like the above.

 * We cannot actually produce such a scale as the conception of brightness is entirely within the brain.

'Brightness scale of pigments'

'Brightness scale of Nature'

Exercise reproduced from page 183,

When this 'pigment brightness scale' is compared to the range offered by nature on a clear, bright day, it is clearly very limited'

If the whitest paint is rather gray when compared to the glaring lights of nature, how is the artist to compensate for the deficiency?

There is really only one way to bring the two scales closer together: In the exercise on page 183, reproduced above, the after-image from the black square appeared white even when superimposed onto the whiteness of the paper. The after-image from a dense black is *far*

brighter than the whitest paint, priming or paper. If, therefore, the lightest areas of a painting are set against the darkest, the contrast between their values can be exaggerated *through the effect of after-image.*

Our white paint can be made to appear even brighter and our darks even darker, taking them closer to the extremes of nature.

As always, we paint with two layers, paint followed by the 'light' of the after-image. Why not take full advantage of this fact if you wish to extend the range offered by pigments alone?

Examples of the contrast of light and dark are all around us.

By placing areas of dark alongside or around areas of light in a painting, the limited range of values available from our paints or other colorants can be stretched closer to the offerings of nature.

We can be certain that the limits of the palette can be extended by the skilful and considered use of light-dark contrast; by bringing the after-image into play.

Very few painters realise this and many attempt to portray the brightness of a sunlit day using paints alone. This approach cannot begin to give an accurate or believable rendition.

Even the use of white in such a painting will only give a 'gray' when compared to the reflected light of nature.

The use of the after-image is essential when portraying a brightly lit scene, or in non-representational painting if a wide range of values is required.

Can you see that a close and comfortable knowledge of the effect of after-image is absolutely vital to the artist?

It is not enough to understand the first layer of color, the paint. The second layer, after-image light, is as important. And it really isn't that difficult to come to terms with.

A Cottage Garden, 1888, Walter Osborne
National Gallery of Ireland

Lightest against the darkest.

The light-dark contrast is not only invaluable when depicting a bright day or when the illusion of depth is required. It can be used in any painting to direct the eye and to add visual interest.

In the above painting the contrast does, I feel, draw the eye from the collected flowers to the left, over to the single flower to the right. The contrast intensifying along the way. The lightest area is to be found alongside one of the darkest.

The contrast is repeated, but to a lesser extent, lower in the painting. This is where the eye was I feel, meant to wander next.

A Gray Hunter with a Groom and a Grayhound
at Cresswell Craggs, 1762-4, Stubbs.
© Tate, London 2002

A little contrived perhaps, but still believable.

Many artists, particularly from earlier days, have employed this particular contrast. It might be used in small areas of a painting or be the principal contrast, as above.

George Stubbs was one of many who based entire paintings on the strong contrasts offered. You will notice that not only is most of the white horse set against a dark background, but the area of sky which serves as a backdrop to the horses neck and head has been darkened.

The dog, buttons and cravat are also set very definitely light against dark. Another contrast seems to have been set up between the mainly light left half of the painting and the mainly dark right side.

Such manipulations (particularly around the horses head and neck), can look a little contrived; but only, I feel, to those who know what to look for. The general viewer is more liable to be struck by the power and balance of the composition.

As I have mentioned elsewhere, if you know what to look for, and can quickly and easily analyse a painting (even in a very general way), you can learn a great deal from the work of other artists.

Introduction

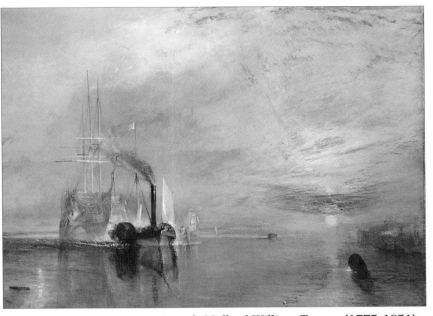

The Fighting Temeraire, Joseph Mallord William Turner (1775-1851)
National Gallery, London, UK/Bridgeman Art Library

William Turner was one of the first artists to fully realise and exploit the visual interest obtainable from the complementaries.

The complementaries blue and orange.

The complementaries yellow and violet.

Yellow and violet again.

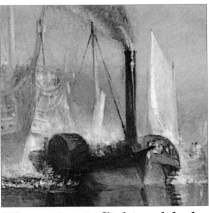

The contrast of light and dark.

Rather than employ and concentrate on just one approach, the use of a particular complementary pair for example, an artist with mastery over color will often combine several arrangements in the one painting.

Notice how the blue in the sky is sandwiched between the two areas of orange in the above painting. Looking elsewhere you will see the complementary pair yellow and violet, at varying strengths. Both blue and orange and yellow and violet are intermingled in the sky, together with their colored grays. The contrast of light and dark is also evident.

I have only selected a few of the pairings and contrasts. You will find others such as the contrast of saturation and temperature.

361

Bathers at la Grenouillere, 1869, Claude Monet
© National Gallery, London

In this work Monet used the complementary pairs blue and orange, red and green and light and dark. The contrasts of temperature and saturation have also been brought into play.

Let us consider the thinking that might have gone into this painting. For a start, the boats would almost certainly have looked like most river boats; a rather dull, flat gray with evidence of the local duck population.

Whereas many a 'realist' painter might depict the boats in similar dull grays, to Monet they were an ideal opportunity to employ blue and orange together; adding 'life', color and strong visual interest. Notice how the two hues have been used to darken each other. These *colored* grays, as well as the neutralised oranges and blues are then further reduced with white to produce a balanced, harmonious arrangement.

To build on both the harmony and the contrasts obtained by the use of this complementary pair, the two basic hues, at varying degrees of saturation are played one against the other throughout this entire area of the painting. As you work your way visually around the boats you will see what I mean.

1. The very skilful interplay of blue and orange.

2. A second major complementary pair, red and green have been introduced, the green almost surrounding the red, which will be enhanced visually.

3. The same pairing of blue and orange as used in the boats has been repeated in a separate area.

4. And again, with the orange made brighter. This approach is very useful as a means of holding the various areas of a painting together.

5. The contrast of temperature within the single hue; green.

6. The contrast of light and dark.

7. Yellow-greens and blue-greens, at varying saturations with a touch of the complementary red. Plus the contrast of light and dark.

1.

2.

3.

4.

5.

6.

7.

1.

2.

3.

1. The model might have been wearing a blue hat, but the color does little for her.

2. Green becomes part of the background scenery and the figure almost disappears.

3. The headdress almost has to be red to bring life and interest to the entire painting.

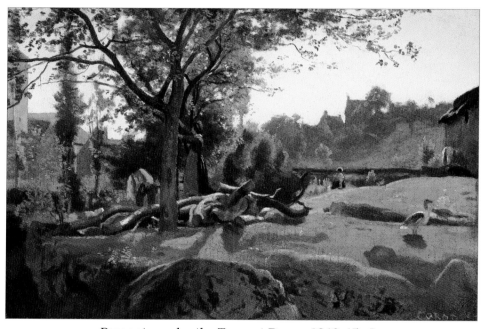

Peasants under the Trees at Dawn, 1840-45, Jean
Baptiste Camille Corot
© National Gallery, London

In the painting 'Peasants under the Trees at Dawn', attention is directed to the central figure by surrounding the relatively saturated red of the headdress with a large area of desaturated green. (Red and green being complementaries of course).

If the color of the headdress is changed to say blue or green (which the model might well have been wearing), the visual interest is reduced.

If you find yourself in agreement with me, you will see that the headdress almost *had* to be painted a red in order to draw attention to the figure and to breathe life into that particular area of the painting. Any other color and this section of the painting dies.

This approach was often employed by Corot, never by accident but by purpose.

A typical painting might depict a river scene: The trees, bushes, water, boat and clothing of those in the boat will be painted in dull greens. So far a rather uninteresting composition. The painting is brought to life however by a touch of red in a scarf or other small item of clothing.

364

Blue and orange, another complementary pair, are brought into play. Here, they might have been used to dull each other slightly, but the main method of desaturation has been through the addition of white.

Here the orange has been deepened, almost certainly through the addition of the same blue; which is still only applied as a tint.

Once a complementary pair has been decided upon, the variations are almost endless.

Yellow and violet, yet another complementary pair, have been introduced into the background.

The yellow will almost certainly have been used to desaturate the violet, and vice versa.

Although a little difficult to discern in printed form, yellow and violet have been used for the buildings on the left side of the painting. The yellow has been used to desaturate the violet and appears itself in the strip on the corner of the tower. The dulled violet is further reduced with white.

The pile of logs presented the artist with the opportunity to employ yet another pair of complementaries, light and dark.

We can describe this approach as either 'a complementary pair' *or* the 'contrast of light and dark'. Either way, visual interest is added.

Another interplay of light and dark has been added between the branches and the sky.

You will notice that many of the lightly colored leaves have been set against the darker shadow rather than against the lighter areas. Contrasts have been built in wherever possible to add interest.

365

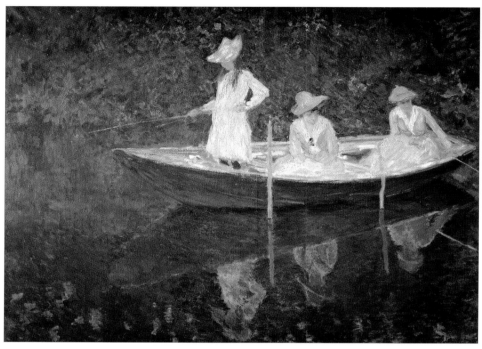

The Boat at Giverney, c.1887 (oil on canvas) by Claude Monet (1846-1926)
Musee d'Orsay, Paris, France / Bridgeman Art Library

Monet, one of the leading Impressionists, continued to develop his color work to the end of his life. His understanding of light and his mastery of color are, I believe, well demonstrated in this painting.

Based largely on the interplay of light and dark, the work then goes on to explore various other combinations. I will leave you to discover these arrangements.

When you can quickly analyse a painting you will be able to learn a great deal from it to include in your own repertoire.

It is a little like learning to play a musical instrument. You can watch an accomplished musician for a very long time and learn nothing. But if you have already taken the trouble to learn the basic notes and chords you might learn a great deal in a very short time.

Your next visit to a skilfully executed painting should be your next lesson.

Long Grass with Butterflies, 1890, Vincent Van Gogh
© National Gallery, London

During art lessons we are often taught the importance of drawing, of perspective, composition, and subject matter. But seldom the importance of color.

Many people stand before this painting for a very long time. Yet it has to be said that there is little evidence of drawing skill, perspective or composition. And the subject matter, I would suggest, is not of particular interest either, a patch of scrubby grass.

What holds the viewer before this painting is, I feel, all to do with the very skilful use of color.

Desaturated (with the complementary, with white or with both) are reds and greens, yellows and violets and blues and oranges. All interwoven and playing one against the other.

367

Introduction

Image State

Image State

Image State

The average person may find pleasure in nature's color schemes but few examine them closely. Of all people, the artist is probably closer to the delicate changes and nuances of hue which are on offer.

But even amongst artists it takes a special interest to really observe the delicate, finely balanced harmonies which constantly surround us. Most are deceivingly simple, being based on very few base colors but a vast range of saturations.

The colors of nature might or might not be associated with evolution and survival (see page 37). However, one thing seems fairly certain; the peoples of the world find that the colors which surround them work together with ease.

From the muted yellows of the desert to the lush greens of the rain forest, everything in the landscape seems to balance. Around the world and over the centuries, few people have found fault with the color schemes of nature.

Image State

Do we take nature's often very simple offerings and over complicate them?

The question has to be asked however, with the colors of nature as a constant guide, how is it that, (to my eyes at least), the realist painter, (in fact artists of all approaches), rarely produces work which harmonises well?

Could it be that the colors which surround us are often related or repeated, varying mainly in saturation, whereas the artist tends to over complicate matters and perhaps introduces too many unrelated colors?

A scene such as that to the right is mainly based on a blue-violet at varying degrees of saturation and a basic green which also varies in intensity. With a knowledge of color mixing the artist can depict such an arrangement with very few colors.

The same violet-blue used in the blue-violet flowers would be used in the dulled greens as would the orange-yellow used to desaturate the blue-violet. The same violet-red used in the violets and pinks would be employed to produce the very dark greens. And so on.

The unskilled painter would mainly work with the blends that happen to turn up from a very wide range of mixing colors.

Many of nature's color arrangements are based on a small number of basic hues but a vast number of variations in the intensity of those hues.

369

Portions of the blue, violet and green which make up white light are separated from their travelling companions and become visible.

For the sake of clarity, only the blue portion of the light is shown as being scattered in this diagram.

A blue sky appears that color because the blue and violet portions of the white light are scattered about.

It is as if a large blue lamp was hanging in the sky, sending down a weak blue light.

Although this is not the place to go into detail, it will help in our understanding of colors at distance to first look at why the sky often appears blue.

White light, which travels from the sun to the earth, is made up of the full range of spectrum colors, the hues found in a rainbow. The colors arrive in the form of 'energy waves'. As these 'energy waves' travel through the atmosphere they come into contact with the molecules of gases which combine to give our air.

Many of these molecules are of a size which interfere with the passage of the blue and violet parts (or energy waves) of the light.

Whereas, in most instances, the red, yellow, orange and green parts of the white light travel unhindered, a portion of the blue and violet (and some green), is separated and scattered about the sky. It is this scattering of the blue and violet light which gives rise to a blue sky. In effect we have the equivalent of a large lamp in the sky sending down a weak blue light.

The scattering of 'blue light waves' which provides the blue of the sky also visually moves distant objects towards blue.

Although it would be a little difficult to arrange, a mountain flying past ten miles up in the sky would look bluer than when close up due to the scattered blue light.

We would be looking at it through ten miles of what is in fact, blue light,

The closer the mountain became, the less blue it would appear because we would be looking through less blue light.

If that same mountain were then to land ten miles away we would look at it through the same ten miles of scattered blue light.

The scattering takes place at ground level as well as in the higher reaches of the atmosphere.

As in the example of the high flying mountain, the closer we were to the mountain, the less blue it would look. This is because we would be looking at it through less blue light.

Alternatively, if we moved away from the mountain it would become bluer, as in real life.

Distant objects tend to move towards blue. They do not only move towards blue but become lighter and grayer.

It is because of the factors just discussed that distant objects tend to move towards blue. They do not only move towards blue but become *lighter* and *grayer*.

Atmospheric conditions and the changing light can, and often do, upset this arrangement but we can state that with distance, objects such as mountains, trees and boats generally become bluer, paler and grayer. This phenomenon occurs in both the land and sea scape.

The reason that I am going into this in some detail is because as all objects become bluer, paler and grayer *they become more closely related*. This closer relationship helps move them towards a more harmonious balance.

It is for this reason that colors at distance often appear better balanced than the scene close up.

This approach can be employed to bring harmony to a painting. Not just for distant colors but those that are nearer can be made to relate more closely, regardless of the scene.

Basic color mixing skills are required in order to depict color at distance. If a tree appears green close up, add a little blue progressively to more distant trees.

White from paint or the background will gradually lighten the hues and a touch of the complementary red will gradually gray them.

Mist, rain and snow falls influence the colors which are all around us. Colors brought together in such a way can look particularly harmonious. Atmospheric conditions and the time of day can affect the harmony of many a landscape. Mist, in particular, will bring colors together

Contrasts weaken and colors become closer as they assume each other's characteristics.

It is not only distance that brings the colors of the land and seascape together,

During rain, mist and light snow falls the imposition of the 'veil' between the viewer and the surrounding area tends to bring colors closer together.

In almost any arrangement colors seem to work better when they appear to have around the same degree of grayness or are all influenced by a single factor, such as the effect of the light mist in the example above. In this instance the graying effect of the mist is added to the effect of distance. They combine to give a scene which rests easily on the eye.

Winter Landscape, Rihard Jakopic
The National Gallery, Ljubljana, Slovenia

A blanket of snow or a fine covering of sand or dust will also bring colors together and move them towards a closer relationship.

You might find that you start to look closely for such influences in the world around you. Of snow, rain, mist, dust, sand, mud etc. and of the ever changing light. Your observations might initially be for the sake of working towards color harmony in your painting.

However, you might find it to be an enriching experience if this develops into a closer observation of the colors of nature for pure pleasure. This has certainly been my gain during research for this book.

Glowed with the Tints of Evening Hours, Joseph Farquharson (1846-1935)
Roy Miles Fine Paintings / The Bridgeman Art Library
By Courtesy of Felix Rosenstiel's Widow & Son Ltd., London

.........with a single hue appearing in repeated small 'touches'
as well as in mixes with all or many other colors.

The pale yellow light of early morning and the warmer orange light often present in the late evening add their own special unifying influence.

When a hue such as yellow or orange, or any color for that matter, is added to all others, either in the form of colored light or paint, it helps to bring them all together.

This approach can be taken in a painting, with a single hue appearing in repeated small 'touches' as well as in mixes with all or certain other colors in the work. The above painting demonstrates the orange light of many a late evening. It is an actual colored light and can be depicted as such. It is worth observing and noting such influences yourself.

Chain Pier, Brighton, 1826-7, John Constable. © Tate, London 2002

Such factors as mist, snow, rain etc. as well as the influences of the ever changing light can be depicted in a painting in various ways.

Perhaps by adding a certain color to all others in a painting, by working with the complementaries or by applying a very thin layer of color over the entire surface.

Alternatively, you can work *over* a colored background. It all depends on the actual scene that you wish to depict.

In the painting above, Constable applied a layer of pink over the entire surface of the piece. Working on this colored ground he allowed it to influence the entire painting. In some areas it shows through thinly applied paint, in others it is left exposed.

Having decided that the sky would be so colored he depicted the influence of the resulting light almost before starting the actual painting. It was quite common at one time for artists to work over a colored ground.

Contemporary painters tend to work only on a white ground. Could we be missing something?

The Virgin and Child with St. John, Michelangelo
© National Gallery, London

Michelangelo took a similar approach in the painting above. The dull green influencing following paint layers.

376

Spring Sun, Matej Sternen
The National Gallery, Ljubljana, Slovenia

Can the colors of nature be improved upon? This all depends on how you feel. It is, I believe, virtually impossible to depict nature in a totally convincing way.

The rainbow, for example, has never been painted in a wholly convincing fashion (my opinion only). This is due to the nature of light and the limitations of artist's materials.

But then, is the role of the painter to offer the identical scene as that provided by nature? If this were the case, why paint? Why not simply look out of the window?

Very many painters *do* make the attempt. It is an approach which has possibly led to the 'photo realism' school.

Personally I feel that the greater degree of skill shown by the painter in this respect the less like a painting the result becomes.

One alternative (and there are many) to this approach is to learn from nature, perhaps use it as inspiration, but to inject an element of 'painterliness'. I find this to be an impossible quality to fully define but it is obvious whenever encountered.

It is, perhaps, exhibited in the work above; dabs of color scattered about, visible brush strokes, hues repeated throughout the work and carefully scattered around, and the blues and violets of the shadows exaggerated.

Related as well as complementary arrangements worked together. All 'trademarks' of the painter rather than the photographer.

To quote Matisse "Color is not given to us in order that we should imitate nature. It was given to us so that we can express our own emotions.

Branch of the Seine Near Giverny, Claude Monet

As has been mentioned, the colors of nature are usually based around a limited number of hues which are presented in a vast range of saturations.

A single leaf might be a certain green, and all of the leaves from the same tree might appear to be that same green when plucked and viewed under identical lighting conditions.

But those same leaves, on the tree, are subject to light and shade, reflections from one leaf to another and to reflections from other surfaces; and they are also subject to the effects of distance.

Then the whole takes on a quite different appearance to a series of individual leaves viewed under the same conditions.

When the basic hues, shown in a range of saturations, are played one against the other with care and sensitivity, color harmony be-comes possible. If small 'touches' of those same basic colors are then placed around the painting the whole can come together in a way which many, including the author, find to be quite beautiful.

In the painting above, the greens, for example, are taken from the trees to the left and find themselves, in a reduced form, in the tree to the right. They also appear, in a stronger form, in the water and even in the sky at top right, in a very subdued application. The green-blues and violet-pinks are also subject to the same treatment.

That Monet struggled to sell such work, even at very low prices, should be an encouragement to all painters with an interest in color.

If you cannot sell your work it is no indication of its worth. The taste of the buying public should have no influence on you whatsoever.

Bridge over the Dobra River, 1907, Matija Jama
National Gallery, Ljubljana, Slovenia

As with Monet's painting to the left, the artist has taken a limited number of basic hues, presented them in a myriad of saturations, played one range against the other and has repeated each color throughout the piece.

Touches of violet-blue into the orange-yellow and vice versa. Larger areas of each color have also been placed one against the other and have been scattered about.

You will, I feel sure, find many examples of such arrangements in nature. *That is where you will learn.* I can only present my own observations of the colors of nature and their possible application in fine art. It is up to you to truly observe the world around you.

Even if such observations are not of interest in your work, they might become ever more enjoyable in their own right.

379

I am convinced that, if the basics are kept in mind, the painter can learn far more from close observation than from any book.

Let's 'take in' the picture above, a cow standing in a field on a rainy day. It is a fairly bland scene which would be easy to ignore when passing. Yet the observant artist, presented with the above, will note the following;

1. The hues, green, blue etc. disappear rapidly with distance even during light rain (or mist).

2. Colors (including the grays) quickly become desaturated. The cow is a fairly saturated color, the tree to the right less so. Behind these the saturation quickly drops off.

3. The relatively saturated color of the cow seems to bring it closer. This is because saturated colors appear to advance.

4. The sharper detail of the cow also makes it appear to be a lot closer.

5. The roof on the house to the right of centre is a rather garish orange on a bright day. Here the color is suffused.

The graying effect of the rain brings all colors closer together, making them very easy on the eye. This 'bringing together' of colors is one of the keys to harmony.

Such simple observations can be 'worked into' the next painting, even if it isn't that of a damp cow.

So, lessons can be learnt simply by being observant, but observation with certain basics in mind.

The next step with such a scene brings the artist and nature closer together.

I have deliberately chosen a rather bland setting which would probably not make a very interesting painting if copied directly.

The *thinking* artist might decide to incorporate the lessons but feel free to make adaptions.

The color in the background might be 'lifted' slightly to add visual interest. Touches of sharp detail might be added to the grass in the foreground to bring it 'closer' and add depth. It might also be made more saturated. A little blue might be added to the sky.

The scene would still be of our rather wet cow but it could make a more interesting painting.

Alternatively the influence of Gauguin could see a blue cow on pink grass, But lessons will have been learnt from the earlier observation which will bring depth and harmony to the piece.

The artist as interpreter rather than copyist.

Introduction

The stems, leaves, buds and flowers are colored by the blending of just two pigments.

The range of mixed hues is extended by the differences in saturation. Such differences are mainly caused by the varying light.

The full range can be duplicated quite closely on the palette, using the two main pigments as a basis.

One of the main areas of inspiration in nature must surely be the range of colors displayed in various plant forms, from flowers to trees to the grasses and ferns which cover many landscapes. Yet few actual colorants are present in the plants themselves.

Many plants have only two main pigments and rely on their wide range of hues from the intermingling of these two pigments.

For example, a rose might contain a red in the flower with mainly green colorant in the leaves and stem.

Touches of the green pigment might darken the red of the flower and the red might deepen the green on the upper or lower side of the leaves. The 'reddish browns' in the main and leaf stems and certain of the leaves are a mixture of the two.

Swatch 32 Cad. Red Light and mixed bright green.

Swatch 38 Cad. Red Light and mixed blue green.

The simple arrangements of nature can often be depicted by just two colors in paint form when color mixing is fully understood.

Swatch 21 Quinacridone Violet & Phthalo. Green.

The mixing swatch above would be a useful guide to work from when depicting the plant to the left. A touch of yellow will need to be introduced to depict the effects of light etc. on the leaves.

This simple arrangement can be depicted, in the main, by just two colors in paint form when color mixing is fully understood.

Yet many an artist will use several reds to depict the flower, three or four greens for the leaves and stem and reach for a 'brown madder' or similar for the 'browns' of the stem and leaf stems. Seven or eight pigments instead of the two used in nature.

The introduction of so many 'outside' colors tends to reduce the potential for color harmony and seldom looks natural.

When, as in nature, the combinations are kept very simple it becomes a fairly straightforward matter to achieve color harmony and realism.

It is essential however, to be able to control the saturation or strength of a color.

1.

2.

3.

In the main, the vast range of colors found in the plant world result from the intermingling of three color groups; violet, yellow and green.

The violets vary from blue to red-violet (1), the greens from blue to yellow-green (2) and the yellows (3), between green-yellow and orange-yellow.

4.

5.

6.

Of these three color groups only two are usually found together.

A very wide range of wild flowering (as opposed to cultivated*) plants rely on chemicals which provide either yellow and green coloring (4) or violet (blue to red-violet) and green (5).

Where violet and green are the main colors, a touch of yellow often appears within the violet (6).

Cultivated plants frequently exhibit color combinations not seen in wild flowering species. We are more concerned with the latter.

Chlorophyll

Chlorophyll, or 'leaf-green' is more abundant in younger parts of a plant, in the buds and unripe fruit.

As these mature, chemical changes cause the green to diminish and (most commonly) red coloring to develop. For this reason many varieties of apple change gradually from green to red. Mature flowers and fruit are seldom green.

It is a different matter when we come to the coloring in leaves. Young leaf buds tending to lean towards red and red-violet; colors which are less common in mature leaves.

Whereas the 'flower-blues' flow with the sap in a plant, chlorophyll tends to be fixed within the tissues of the plant and does not move around.

The greens provided by chlorophyll vary from blue-greens to yellow-greens and are easily duplicated on the palette.

If you have difficulty in this area, we have a small book 'Mixing Greens' which might be of help. Alternatively, 'Blue and Yellow Don't Make Green' will help in all areas of color mixing.

Yellows

Various pigments provide the yellows in plants, one of the more common being Zanthein. Many plants only contain a yellow coloring and green; yellow flowers and green leaves.

As we can learn so much from nature it will be worth examining the chemical bases which give plants their vast range of colors.

Anthocyans

Anthocyans, or 'flower-blues' provide the wide range of blues, violets and many of the reds to be found in flowers, leaves, roots, stems and fruit.

In their free state the anthocyans are found in the sap of the plant and are red-violet.

When they come into contact with certain chemicals within the plant they move towards red, when in contact with an alkali they move towards blue.

The acid or alkali taken up by a plant from the soil will often determine the color of the flowers.

This is particularly noticeable in certain species. Acidic soil leading to red or red-violet flowers whilst blue flowers will result from alkaline soil.

Green leaves do not usually show areas of red, violet or blue-violet; and green is seldom seen in mature flowers.

'The 'flower-blues' tend to be in greater abundance in stems and leaf stems than in the leaves'.

If the leaf stem is damaged or loosens the color of the leaf changes from green to various yellows, reds and oranges.

Colorants working together

The 'flower-blues' and chlorophyll would seem to 'oppose' each other as green leaves (rich in chlorophyll), do not commonly show areas of red, violet or blue-violet.

Conversely, the latter hues do not often share their space on mature flowers with green.

If the various chemicals which the leaf produces are prevented from leaving the leaf the level of 'flower-blues' and yellows tend to increase. If the stem of a leaf is damaged the leaf will change from green towards orange and yellow.

For the same reason, as the leaf stem loosens on deciduous trees in the Autumn (Fall), the color changes once again from green to the various yellows, reds and oranges associated with that time of year.

The 'flower-blues' tend to be in greater abundance in stems and leaf stems than in the leaves. This is why the various stems tend often to take on a brown to violet appearance as the reds, red-violets, violets and blue-violets from the 'flower-blues' mingle with the green.

When such simple mixes are produced from paints, dyes or similar coloring matter, the colors of nature are relatively easy to depict.

It is only when we reach for additional 'outside' colors that things start to go wrong as far as harmony and realism are concerned.

Although the three main colorants, the 'flower-blues' the greens and yellows often occur together in the one plant, only two tend to dominate.

The flower might be red, the upper leaves green and the stems and under leaves a mixture of the red and green. The third colorant, yellow, might appear as tiny flecks on the petals, leaves or stems, or in the stamens or other parts of the flower.

Swatch 39 Mixed blue green & Quinacridone Violet

'Flower-blues' tend to congregate on the underside of leaves as well as in the stems.

In many aquatic plants the underside of the leaves can be a strong red to violet, whilst the upper side is green.

Grayed greens are often found on the undersides of leaves or, as in these examples, can also form on the surface of leaves.

The mixture of violet-red with the green of the chlorophyll gives a similar range of desaturated reds and greens as would a mixture of such colors in paint form.

Analogous

Complementary

Many of the color schemes found within plants are either clearly analogous or complementary. It is perhaps due to such simple arrangements that most plants exhibit harmonious color schemes. The analogous groupings such as green, yellow-green and yellow tend to sit together very well as they are closely related. The complementary pairings, such as red and green, usually work well as the two principal colors are extended and made more compatible by their intermixing in the stems, veins or underside of the leaves.

Not all arrangements are simple, orchids for example often exhibit a very wide range of colors in the one plant. A flower might move from violet in the centre to blue-violet, then onto green-blue and yellow.

Fortunately the coloring matter very often intermingles within the flower in a way that can be depicted with ease on the palette.

Swatch 33 - Quinacridone Violet and mixed bright green

The fewer the hues needed to give the range required in a piece of work the better, as far as color harmony is concerned.

Swatch 42 - Hansa Yellow and mixed bright Violet

Swatch 44 - Mixed bright orange and Cerulean Blue

The intention is not to suggest how the colors of the plant world can be depicted in a painting, although this might be of interest to some, it is more to show that the colors of nature tend to harmonise because they are usually related to each other.

The principal reason for this relationship is due to the limited number of colorants which are normally involved.

If, in any piece of work, we obtain the range that we require from as few base colors as possible, we are most of the way to achieving color harmony.

The color mixing swatches above are shown to demonstrate the potential range from just two basic hues. The number of mixes are necessarily limited but could be extended dramatically through further blending.

The surface texture of a plant can help bring colors together which might not otherwise work well in paint form.

Surface texture is an important factor to consider when both trying to *depict* the colors in the plant world and to learn lessons in color harmony.

The surfaces of a plant can vary from a velvety, matt finish to a smooth, shiny appearance. The same red coloring, for example, will take on a quite different appearance in a flower with smooth petals than in another with a soft, velvety surface.

It is a little like comparing satin, rough cloth and velvet which have all been dyed with the same colorant.

Such changes might present a challenge to the artist but they do tell us a little about color harmony.

With the vast range of colors which appear in plants, certain of the arrangements might not suit our idea of color harmony. However, it is the relationship of colors one to another which is important.

A plant might exhibit hues which we find do not sit together particularly well. However, if the entire plant, leaves, stems and flowers has a soft, velvety appearance, this quality alone will bring the colors closer together.

Much in the way that mist or rain will bring the colors of the landscape together.

This factor is possibly of less importance in an 'all over' smooth plant. Such subtleties can be very difficult to convey in a painting. As can the effects of light and shade.

For this reason I feel that the painter has to call on every device possible. If the colors in a 'real life' scene work well together until depicted in paint form, it might be the time to start altering the color arrangement.

By keeping the palette as simple as the subject will allow, and ignoring or adapting colors which are harmonious in nature but obtrusive in the painting we can start to work towards color harmony.

If one red can be used instead of two, (to depict a red flower as well as to darken greens). If the same green can be adapted with the same red rather than introducing 'outside' greens we are in with a chance.

If there is a hint of a complementary pair we can exaggerate that hint. Alternatively a complementary color can be introduced for the sole purpose of adding visual interest.

The colors of nature can teach us a great deal but we can choose whether to become copyists or colorists.

Swatch 33, Quinacridone Violet and mixed bright green.

Swatch 21, Quinacridone Violet & Phthalo. Green

Nature can give the inspiration, it is up to the artist to give the interpretation.

Rather than feel duty bound to try and match colors exactly, as so many who paint feel they must, the true colorist will decide the final outcome with or without reference to the subject.

The range of colors in the plant shown above are provided by nature from violet-red and a mid-green. These two hues, plus their various degrees of saturation, can be duplicated on the palette with ease. Swatch 33 with slight modification, greens more heavily applied etc.

White paint can be used to create tints or a white background can be allowed to show throughout.

Without a doubt there are small areas of color which cannot be matched closely this way, these are normally due to changes brought about under varying light conditions.

If, for example, you wished to take the green towards either blue-green or yellow-green, it will aid harmony if you use the same blue or yellow as employed in mixing the original mid-green. If, for instance, you had used a green-yellow, stick to it instead of introducing an orange-yellow.

Other steps can be taken which should lead the painting towards color harmony. The darks in the background and the colored grays in the stonework cannot be mixed from the mid-green and violet-red paints used to depict the plant. (Swatch 33)

In order to keep the colors as *closely related* as possible, a transparent green such as Phthalocyanine Green can be introduced. (Swatch 21). If darkened with the *same* violet-red as used in the plant, the darks of the background can be created.

If *more* of the violet-red is then added to the Phthalocyanine Green a series of dark colored grays will be created (around the middle of the range). These darks, with or without white (in one form or the other) will give the colored grays of the stonework.

Even if the grays were slightly different from those shown in the *actual* stonework, it will aid harmony if the colors of the painting are as related as possible. In the above case the grays will come from the violet-red and Phthalocyanine Green with ease.

However, if the colors in the *actual* stone work could be better matched from say, Burnt Sienna and Ultramarine Blue, to introduce such 'outside' colors would limit the possibility of color harmony.

At the end of the day, are you a painter or a camera?

391

The color schemes of nature are usually quite simple. In this example, violet-red plus green, together with their mixes and influence from the light provide the full picture.

This simplicity can be adopted when it comes to the selection of the paints to employ. If any additional colors are required, they should, perhaps, be kept to a minimum.

Quinacridone Violet and mixed green.

Quinacridone Violet and Phthalo. Green.

Violet-red (from the 'flower-blue') coloring appears in the flower, the stems and around each immature berry.

The presence of chlorophyll modifies this redness, giving the range from the 'unmixed' hue of the flower to the dulled violet-red of the stems and onto the 'brown' around the fruit.

Many a painter would select 4-5 different colors to depict this range plus a further 3-4 greens to use when painting the leaves and darker background.

In nature, only two pigments provided the range of hues. These two, plus variations in saturation brought about by the light provide the entire range.

When depicting such colors in a painting, the mixes provided by violet-red and a mixed green will give most of the required hues.

The darks in the background can be added by mixing a little Phthalocyanine Green (or Viridian) with the same violet-red. When kept deliberately simple, harmony is available.

The range provided by just two colors, particularly if they are mixing complementaries, can be more than sufficient for many a piece of work, or a passage within that work.

If any additional colors are required they should be chosen with care and for sound reasons. Not just because they happen to be left over on the palette!

When leaves are damaged or the stems become loose, (as in the Autumn/Fall) the green Chlorophyll is restricted in movement. This triggers off certain chemical changes which lead to the yellows, oranges, reds and violets as shown above. The changes also lead to the amazing free color show provided in the Autumn (Fall) in many countries.

When depicting such colors in a painting, it will aid color harmony if the yellow used to paint the yellowing leaves is the same as that used when mixing the greens.

If the yellow of the damaged leaves leans towards orange, it will help if the greens are mixed from the same orange-yellow.

If the red-violet shown above in the leaf to the right, is also used in the stems we have another close relationship.

A further aid to harmony comes about as the yellow and violet are visual complementaries. This factor can be emphasised in a painting. Perhaps by touches of a slightly brighter violet, or the conversion of a few green leaves into yellows and violet.

Two colors can be enough for an entire painting, or certainly for passages within a painting. Three colors and we have a very wide range at our disposal. Four hues will give an enormous array to work with.

Five-six or more and most painters have lost control of color harmony almost before commencing the work.

A restricted palette, used with thought and a little skill, offers the best opportunity for color beauty. If you need help with color mixing, let us know. Contact details on final page.

393

Introduction

NHPA © Kevin Schafer

There are some wild and startling color arrangements in the animal world, but somehow they blend with their surroundings.

In the animal world, other things are going on and for other reasons. Color arrangements are used to give warnings, entice, camouflage, identify and send messages.

Hues, which can be very bright, are frequently arranged in patterns and are more often contrasted with white, black or gray than in plants.

Although a great deal can be learnt from the animal world as far as color combinations are concerned, we need, I feel, to take into account surface textures to a greater extent than when seeking answers from the plant world.

A painting of brightly colored tropical fish, for example, might look rather gaudy and less than harmonious than the same scene in real life. This could well be because paints cannot match the variable color *qualities* of the live subject in water.

This is when the artist needs to draw on other skills and perhaps alter the surrounding hues in order to balance the painted colors of the subject.

NHPA © Anthony Bannister

There are color *qualities* in nature which probably should not be attempted, even by the most skilful of painters.

The 'silver' light reflected from the side of a turning fish might be one example. However well applied, silver paint placed alongside conventional paints can look pretty awful. (I have seen it and it does)! A simple area of white can look more convincing.

In much the same way, the ever changing 'metallic' colors of a beetle, the plumage of certain birds or the wings of many a butterfly are perhaps best depicted in a simple manner, with conventional paints.

Such colors are caused by tiny ridges on the surface which interfere with and alter colors, depending on the viewing angle.

'Interference' colors in paint form have been introduced in recent times. They might act in much the same way as the ridges on a beetle's back, but (to my eyes) bring as much subtlety to the work as would a picture of Mickey Mouse in the corner.

NHPA © Image Quest 3D

*The Sea Anemone larva exhibits a calm beauty amongst the many
bright contrasts to be found in and around marine animals.*

A wide variety of contrasts and harmonies are provided by marine life.

Although a seemingly endless range of color schemes are available for inspiration, they can be rather difficult to depict realistically.

This can be due to a variety of factors; the texture of the plant or animal, the optical influence of the water and the saturation of the colors, which can be intense.

Strong contrasts are in evidence as are many subtle harmonies.

The Sea Anemone larva above, for example, exhibits a calm beauty amongst the many bright contrasts.

Many fish have good color vision and are themselves multi hued. They use color as a means of identification as well as a warning. The shark, on the other hand, sees the world in a variety of grays.

NHPA © B. Jones & M. Shimlock

When you cruise along eating with the minimum of discretion you have little need for color vision.

Introduction

As mentioned on page 370, white light from the sun is made up of the full range of colors in the spectrum. These travel in a combined form through space towards our atmosphere.

As the light enters the upper atmosphere it encounters molecules of the various gasses, mainly oxygen and nitrogen.

These tiny molecules tend to interfere with the passage of certain 'colors' in the light. The violet to blue to green end of the spectrum is the most affected.

Much of the red, yellow, and orange light travels unhindered to earth, but quite a high proportion of the violet to blue to green light is of just the right frequency to be diverted from its path.

Once so diverted the violet/blue/green light becomes separated from its travelling companions and becomes visible.

This diversion is known as 'scattering' as the blue/violet/green light is scattered about the atmosphere.

This scattering gives rise to the blue of the sky. A higher proportion of violet is scattered than blue and more blue is affected than green.

The reason that the sky appears blue rather than a very *violet* blue is because much of the energy in the violet end of the range is dissi-pated high in the atmosphere. This leaves mainly the blue light, and to a far lesser extent the green light, to color the sky. We can sometimes see the various layers of colored light as the sky often appears violet-blue in the upper regions, moving down to a mid-blue and then onto a greener blue in the lower regions.

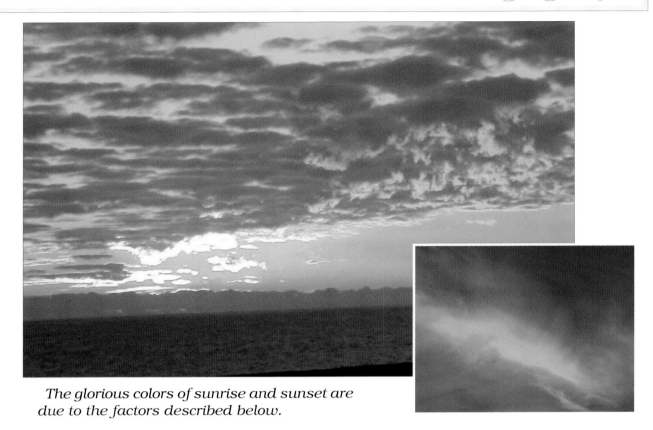

The glorious colors of sunrise and sunset are due to the factors described below.

At midday, light from the sun has a relatively short distance to travel through the atmosphere, which it enters at around 90 degrees.

We tend to see only the scattered violets, blues and greens.

On a clear day the sun is very bright and cannot be observed directly. This situations remains in force for much of the day.

As the sun either rises or sets, the light from it has to travel a far greater distance than it does during the rest of the day. It also has to travel through the denser layers close to the earth's surface.

Much of the blue light peters out near the horizon and we often see the remaining red, yellow and orange light reflected from clouds, moisture or dust. Hence the colors of sunrise or sunset.

The hues of the atmoshere are stylised above. The various wavelengths only become visible when they are reflected from a cloud or moisture etc.

On a clear day, with a blue sky, we can imagine the effect being similar to a lamp sending down a weak blue light.

On occasion, the evening light can be imagined as a large orange-yellow lamp hanging in the sky, sending down an orange-yellow light.

The position of the sun and the condition of the atmosphere lead to changes in the light. This can vary from clear white light, to yellow, orange and reddish light. As with the weak blue light on a clear day with a blue sky, we can imagine a yellow or orange lamp in the sky as the sun sets. We often find the same effect during sunrise, but to a lesser extent.

Whatever the color of the light, be it the blue of a clear day or the yellow-orange of an evening, the color of the light will mix with the color of an object in much the same way as paints mix.

I mention this because paints and dyes etc. mix in a quite different way to colored lights.

At a balanced intensity, red and green *light* will give a yellow when combined. Red and green *paint* will move towards gray.

It is indeed fortunate for the artist that the colored light arriving from the sun and the colors of the earth's surface mix in much the same way as paints.

A yellow light falling on an otherwise red surface will move that surface towards orange, for example.

The 'warm' yellows to reddish oranges of evening light are often depicted by artists. In this painting, the blue of the sky has long petered out, leaving the stronger yellow, orange and red light to dominate. It colors all that it touches.

For more information on this subject, as far as color mixing is concerned, you might find my book *'Blue and Yellow Don't Make Green'* to be of use.

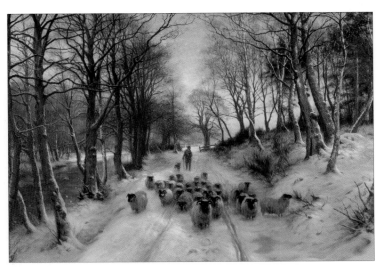

399

Introduction

On a recent visit to Australia I entered into a conversation with a prominent art teacher on the subject of color harmony and nature.

During that conversation he announced 'You would not, of course, ever use two secondary colors together, such as green and orange. I make a point of teaching my students such basic rules'.

It turned out that the advise had been obtained from various books on the subject of color use by the artist. As I believe that *any* two (or more) colors can be encouraged to harmonise I took the photographs reproduced above during a short walk. Rather than never, or hardly ever seen together, these particular two hues *dominated* the landscape.

By the same token violet and green, or orange and violet should not be used together.

Never mind what somebody else says, its what you see that matters!

If, perhaps, one of the roles of the artist is to interpret the world around us for others, that world has to be seen first.

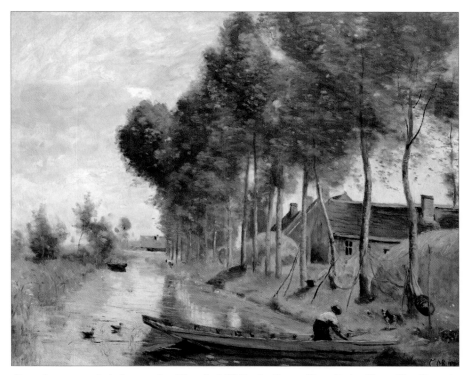

Landscape at Arleux-du-Nord, 1871-4, Jean Baptiste Camille Corot
© National Gallery, London

The advice that the teacher had taken, without further thought or observation, is very common. Color theorists and art professionals have been telling us for about eighty years that we should not use two secondaries together, or two primaries, or these two or those three. That certain area proportions are 'correct' and that others should not be considered.

They have also been telling us that this system is 'correct' or that one. That colors will always harmonise if they mix to a mid-gray because the eye seeks a mid-gray etc.

A great deal of what we have been listening to and using in practice concerning color is nonsense. (That should start the letters).

Of course, a combination such as orange and green, if employed in a fully saturated state would not sit together well for many people.

But each of these basic hues is backed up by an enormous range of possible saturations, Put the two ranges together and the permutations are almost endless.

As artists such as Corot, above, have shown,

ANY arrangement of colors, no matter how awkward they might appear fully saturated, can be made to harmonise, as they can also be made to contrast. If nature can do it with ease, there must be something that we can learn.

This mixing swatch is just one possible combination. Any of a vast range of greens could be used and the orange could lean towards yellow or red, be bright, of medium intensity or dark.

To pick just two from the range and state that green and orange should not be used together really is a nonsense. If all that I have done is to show that *any* color arrangement is available for color harmony, I will be satisfied.

Introduction

The following color mixing swatches are offered should you wish to try any of the suggested color arrangements. Information on using the swatches is given on page 70.

If you possess our Color Mixing Swatch book you will probably find it more convenient to work directly from that.

The mixing swatches which follow, as well as the color arrangement swatches to be found throughout this book, can only offer general guidance.

Conventional color printing has many limitations when it comes to depicting the range of paints and mixes which are available to the artist. To this must be added the fact that watercolors, oils, acrylics and other media tend to alter in color as they dry. Acrylic paints, for example, darken slightly.

Added to this is the fact that readers of this book will work with various makes of paint. Some will use our School of Color paints, others will prefer different makes. There are many color variations between the brands.

All in all it would be impossible to offer exact guidance to suit all media. Therefore please bear in mind that the following guidance is as accurate as the situation will allow.

Please note: As you will find, the first Color Mixing swatch is numbered 9 rather than 1. This, plus other slight changes to the sequence is to allow the Mixing Swatches to take the same page numbers as our Color Mixing Swatch book.

Color swatches

Swatch 9 - Hansa Yellow and Cerulean Blue

A range of bright greens which vary in transparency from the semi transparent green-yellow to the opaque green-blue. Why buy pre-mixed greens when they are so easy to prepare?

Swatch 10 - Hansa Yellow and Ultramarine Blue

Useful mid intensity greens. As the yellow is semi-transparent and the blue is very transparent, the tints will be particularlyclear. Green-yellow to violet-blue.

Color swatches

Further mid intensity greens. Both the yellow and the
blue are opaque. At full strength the mixes cover well
but tend to lose clarity when thinly applied
due to the opacity of the contributing colors.

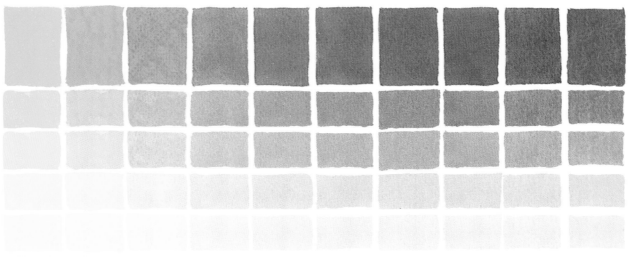

From dull opaque yellow greens to dulled semi transparent violet
blues. A range of very useful landscape colors. An ideal way to
mix deep, subdued greens.

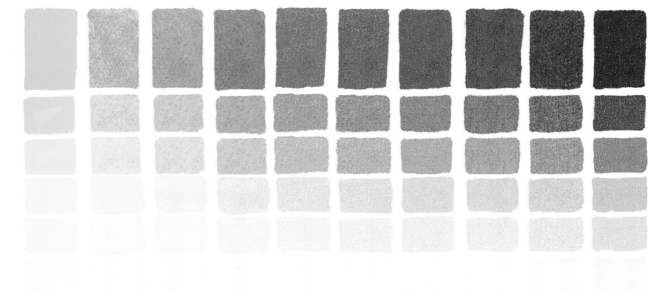

404

Color swatches

A range of clear bright greens which will be more intense in
paint form than shown printed here.
Semi-transparent green-yellow to very transparent green-blue.
The tints will wash out very thinly.

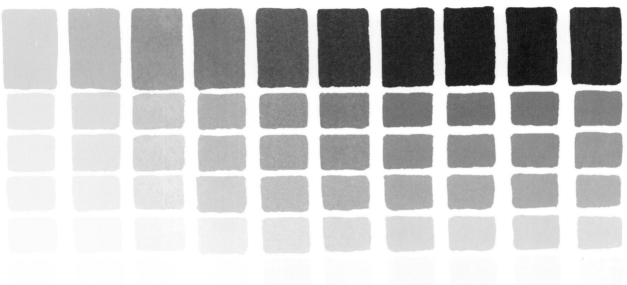

From a semi-transparent green-yellow to the
very transparent Phthalocyanine Green. A valuable range of clear,
very bright greens. Phthalocyanine Green is very intense
and should be used with care.

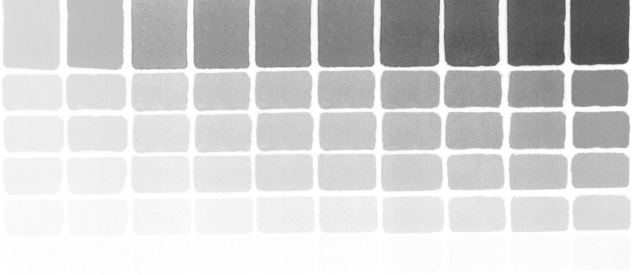

405

Color swatches

Being an orange-yellow the Cadmium Yellow Light
will bring very little green to the mixes. From opaque yellow, to
semi-opaque mid greens and on to transparent bright green.

As the blue is opaque and the green very transparent these
mixes will change in opacity, becoming more
transparent towards the green end of the range.
An important factor in color use.

Color swatches

As both colors are very transparent the mixes will give particularly clear tints. A range of slightly subdued blue greens with many applications, particularly in seascape painting.

Very deep, blackish greens emerge from these two poor 'carriers' of green. In thinner applications these hues give a series of very subtle tints. Such colors are difficult to reproduce in print form.

407

Color swatches

Raw Sienna is a soft neutral orange-yellow
varying between transparent and semi-transparent.
Very soft greens emerge from these two hues
which are particularly useful in glazing.

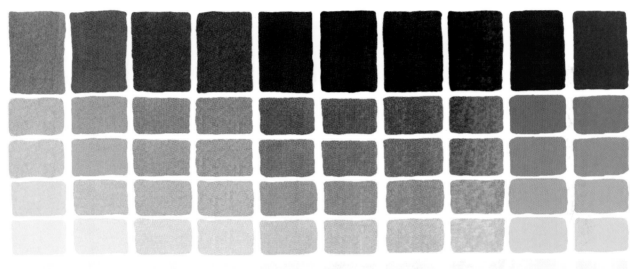

For the brightest possible mixed transparent greens.
Intense colors which give very clear tints when
lightly applied. Both colors are strong and should be
used with care when mixing with other hues.

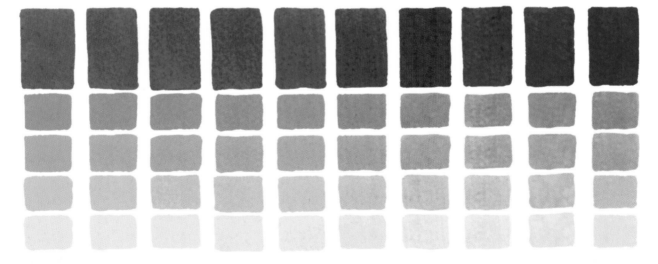

Color swatches

As both contributing colors are transparent
and also mixing complementaries, expect very dark
colored grays around the middle of the range
when the mixes are at all heavily applied.

Swatch 22 - Quinacridone Violet and Ultramarine Blue

Red to blue violets; bright, strong and very transparent,
the brightest lightfast violets that can be mixed.
The results will be much duller and will turn bluer
as the red fades if you use unreliable Alizarin Crimson.

409

Color swatches

A range of mid intensity violets will emerge as these two are mixed as only the blue is a good 'carrier' of violet. The blends will vary in opacity from the opaque red to the transparent blue.

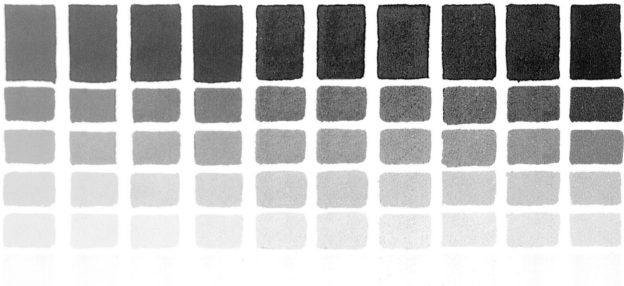

Further mid intensity violets. This time only the red 'carries' a useful 'amount' of violet, the blue reflects very little. From transparent violet red to opaque green-blue.

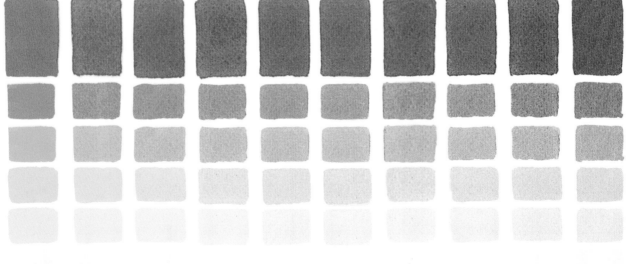

Color swatches

Dulled violets around the middle of the range with subdued orange reds and green-blues at either end. As both colors are opaque the full strength mixes will cover other colors very well.

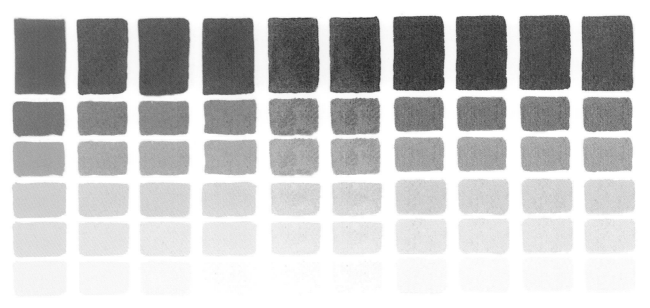

Bright yellow to red oranges. Both colors are strong and opaque, these qualities will be imparted to the mixes. The colors that you mix, if you select quality paints, will be slightly brighter than shown here.

Color swatches

Useful mid intensity oranges. The red 'carries' most of the orange to the mix with the yellow providing very little. The blends will be neither dull or particularly bright.

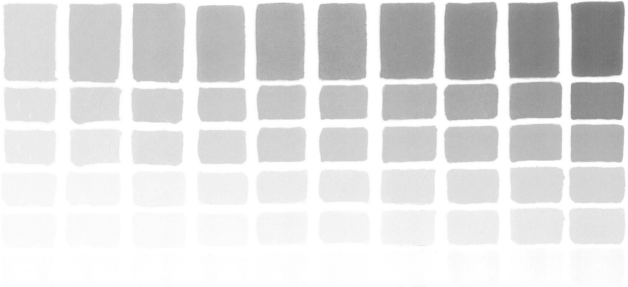

Swatch 28 - Cadmium Yellow Lt. & Quin. Violet

A valuable range of mid intensity oranges.
As only the orange-yellow is an efficient 'carrier' of orange, the mixes will be neither dull or particularly bright. Opaque at the yellow end moving to transparent violet-red.

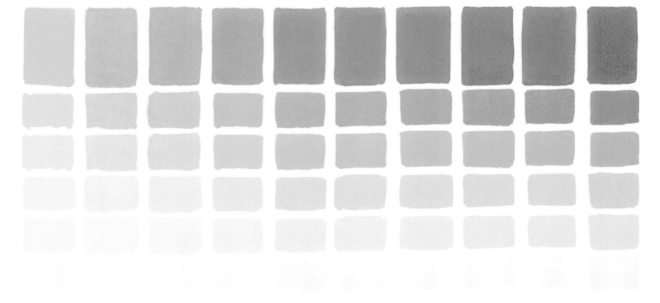

From the semi-transparent green-yellow to the very clear violet-red, the mixes can be considered to be transparent. As neither color brings much violet to the mix the blends will be rather dull.

Yellow Ochre covers well when heavily applied but gives reasonably transparent thinner layers. Soft, subdued oranges which all work very well together.

Color swatches

As with all of the color ranges in this book, these hues can be made to harmonise with ease. Opaque orange-red to bright greens with very subtle colored grays, particularly when thinly applied.

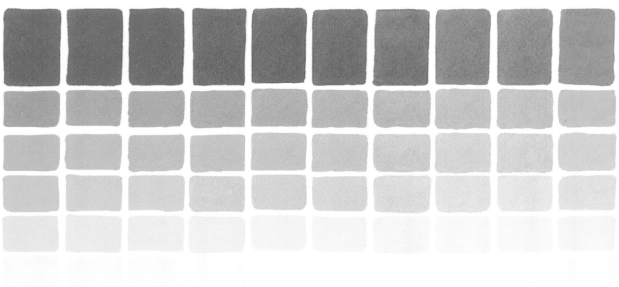

Soft colored grays, neutral reds and greens. The range moves from transparent violet-red to a semi-opaque green. Red and green are visual as well as mixing complementaries. Very subtle tints.

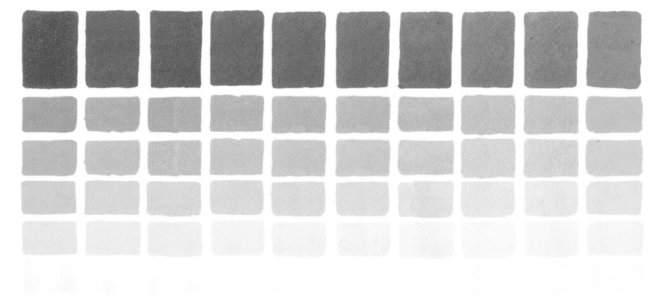

414

Color swatches

As the mixed green can be considered to be semi-opaque, and the red is fully opaque, the mixes will cover well. If the fully saturated red and green are used sparingly, the entire range can be harmonised with ease.

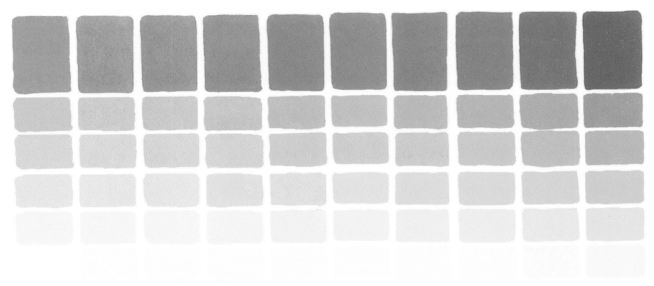

The mixed green will be relatively bright as the blue and yellow are both efficient carriers of green. Yellow-green and violet-red make a versatile mixing pair giving a wide range of colors to work with.

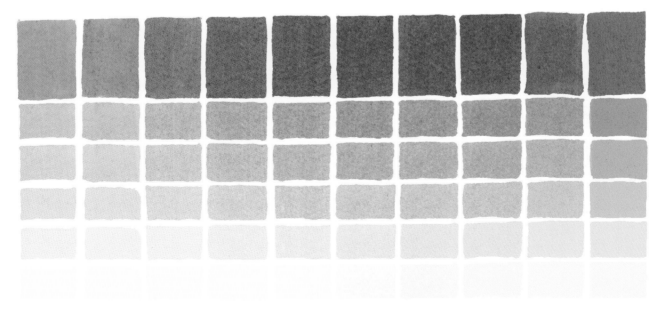

415

A most useful complementary pair. They neutralise
(dull) each other beautifully, give versatile colored
grays around the middle of the range and
an extensive series of subtle tints.

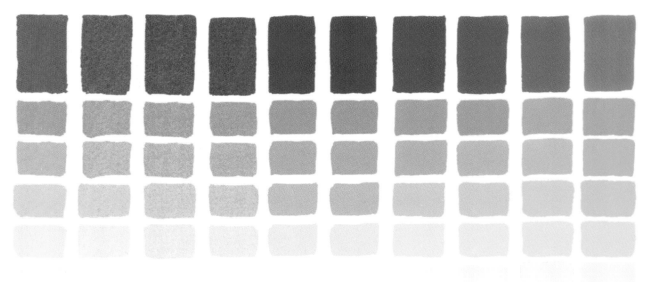

The semi-transparent Hansa Yellow together with
the opaque Cerulean Blue will give semi-opaque blue greens.
The mixes will become progressively
more transparent towards the violet red.

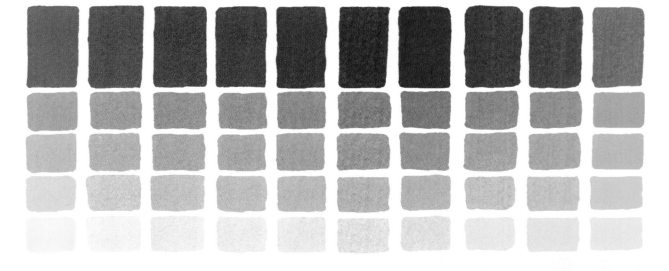

Color swatches

Semi-transparent, colored grays will emerge around
the centre of the range as the yellow and violet absorb each
others' light. Being a complementary mixing pair the
two colors will absorb each other.

As the yellow is changed from an opaque orange-yellow to a
semi-transparent green-yellow,
so the results will alter dramatically
when compared to the mixes on the previous page.

Color swatches

As both the orange and blue are opaque, the mixes will cover other colors well. Subtle colored grays and tints emerge around centre of the range. Invaluable colored grays when mixed to order.

Being a complementary mixing pair they will absorb each others' light. This leads to the dark colored grays around the centre of the range. Such dark colors are invaluable when they can be produced to order.

418

Color swatches

The colored grays around the middle of the range will not be quite so dark as the mixes on the next two pages, because the Cerulean Blue is opaque and the mixes will absorb less light.

A very useful range of transparent colors which can be harmonised with ease. Expect deep colored grays, almost blacks, as the two colors absorb each other and the light sinks in deeply.

419

Swatch 48 - Ultramarine Blue and Burnt Sienna

Being mixing complementaries the two colors will absorb each other, creating darks. As they are both transparent even more light will be lost. The ideal replacement for black, Payne's Gray and possibly Burnt Umber.

If you should experience difficulty in obtaining any of the paints shown in this book we can help. A limited range of lightfast colors have been developed to allow for easy mixing and use. They are central to our approach.

The colors have been selected to give the widest possible range of mixes and are available in watercolors, oils, acrylics and gouache. All are of Artist's quality.

Please see page 424 for contact details.

At the time of writing, the *School of Color* is finalising the development of two computer programs to assist in the selection of color combinations.

The first of these will be known as *Color Cleaver*.

Some time after WWII, leading scientists from the Optical Society of America began intensive research into color relationships. Their work, based on color vision, spanned more than thirty years.

The research led to a model in which hues blend smoothly from color to color and every difference in lightness and purity is represented.

The result is a visually uniform, three-dimensional color world known as the Uniform Color Scales, or OSA-UCS. The model was not based on any individual's ideas of color relationship but on color vision.

It is the most advanced program of its kind in the world.

The color sequences are not an individuals color selection and they do not depend on any color theory. They represent instead the color sequences found everywhere in nature. It is for this reason that the *School of Color* has become involved in the project.

The original research was carried out before the days of the desktop computer. Joy Turner Luke, a leading expert on color vision, took over the project and developed a working computer program.

Joy later joined the School of Color team and we are jointly developing the program to the point where it will become a working tool for all who are looking for quick and highly effective color arrangements.

Color Cleaver™, as the program is known, introduces a fresh approach to the creation of harmonious groups of colors. It provides a way to explore and expand color possibilities, but does not limit either your choices or your imagination.

This program will not suit all artists but will be of interest to those with a need to be able to select effective color arrangements quickly.

The advanced artist, teachers, the graphic artist, designers and web designer would be typical users.

For the fine artist we are also developing a program based on the color swatches to be found in this book.

If you wish to follow these, as well as other developments please see details on page 424.

Described as the first break-through in the field of color mixing in 200 years. Enlarged and updated 2002. Full color, 200 pages. The standard text of artists and art teachers world wide.

The most comprehensive guide to artist's watercolor paints ever published. All leading manufacturers assessed. Their pigments identified and lightfastness examined. 408 pages in full color.

Whether selecting watercolors, oils, acrylics, gouache or alkyds this book will guide you to paints are superb and warn against those which fade or darken. User information on all paint media. 120 pgs. full color.

Comprehensive advice and guidance for those wishing to decorate their home using harmonious color combinations. 240 pages in full color. Titled 'Perfect Color Choices for the Home Decorator' in the USA.

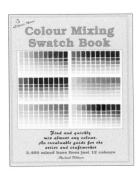

The 'Color Mixing Swatch book' offers 2,400 mixed hues from just 12 colors. An instant color mixing guide. 56 pages in full color.

An easy to follow, step by step guide towards the quick and accurate mixing of greens. 64 pages in full color with spiral 'lay flat' binding.

The 'Color Notes' series. Step by step guides towards mixing and using colors for a variety of subjects. 64 pages in full color, with spiral 'lay flat' binding. Each book is like a mini-course in the subject. A must for the realist painter.

Practical 'paint-in' color mixing workbooks. Each builds into a complete color reference.

Get to know your watercolor paints.

Getting the most from your Color Coded Mixing Palette. We also publish courses on color mixing and color harmony.

A range of products has been designed and books and courses published to help bring about a fuller understanding of color and technique.

We offer paints, color mixing palettes, books, courses, videos and workbooks.

For further information please contact either of the offices listed below:

The Michael Wilcox School of Color USA
25 Mauchly #328
Irvine
CA 92618 USA
Tel: 949 450 0266
Fax: 949 450 0268
Free Phone: 1888 7 WILCOX
e-mail: wilcoxschool@earthlink.net

The Michael Wilcox School of Colour UK
Gibbet Lane
Whitchurch
Bristol
BS14 OBX
United Kingdom
Tel: 01275 835500
Fax: 01275 892659
e-mail: wilcoxsoc@aol.com

www.schoolofcolor.com